WORLD PRESS PHOTO

14

Thames & Hudson

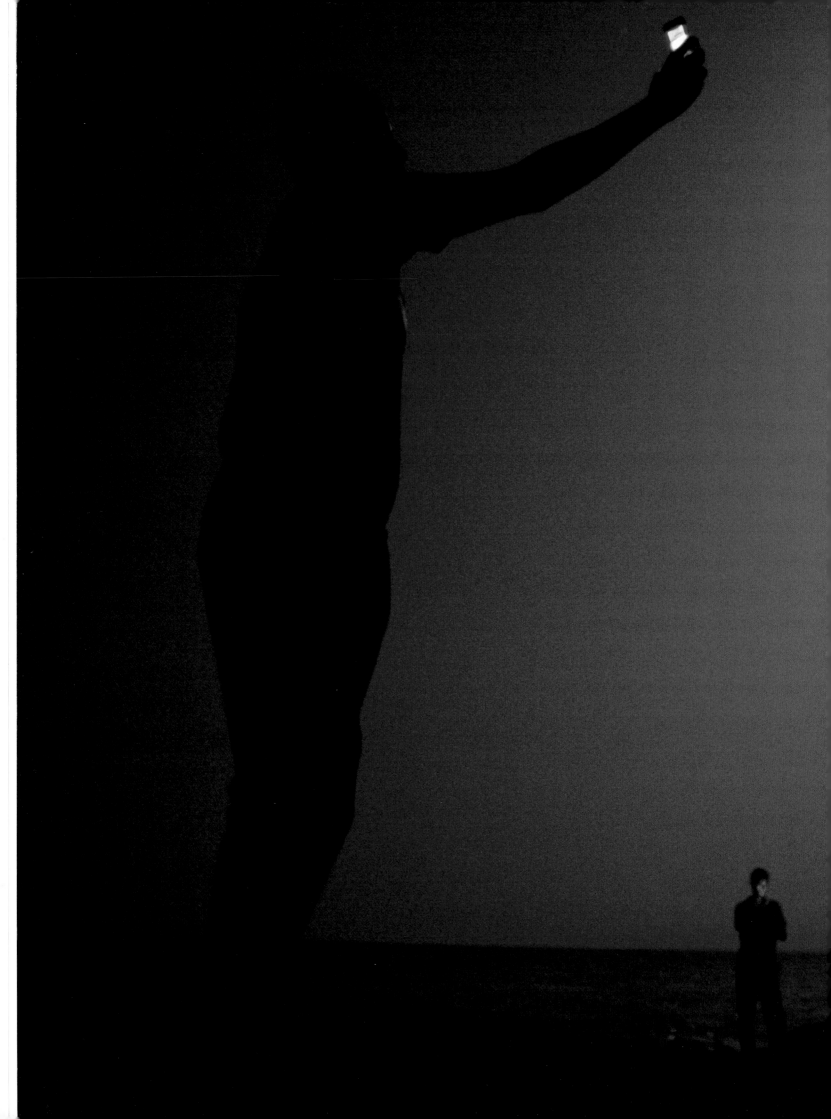

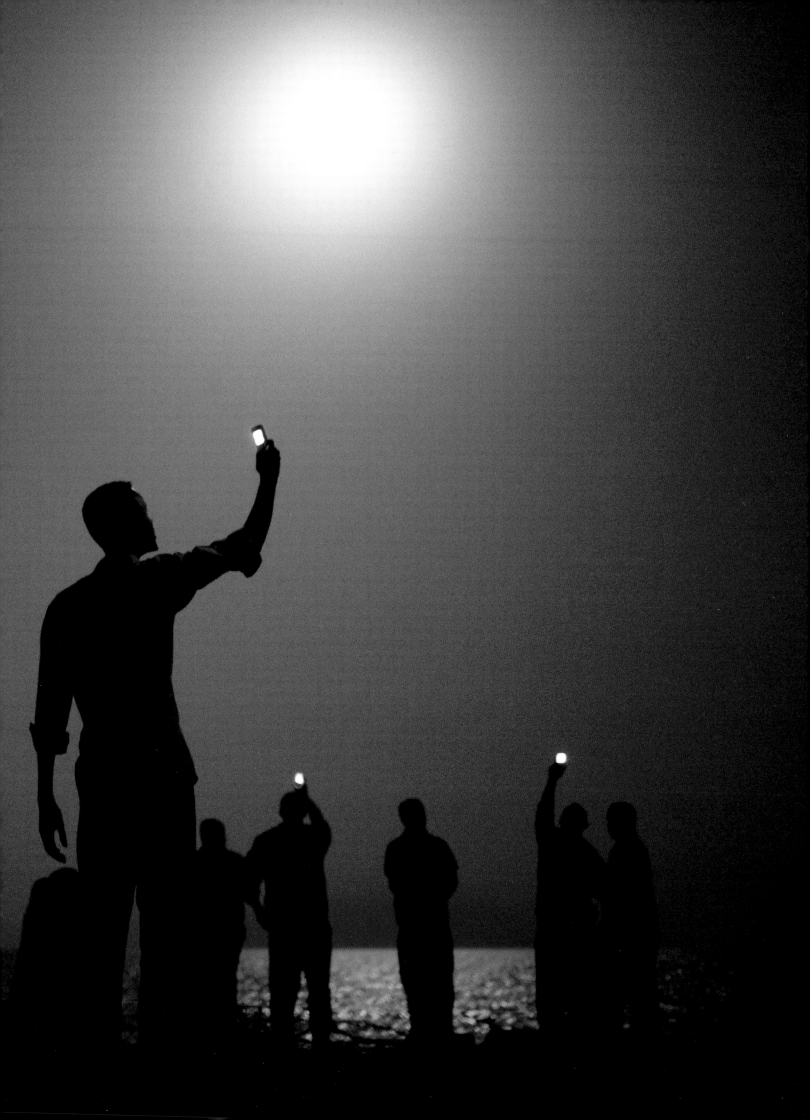

Chair of the 2014 Jury / **Gary Knight**

Sitting in a blacked-out room at the World Press Photo offices, watching thousands of news and documentary images pass before my eyes during the early rounds of judging, I began to contemplate the final jury sessions in the week to come. It is then that the real debate takes place, and where the stakes are so high that the mood can sometimes get a little animated, and unusual decisions can be made. I started to think about what it would take to foster the right conditions for this remarkable jury to reach its potential.

I asked the jury if they thought there should be a hierarchy of issues for the World Press Photo awards, and if so then what they should be. Another way of asking the question would have been: "If we were all unbiased, what choices would we make?" Does an issue or event deserve to win a photography competition if it isn't well photographed? Or should it win if it is as well-photographed as an issue that some jurors may think less important? How do you compare human-rights abuse perpetrated against an individual with what is happening to a large group? Is a war in Africa or the Middle East more important than gender violence in, say, Afghanistan or the USA? Is civil disobedience in Europe more important than what is happening to a small village suffering from rising tides in South Asia? If you start trying to distribute prizes for issues, you walk into a complex moral and philosophical problem with less chance of success than if you try to reward good photography—which was the only thing we sought to judge.

We determined that we were judging the *photography* of issues and events, and not the events and issues themselves. We took the view that editorializing is the purview of the media that publish photography, and of the individual photographers who make the photographs, but not the privilege of an awards jury. This decision was critical. It freed us from contention amongst ourselves, and allowed us to work together to reward photographers who had represented what *they* thought was important to the communities they were

photographing, in the most effective and accomplished way. That decision alone determined the choices we made and not bias, prejudice, or an attempt to be different or make gratuitous statements.

Aesthetics and journalism were both important determining factors in rewarding work, and so was the ability of the photograph to engage the viewer for more than an instant. We favored photographs that were the beginning of a dialogue with the viewer and not the end, and photographs that allowed us to think about what was being photographed and not the photographer who created them. We responded to work that might advance the genre, and which was free of the constraint of historical reference. Work that challenged stereotypes rather than reinforcing them was rewarded, and photographs we thought we had seen before were not. Neither were images that reappeared throughout the competition—similar photos by different photographers—nor pictures that were generic, rather than unique.

Some of the photography you see in this book is rooted in the traditions of photojournalism, and it is here because it reaches the very highest standards in the genre. Other work imaginatively challenges the conventions of press-based photography and pushes the limits of what is possible, but we did not seek to challenge conventions for the sake of it. All of this diverse photography is alive in the press today and deserves a place among the awards. This collection of winning images will likely be regarded as one of the most successfully curated series of photographs the World Press Photo awards has ever seen—and in the context of the current economics of the photo industry, that is cause to celebrate.

Gary Knight
Cambridge, Massachusetts, USA

CONTEMPORARY ISSUES

SINGLES
1st Prize / **John Stanmeyer**
2nd Prize / **Maciek Nabrdalik**
3rd Prize / **Christopher Vanegas**
STORIES
1st Prize / **Sara Naomi Lewkowicz**
2nd Prize / **Robin Hammond**
3rd Prize / **Marcus Bleasdale**

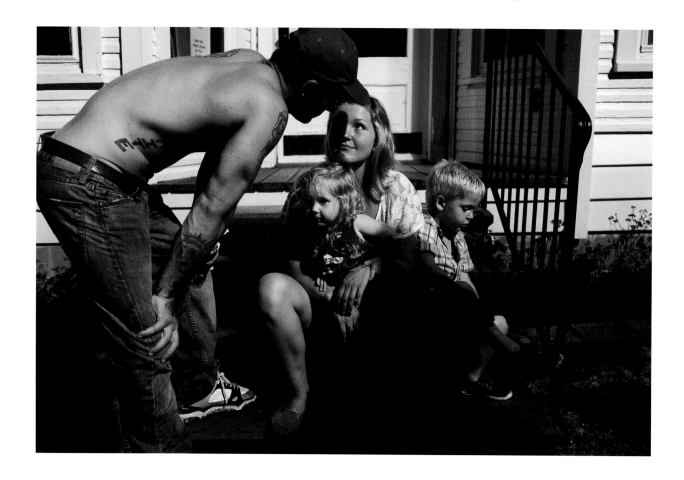

Domestic violence is frequently seen as a private crime, hidden from view, often excused or obscured from outsiders even by its victims. Maggie (19) lives in central Ohio, with her children Kayden (4) and Memphis (2). Her partner of some months, Shane (31), has had struggles with addiction, and has spent much of his life in prison. Above: Maggie sits with Memphis and Kayden. From the beginning of their relationship Shane engaged with the children, asking Kayden to call him 'Dad'. Facing page, top: Shane and Kayden have a haircut together. Below: Memphis runs into the kitchen as an argument between Shane and Maggie escalates into violence. (continues)

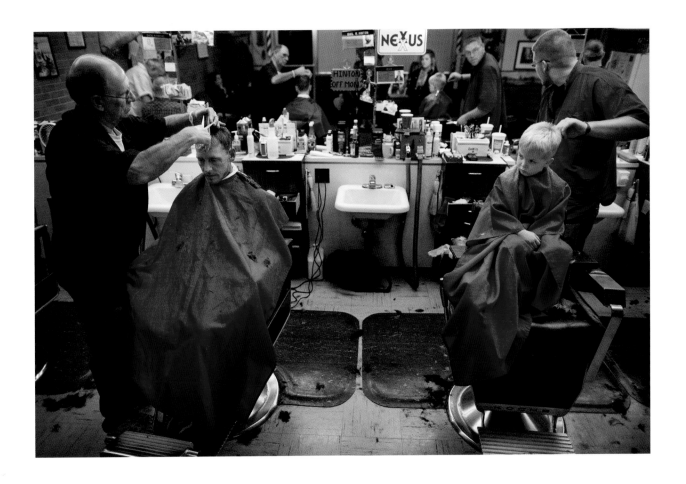

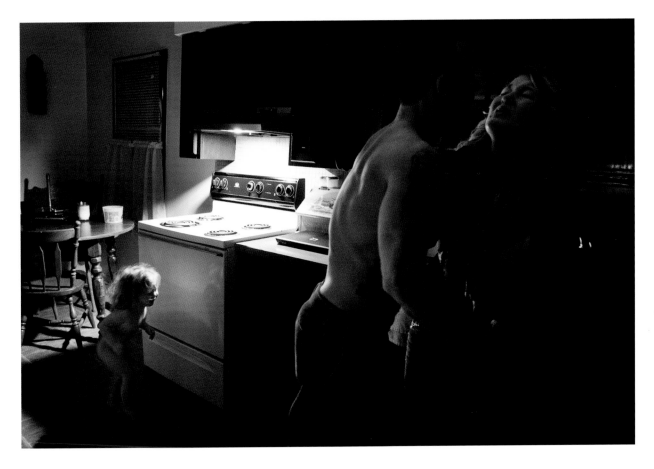

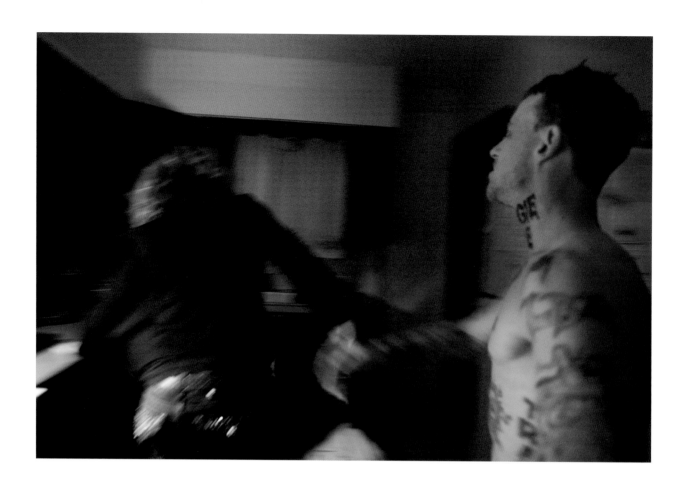

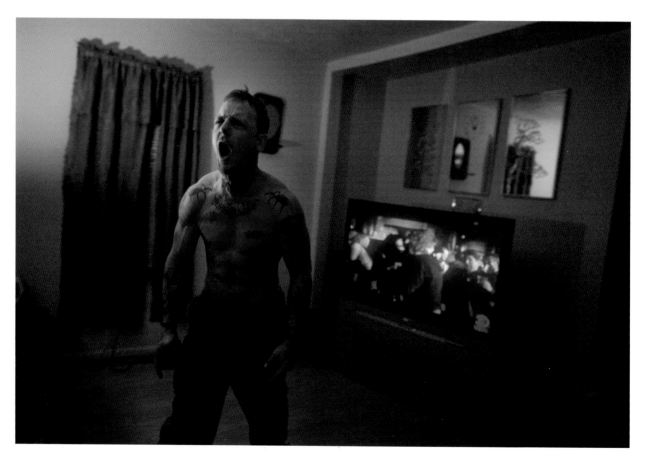

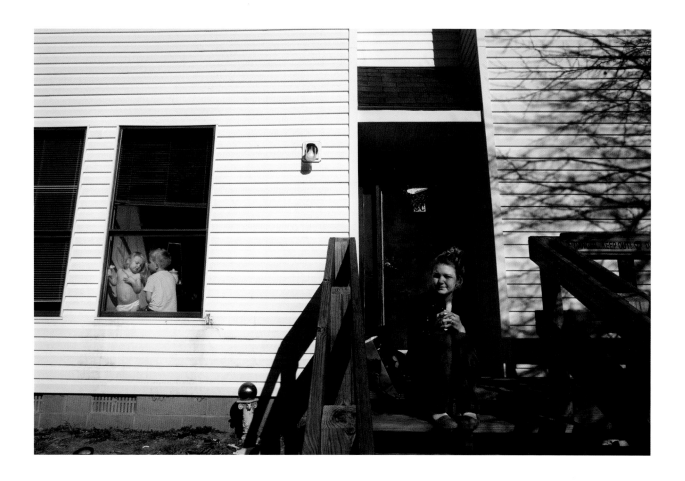

(continued) Shane told Maggie she could choose between being beaten in the kitchen, where a friend was sitting, or going to the basement where they could talk privately. Maggie refused to be alone with him, and his rage grew more intense. Shane was arrested after a resident in the house called the police. He later pleaded guilty to a domestic violence felony and was given a nine-month sentence. Facing page, top: Shane flings Maggie back into the kitchen as she tries to run off. This page: Maggie sits smoking on the doorstep of a friend's house, the morning after the assault. A few days later she decided to move to Alaska, to be closer to her estranged husband.

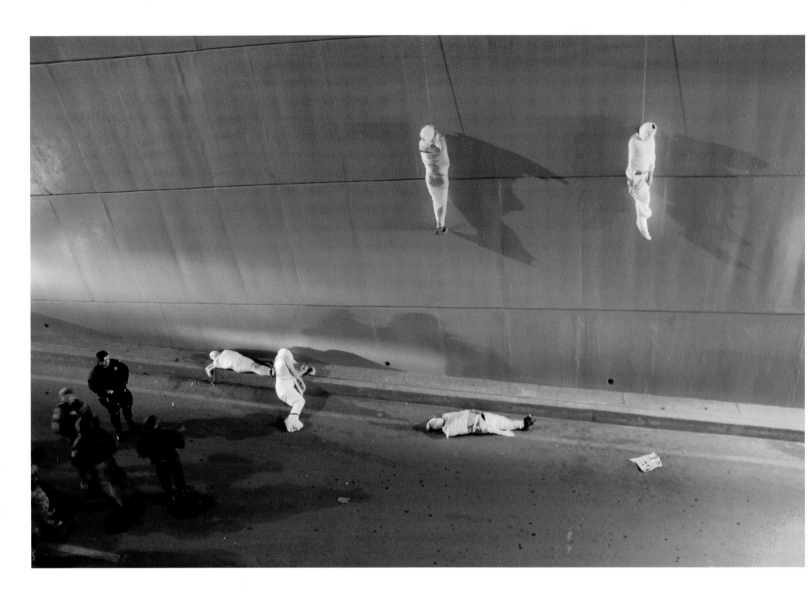

Police arrive at a scene where five bodies had been discovered under an overpass in Saltillo, Coahuila, northeast Mexico, in the early hours of 8 March. Rival organized-crime groups and drug cartels in Mexico often send messages to each other through such public displays. A *narcomanta* ('narco-banner') was found beside the bodies, but the meaning of the message on it was not clear. Three of the bodies were identified; two of the victims had been kidnapped by an armed group some days earlier. The Mexican attorney general's office has claimed that nine out of ten victims of Mexico's drug war are members of organized-crime groups, although this figure has been questioned. At least 60,000 people have been killed since the government began employing military forces against drug cartels in 2006.

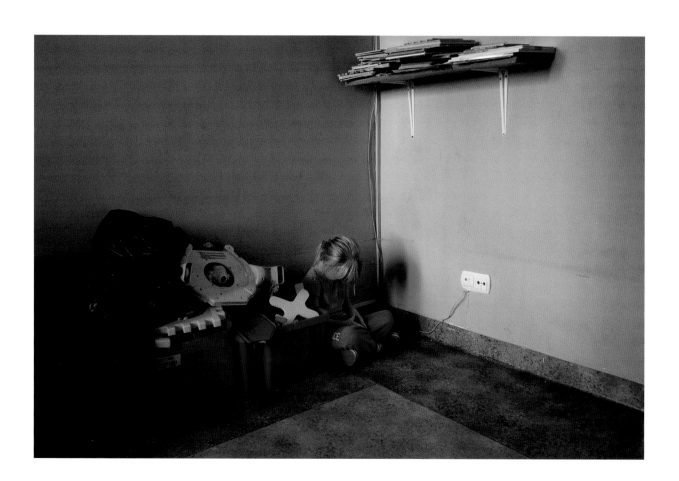

Nicolette sits in the corner of a room at an orphanage in Warsaw, Poland, where she lives with her four brothers. A few months earlier, their mother Ania had been sentenced to time in jail, and the courts did not consider their father a suitable carer for the children. Ania had been out of work for five years, had fallen into debt, and faced a number of other court cases.

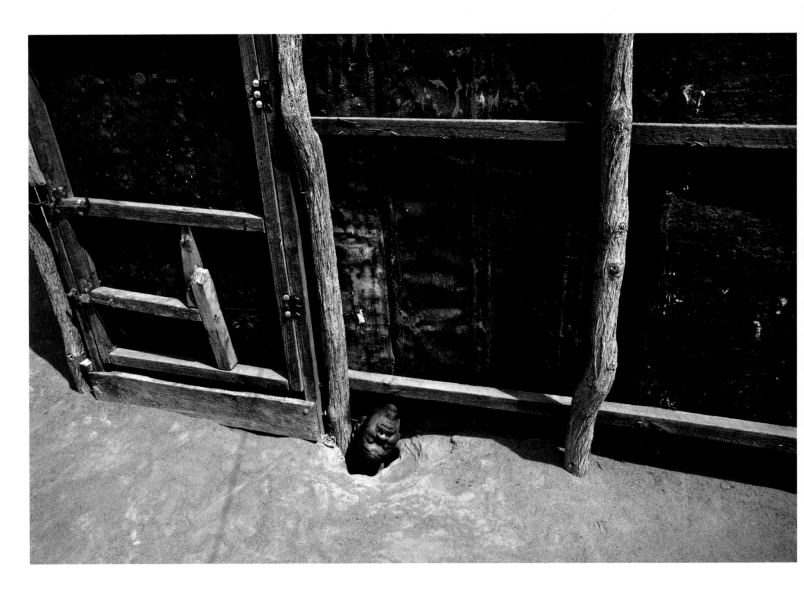

In areas of crisis—in failed states, in refugee camps, in countries where the infrastructure has collapsed—the mentally ill are frequently condemned to neglect or lives of misery. Above: Abdi Rahman Shukri Ali has lived in a locked shack in the Dadaab refugee camp in eastern Kenya for two years. Facing page: A Koranic healer treats patients in Mogadishu, Somalia. The traditional healers recite holy verses to cure mental illness. (continues)

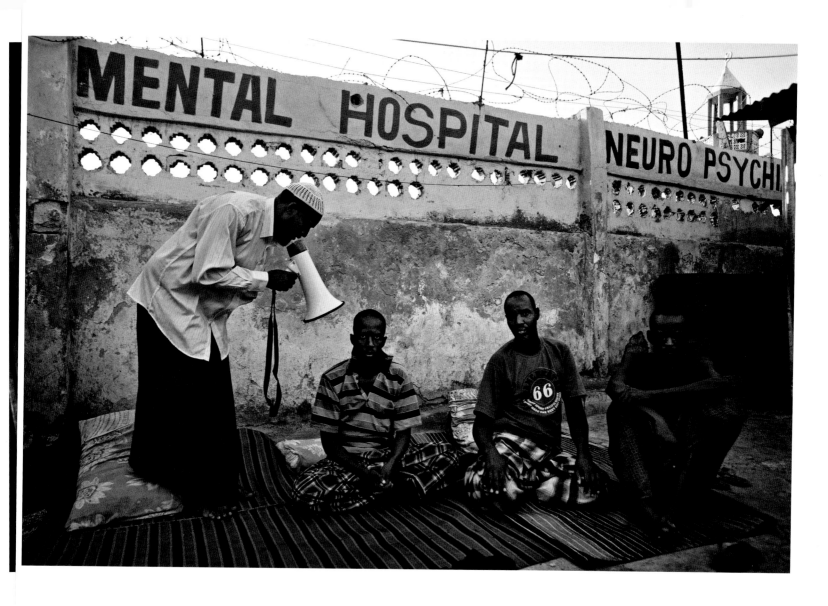

The fishing community on the Lofoten islands of northwestern Norway is slowly shrinking, as a way of life is dying out. A traditional economy based on small-scale, sustainable whaling, and fishing from family-owned boats, is no longer viable. Whaling is dangerous, costs are high and financial returns low; other fishing activity is being taken over by larger companies. The younger generation is opting for safer, salaried work, away from the islands. Facing page, top: A whale is brought aboard one of the community's remaining whale boats. Below: Raymond Nilsen (32) is one of the very few young local men to have taken up fishing in the past two decades. Following spread, top left: A whale is butchered on board the *Nordfangst*. Bottom left: An Egyptian worker takes cod off a drying rack. There were not enough people locally to do the work. Top right: Girls play at a coming-of-age ceremony for a 14-year-old. Bottom right: A derelict sheep shelter in the north of the island is testament to a time when all families kept sheep for food and wool.

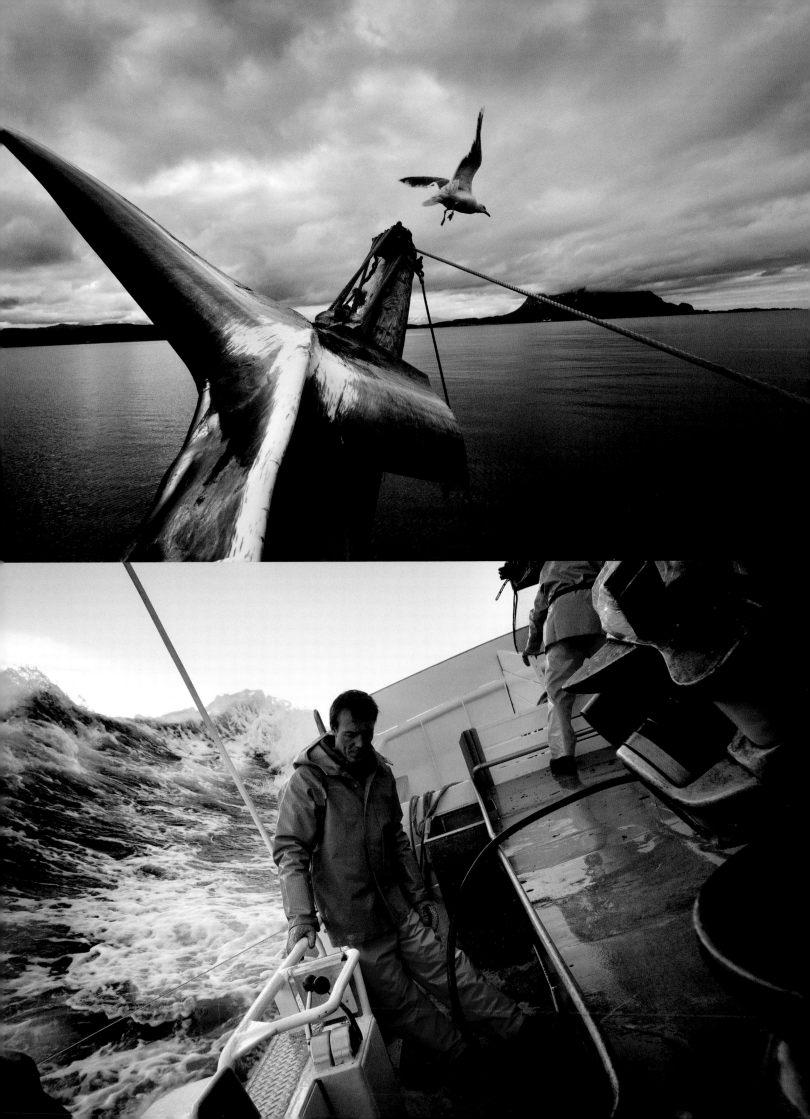

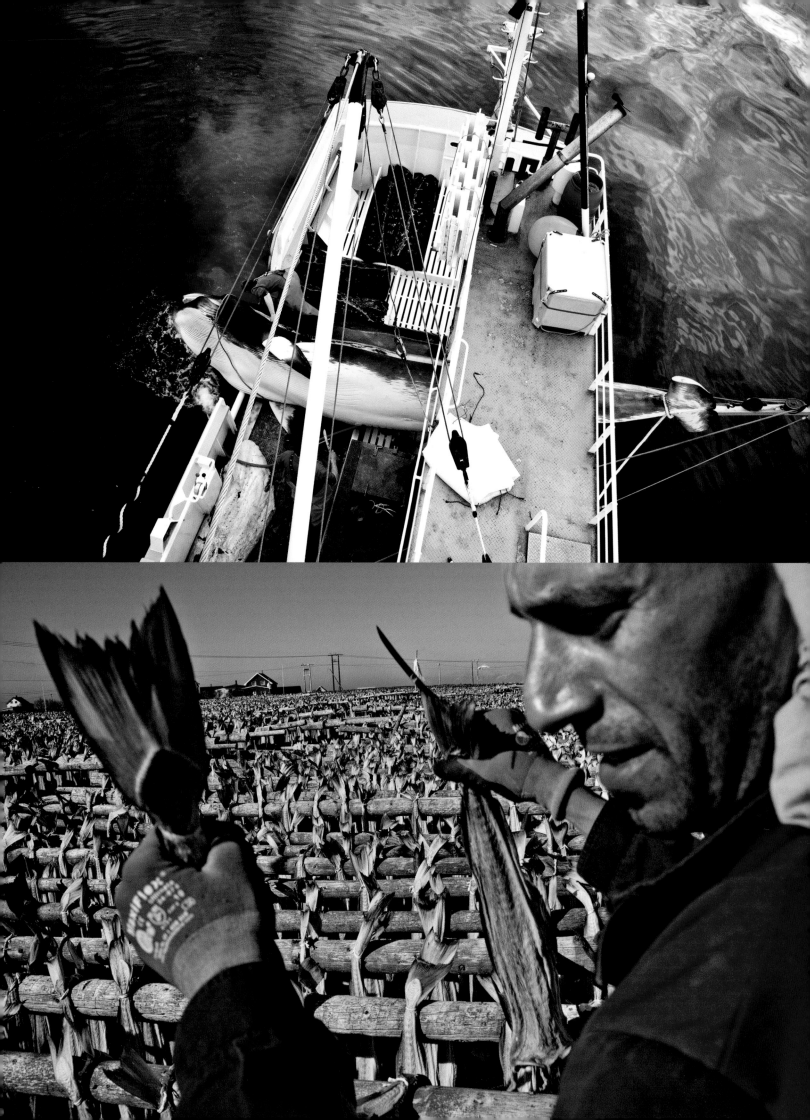

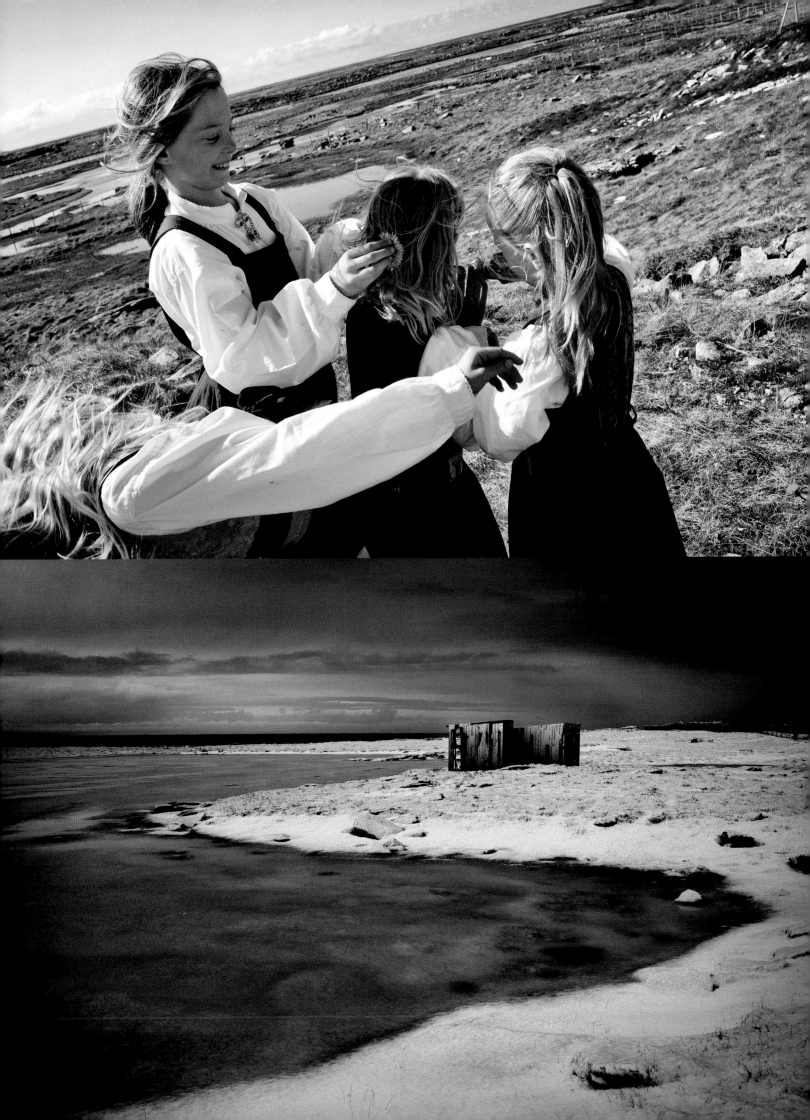

DAILY LIFE

SINGLES
1st Prize / **Julius Schrank**
2nd Prize / **Andrea Bruce**
3rd Prize / **Julie McGuire**
STORIES
1st Prize / **Fred Ramos**
2nd Prize / **Tanya Habjouqa**
3rd Prize / **Elena Chernyshova**
Honorable Mention / **Jana Ašenbrennerová**

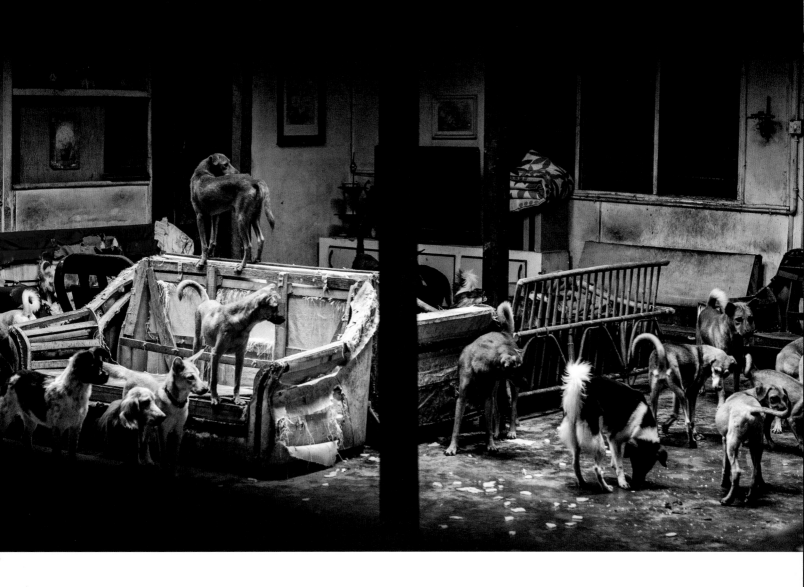

Dogs roam through the home of German expat Barbara Janssen, in Penang, Malaysia. Janssen set up an asylum for strays in 2005, and today offers shelter to some 250 dogs. She occupies a bedroom in the middle of the house. All dogs are spayed or neutered, and treated by vets at Janssen's expense. She operates a no-kill policy, and has established the Penang Animal Welfare Society ('4PAWS'), funded by donations and run with the help of volunteers.

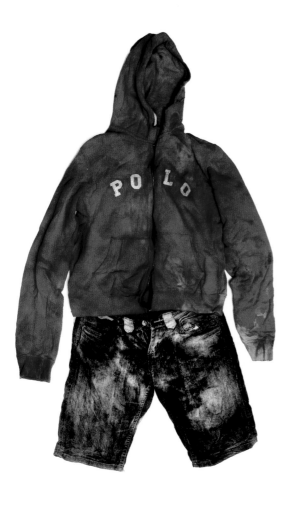

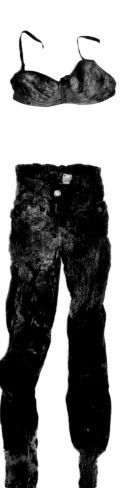

El Salvador has one of the highest homicide rates in the world, much of it gang related. In many cases, the only way of identifying murder victims is by the clothes they were buried in. Date found: 27 December 2012. Time: not available. Location: next to a river in the village of Soyanpago, San Salvador. Gender: female. Age: between 14 and 17 years old. Time of disappearance: not known.

Date found: 1 February 2013. Time: 15:45. Location: a sugar plantation in Apopa, San Salvador. Sex: female. Age: between 17 and 18 years old. Time of disappearance: not known.

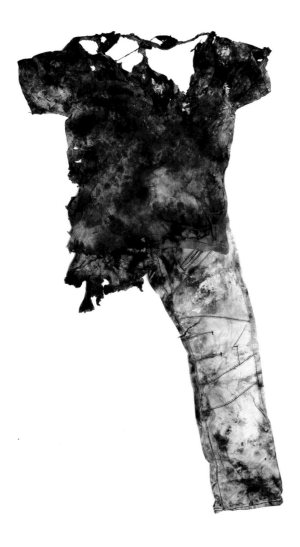

Date Found: 1 February 2013. Time: 15:00.
Location: outskirts of Apopa, San Salvador.
Gender: male. Age: between 15 and 17 years old.
Time of disappearance: approximately one
year previously.

Date found: 6 December 2012. Time: not
available. Location: Juan Opico, La Libertad.
Gender: female. Age: not known. Time of
disappearance: not known.

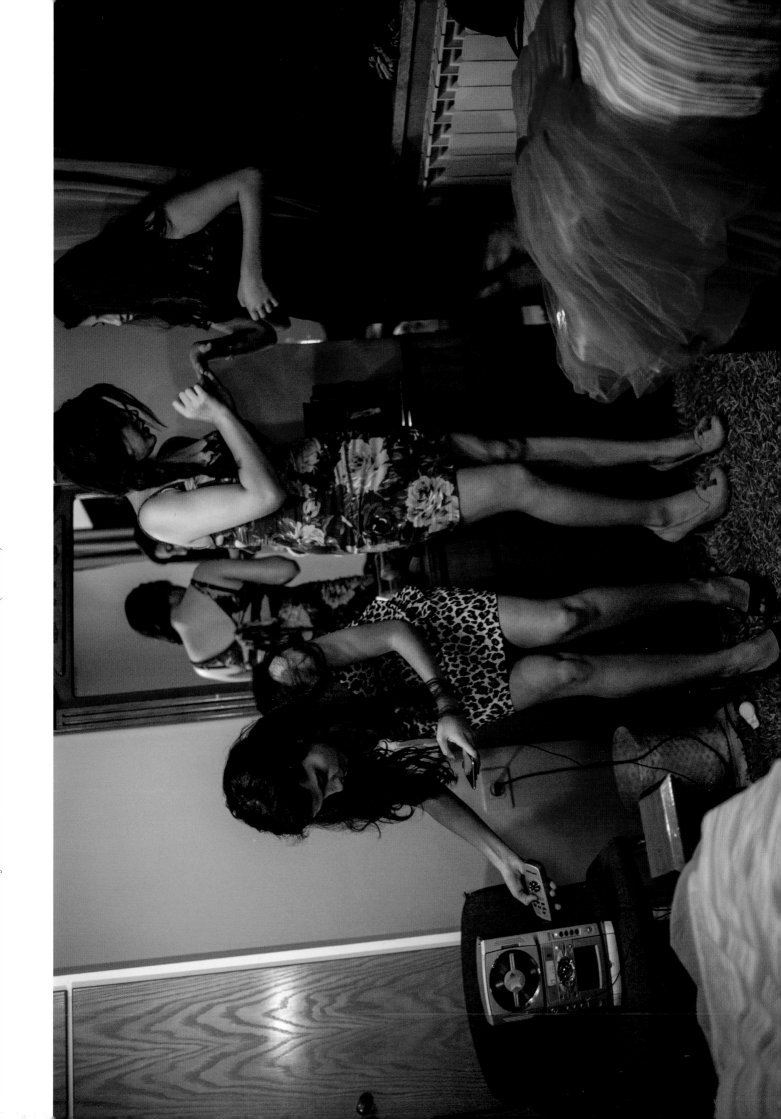

People enjoy moments of pleasure, in the Occupied Palestinian Territories. Above: A youth from Hebron takes a swim in the Ein Farah nature reserve, West Bank. Below: Students try on dresses for a school dance, in Ramallah, West Bank. (continues)

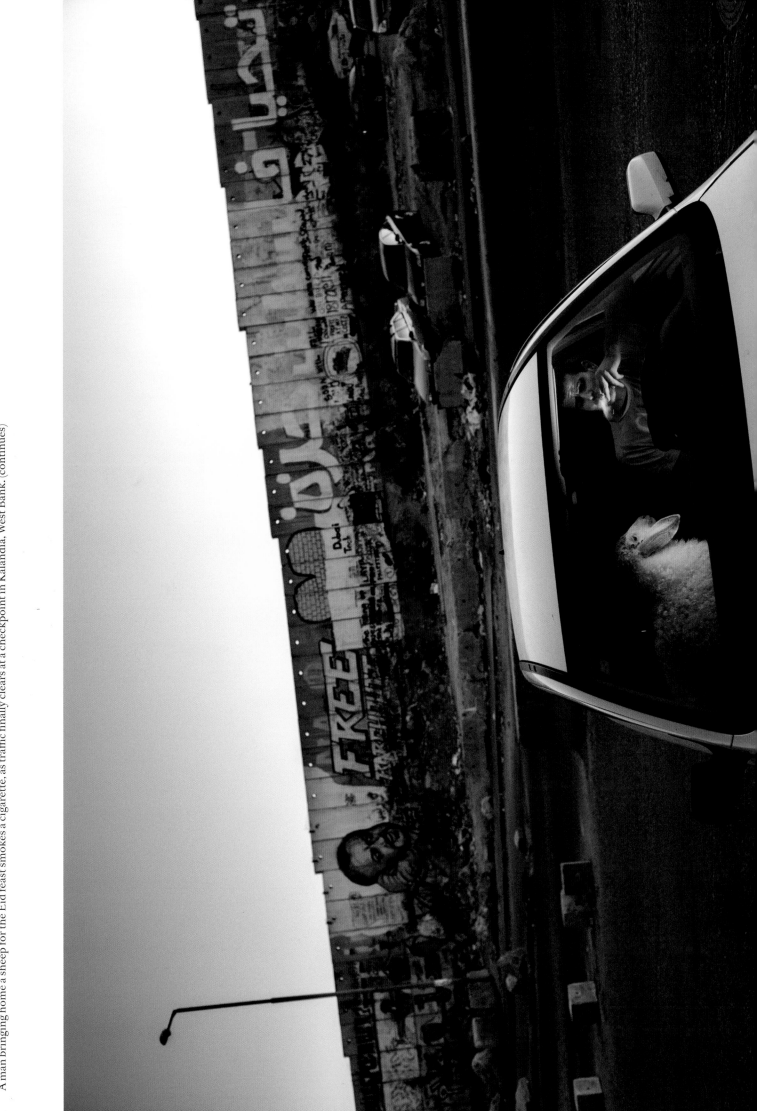

(continued) Over four million people live in Gaza, the West Bank, and East Jerusalem, often in overcrowded or deprived conditions. Below: A man bringing home a sheep for the Eid feast smokes a cigarette, as traffic finally clears at a checkpoint in Kalandia, West Bank. (continues)

(continued) Although the challenges of conflict and occupation overhang everyday life, people are not solely focused on the difficulties of survival. Below: A girl plays on a beach near the Deir al-Balah refugee camp, Gaza, in a party dress she wore to wedding celebrations the night before.

The Democratic Republic of Congo (DRC) has no explicit law against homosexuality; nevertheless there is very little social acceptance of same-sex relationships. LGBT (Lesbian, Gay, Bisexual, and Transgender) people are increasingly subject to discrimination and violence, and many keep their identities hidden in order to avoid assault and stigmatization. In December, a draft bill criminalizing gay sex was proposed in the DRC parliament. Supporters of the bill claim that same-sex activity is un-African, and a result of Western influence. Opponents say that such relationships existed in traditional culture, and point to harsh colonial-era laws as a source of negative attitudes. Very few LGBT support organizations exist, but in the city of Bukavu, in the east of the country, Rainbow Sunrise, an NGO founded in 2011, plays a crucial role in offering people a safe place to meet, a chance to share experiences, and sexual education.

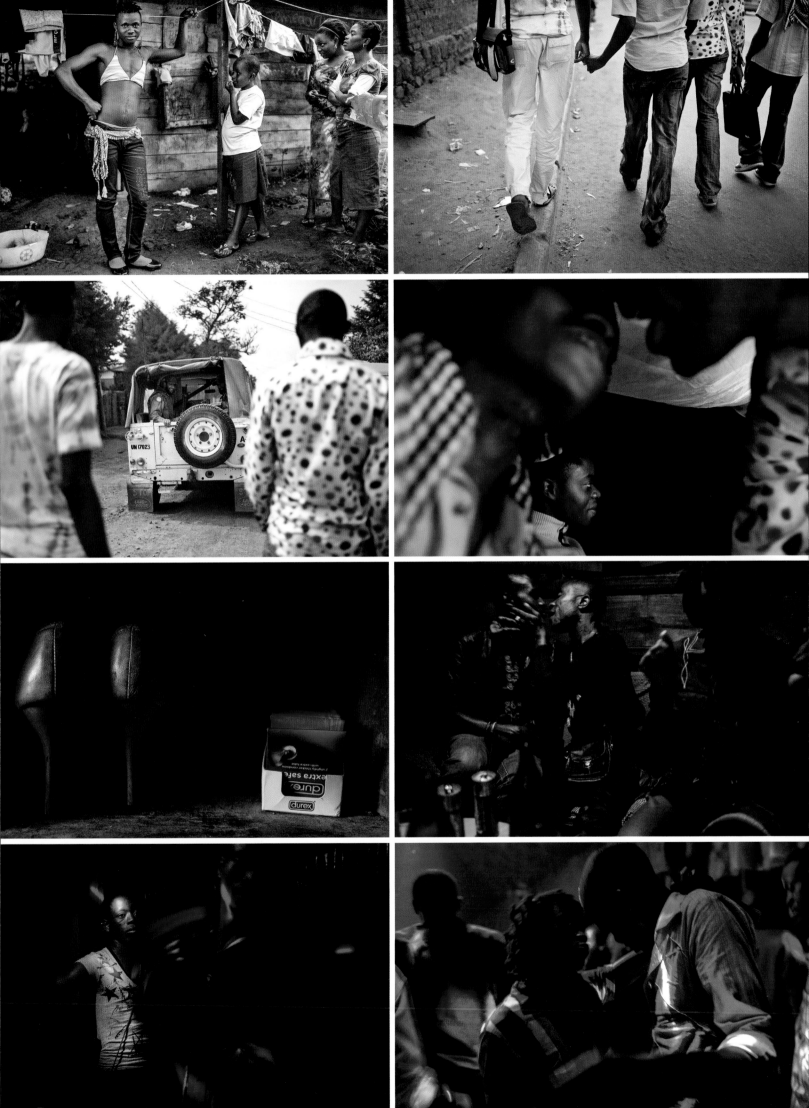

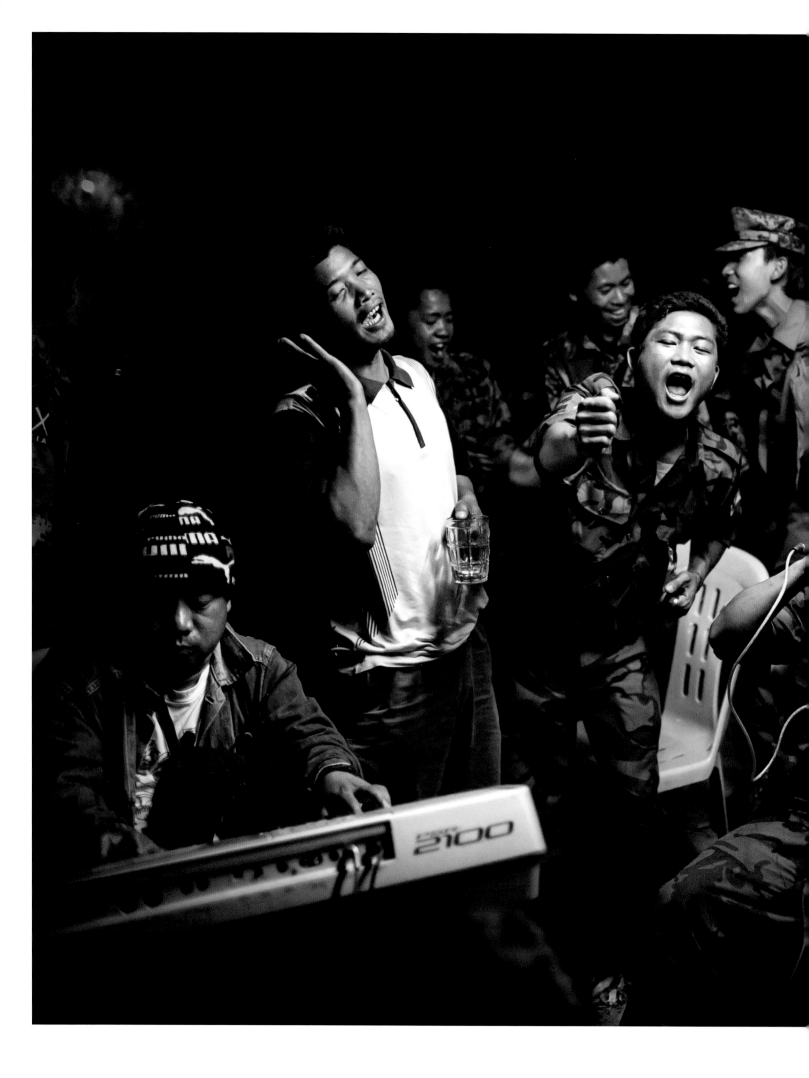

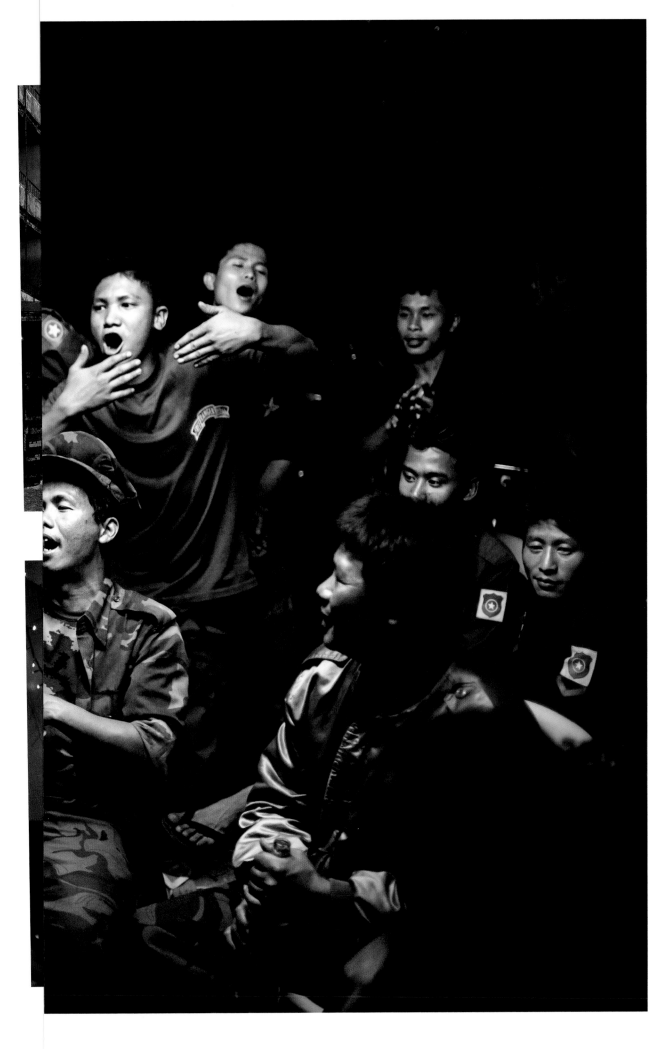

Soldiers of the Kachin Independence Army (KIA) drink and sing together at a funeral for one of their commanders, in the city of Laiza, in Kachin State, northern Burma (Myanmar). The city was under siege by the Burmese military. The Kachin rebellion was one of a number of ethnic uprisings that surfaced after the military junta, which had ruled the country for more than 40 years, began to ease its grip and make moves towards democracy. Kachin State had been given semi-autonomous status soon after Burma regained its independence in 1948. In the 1960s the Kachin launched an insurgency against the central government of Myanmar, demanding greater autonomy. A ceasefire was brokered in 1994, but the KIA refused to give up arms entirely, and maintained some bases in the jungle. Conflict broke out again in 2011.

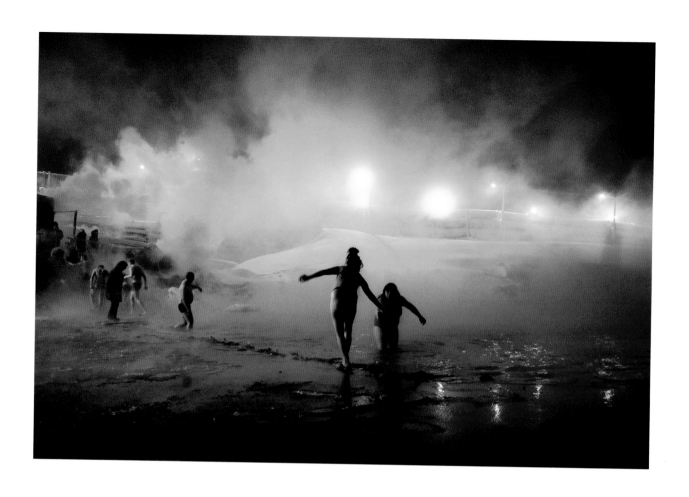

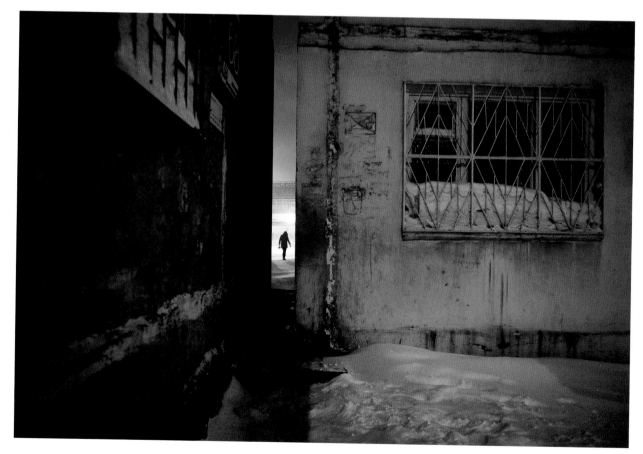

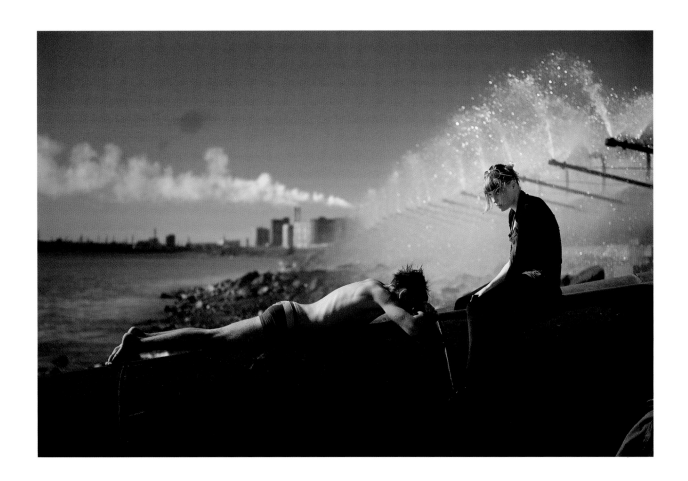

(continued) Norilsk endures an extremely harsh climate, with temperatures dropping below -50°C in the winter, and rising into the high 20s or 30s in the brief summer months. The city is covered in snow for 250-270 days a year, and experiences polar night from December to mid-January, when the sun does not rise above the horizon. Opportunities for outdoor recreation are few. Dolgoe Lake, originally envisaged as a park area was never developed, and though it now lies within industrial terrain is still used for picnics and barbecues. In winter, even in sub-zero temperatures, members of a local 'Walrus Club' plunge into ice holes to swim, before warming up again in saunas heated by steam from the local power plant.

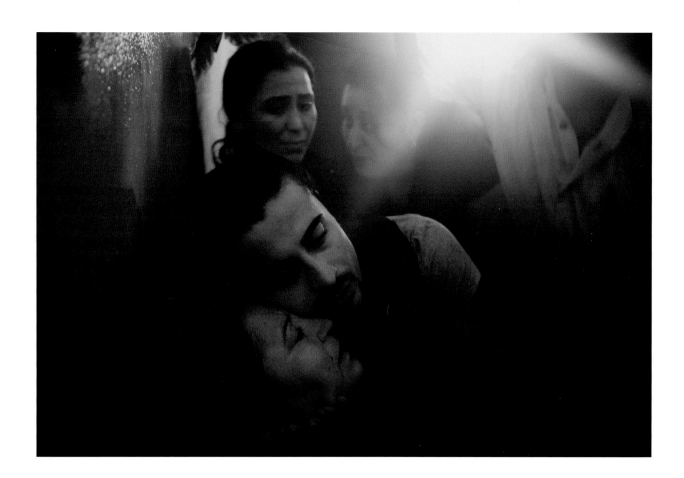

People mourn the death of a 24-year-old Syrian Army lieutenant, who was known by the name of Abu Layth, in a village in the coastal province of Latakia. The soldier had been killed in an ambush at the other end of the country. Support for the government was strong in the region, and the soldier and his family were Alawites, members of the same religious group as Bashar al-Assad, the Syrian president. Abu Layth was the first soldier from his village to fall in a conflict that had been racking the country for two years. Fatalities at the time were thought to exceed 100,000, but figures were extremely hard to verify because of lack of access on the ground to independent observers.

GENERAL NEWS

SINGLES
1st Prize / **Alessandro Penso**
2nd Prize / **Moises Saman**
3rd Prize / **Amir Pourmand**
STORIES
1st Prize / **Chris McGrath**
2nd Prize / **William Daniels**
3rd Prize / **Gianluca Panella**

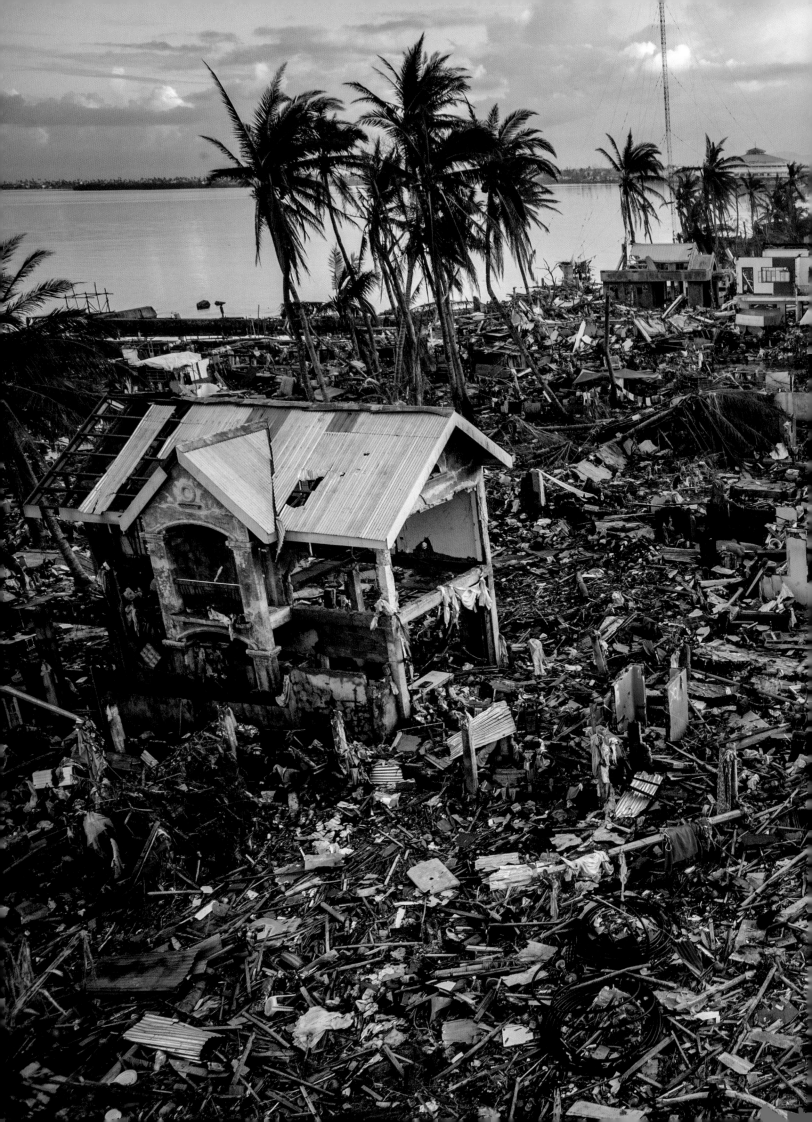

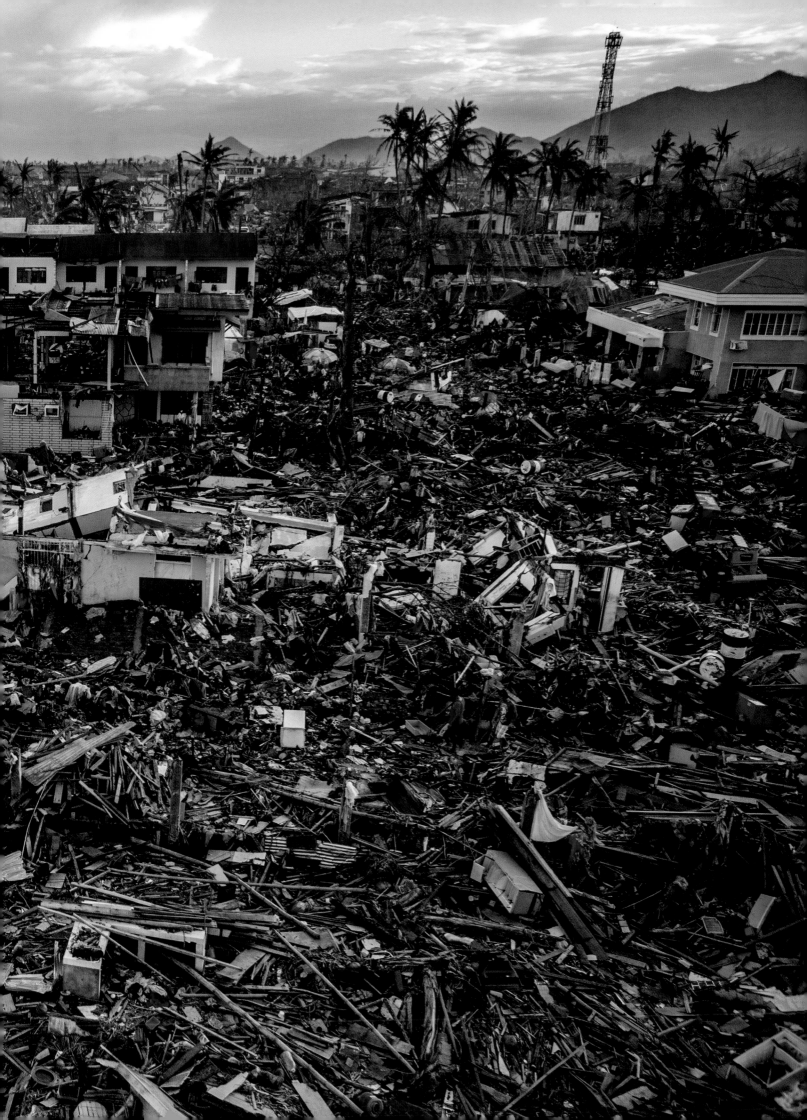

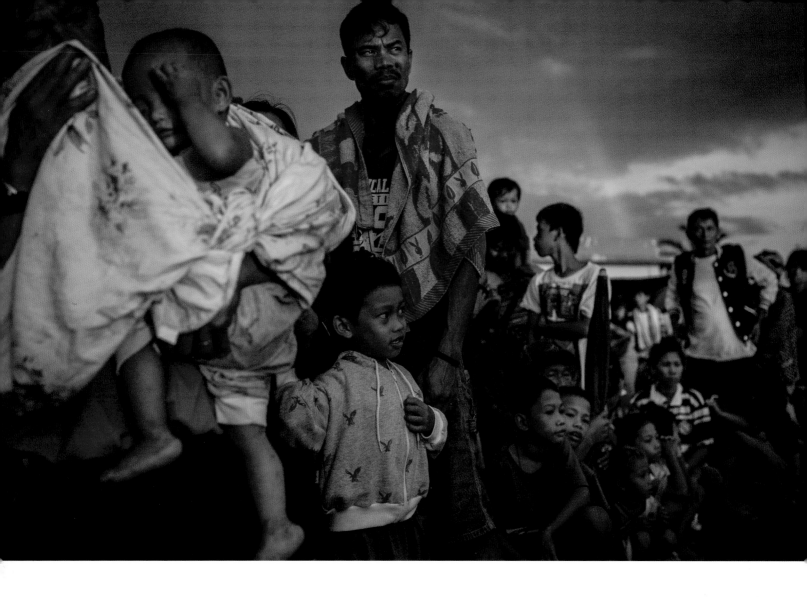

Typhoon Haiyan ripped through the Vasayas region of central Philippines, on 8 November. It was the deadliest Philippine typhoon on record, claiming over 6,200 lives and displacing more than four million people. The eastern islands of Leyte and Samar were the worst affected, with storm surges, high winds and torrential rain causing catastrophic damage to homes and infrastructure. The extent of the destruction meant relief work was slow. Previous spread: The coastal city of Tacloban, on Leyte, lies in ruins. Above: People wait for flights out of Tacloban Airport. Facing page, top: A woman eats dinner in a damaged building in Tanauan, Leyte. Below: Bodies lie beside the road before being placed in mass graves, on the outskirts of Tacloban, on 20 November, as health concerns in the stricken areas grew.

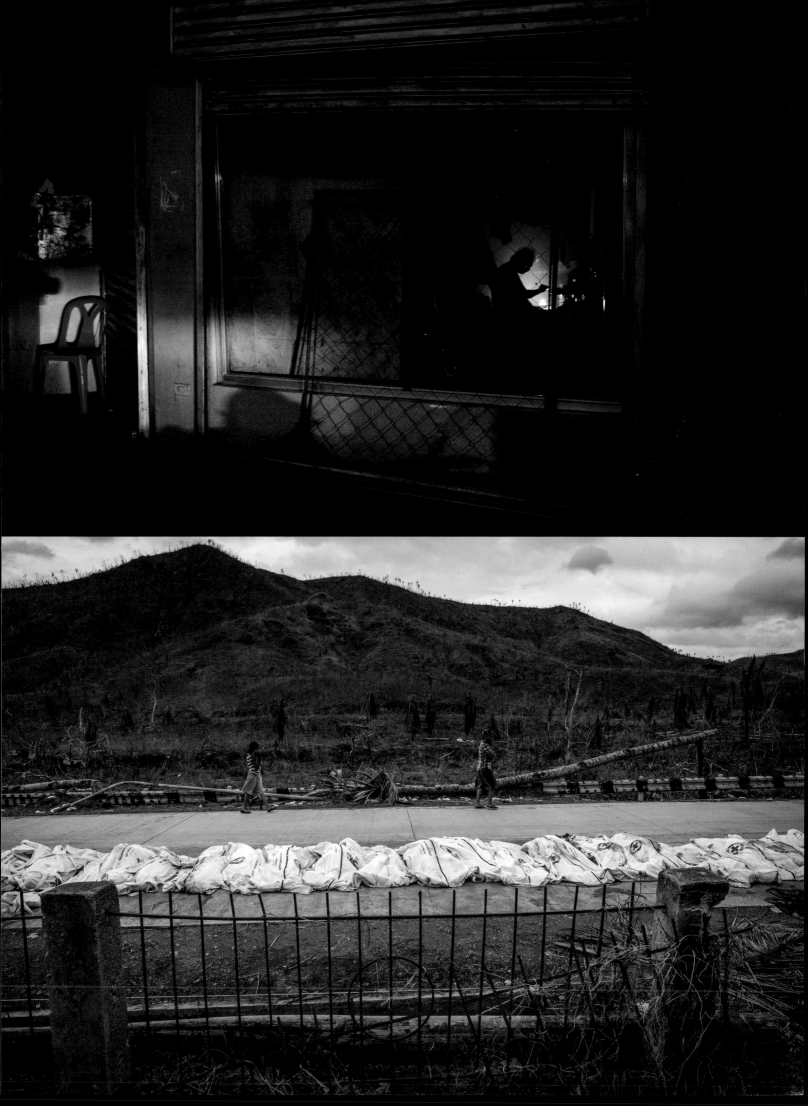

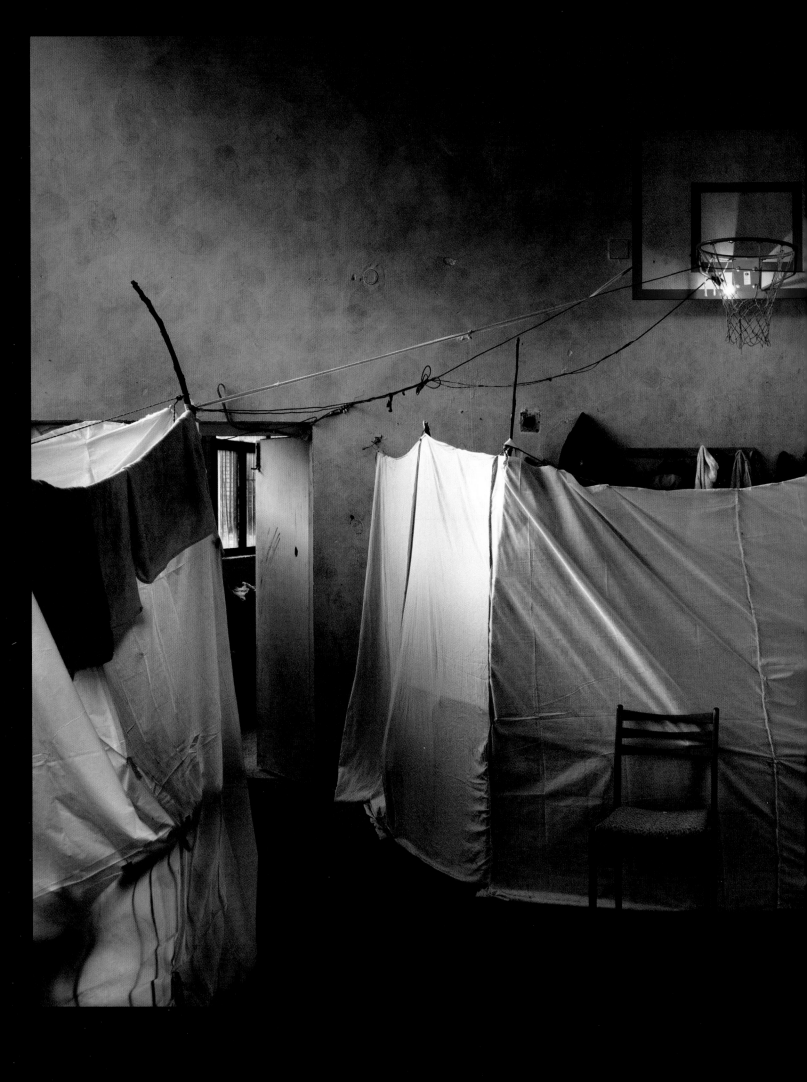

People displaced by the conflict in Syria stay in improvised shelters in the gymnasium of an abandoned school in Sofia, Bulgaria. The school served as a reception center, providing temporary accommodation for newly arrived refugees. The number of asylum-seekers crossing the border from Turkey into Bulgaria rose sharply during 2013, to around 8,000. Most came from Syria or Afghanistan. Bulgaria, one of the poorest countries in the European Union, struggled to cope with the influx. The reception center had no heating or hot water, and the government could offer those living there no food or healthcare. Countries worldwide offered only 18,000 places to the nearly 2.4 million Syrian refugees.

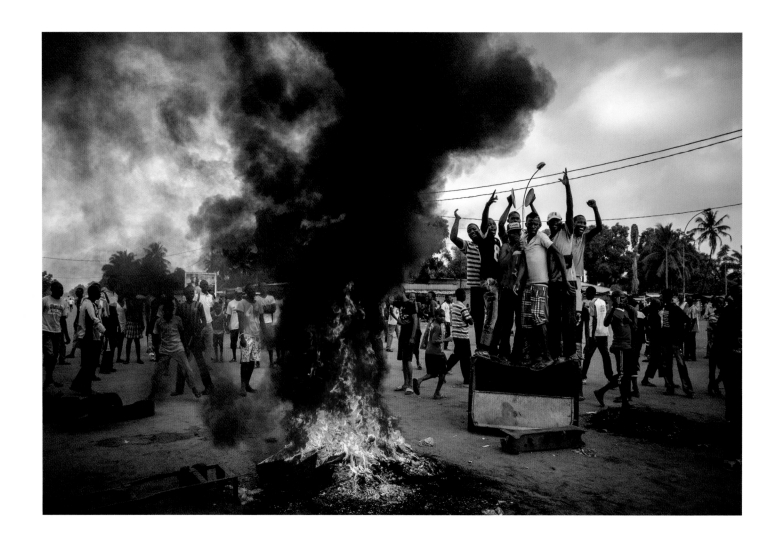

In March, an alliance of mainly Muslim rebel groups known as Séléka seized power in the Central African Republic (CAR). The Séléka were then disbanded, but renegade groups continued to target civilians of the country's Christian majority. Vigilante Christian militia, known as Anti-balaka, sprung up to defend their communities. Above: People demonstrate in the CAR capital Bangui. Facing page: Wounded children are watched over by MISCA (African Union peacekeeping force) soldiers after an alleged attack on their village by Anti-balaka. (continues)

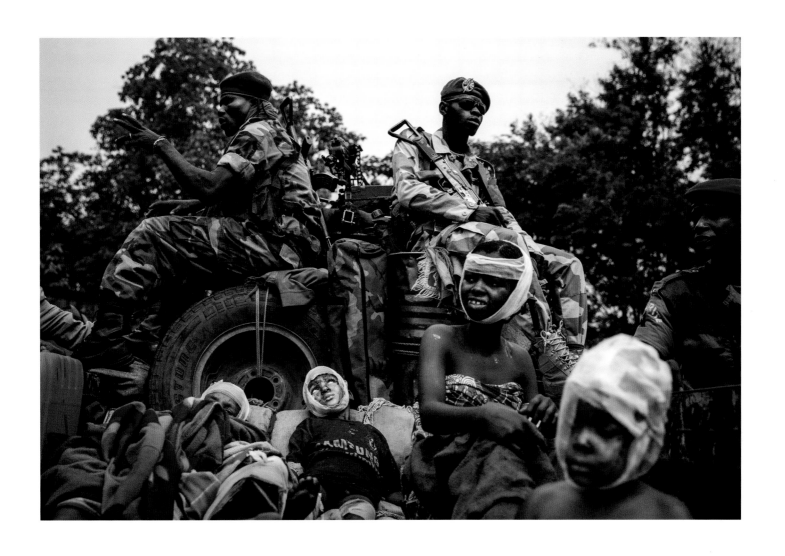

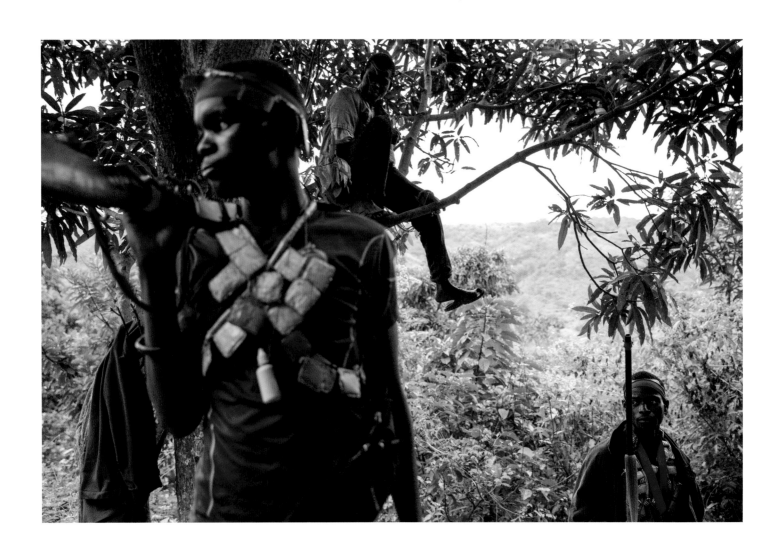

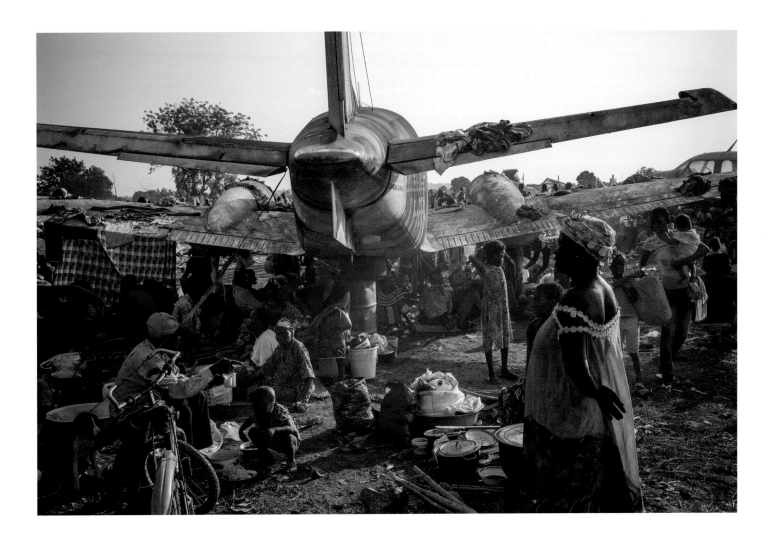

(continued) Hundreds were killed, and some 400,000 people displaced, as violence in the CAR escalated. France sent 1,600 troops to the country to protect civilians and disarm the various militias, while the United Nations warned of deepening chaos and a spiral into genocide. Facing page: Anti-balaka fighters hide in the bush, the day before an attack on the capital. Above: Displaced people take shelter in a makeshift camp that accommodated some 40,000, at Bangui's Mpoko Airport.

Gaza's only power station closed in November, after it ran out of diesel. For years, supply from the Israeli grid had been intermittent, and electricity cuts due to fuel shortages had long been a daily occurrence. Torrential rain and severe flooding in Gaza in December led to even longer blackouts than usual. (continues)

(continued) Alternative diesel supplies had previously been smuggled into Gaza from Egypt, through tunnels running under the frontier. But earlier in the year, the Egyptian military—which had overthrown a Muslim Brotherhood government sympathetic to Hamas—had closed most of the tunnels. (continues)

(continued) In response to the flooding, Israel temporarily lifted its blockade and permitted an emergency supply of 450,000 liters of fuel, paid for by Qatar, into Gaza. The power station gradually resumed operation, but Gaza's infrastructure remains inadequate to meet its energy needs.

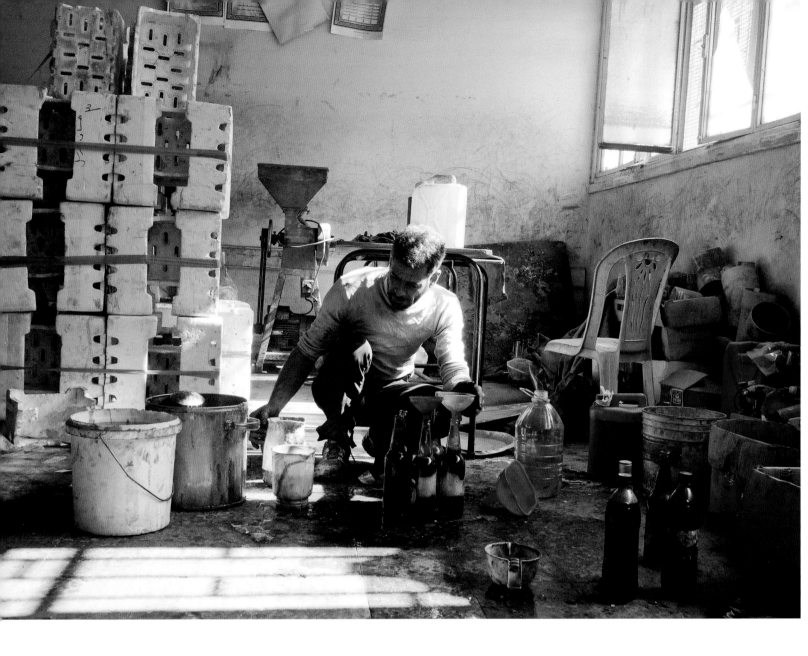

A bomb maker for Syrian rebel forces works in a makeshift bomb factory in the country's largest city, Aleppo. As the civil war in Syria dragged on into its second year, conflict broke out between factions within the armed opposition forces. Much of the in-fighting was directed against the al-Qaeda-linked Islamic State of Iraq and the Levant, and other Islamist groups focused on enforcing sharia law. As rebel factions turned on one another, government troops took the opportunity to launch concerted attacks on rebel-held and contested areas, subjecting Aleppo to heavy bombardment.

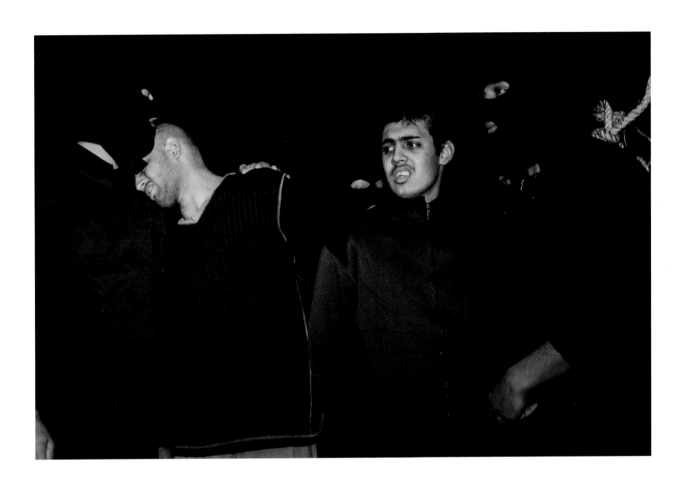

Alireza Mafiha (23) lays his head on an executioner's shoulder, in Tehran, Iran, on 20
January, minutes before he and Mohammad Ali Sarvari (20) were hanged. The pair had
been convicted of stabbing a man and stealing his bag, with belongings worth around €15.
The man survived the attack. Iran is the second-highest executioner in the world. In 2013,
the death sentence is believed to have been carried out on some 600 people.

SPOT NEWS

SINGLES
1st Prize / Philippe Lopez
2nd Prize / John Tlumacki
3rd Prize / Taslima Akhter
STORIES
1st Prize / Goran Tomasevic
2nd Prize / Tyler Hicks
3rd Prize / Rahul Talukder

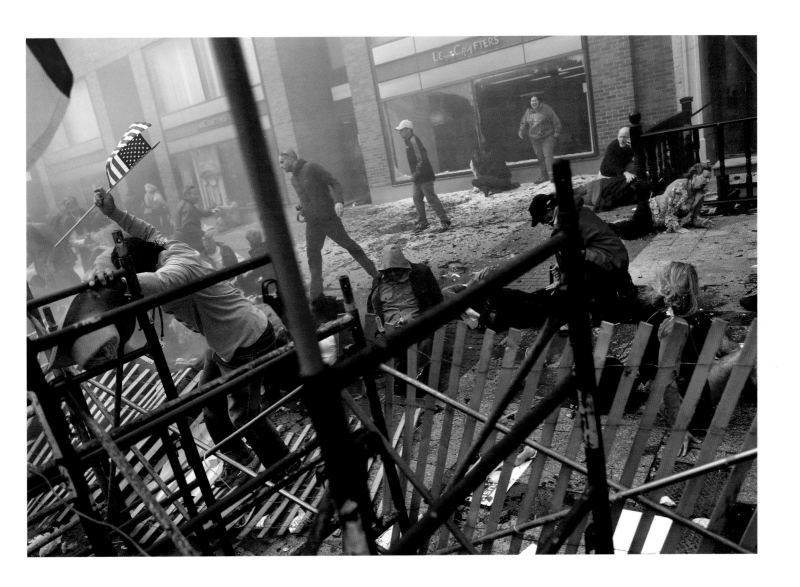

Carlos Arrendondo (left) climbs over barricades on Boylston Street, Boston, to reach people injured by the first of two bombs that exploded near the finish line at the Boston Marathon, on 15 April. The bombs went off 12 seconds apart, killing three people and injuring at least 264. The winners had crossed the line some hours earlier, but thousands of people were still to finish, and spectators lined the street. On 18 April, the FBI released photographs and video footage of two suspects, later identified as Chechen brothers, Dzhokhar and Tamerlan Tsarnev. Shortly after they had been identified, the brothers allegedly killed a police officer and hijacked a car. Tamerlan died following the subsequent shoot-out with police, and Dzhokhar was arrested hours later.

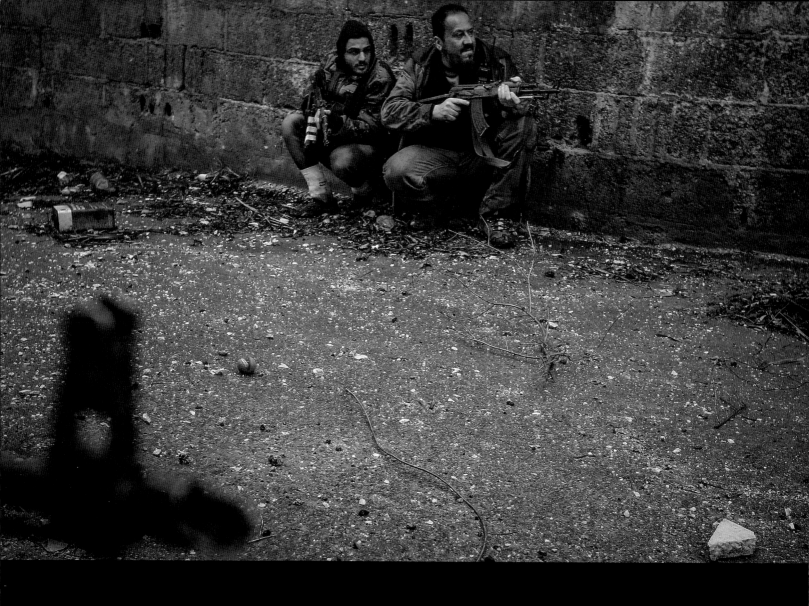

Rebel fighters of the Free Syrian Army (FSA) attack a government check-
point, in the Ein Tarma neighborhood of Damascus, on 30 January. The
battle for the suburbs of Damascus was considered crucial to both parties.
In this incident, FSA fighters conducted the assault on the Ein Tarma
checkpoint over the course of two hours, and were targeted by snipers.
After evacuating a fallen comrade, the rebels returned to the attack while
under rocket fire and then shelling from tanks. Above: Two FSA fighters
take up position for the strike. Facing page, top: A rebel drags his comrade
to safety. The wounded man later died from internal injuries. Below: An
FSA fighter shouts before a renewed assault on the checkpoint. Following
spread: Rebels take cover amid flying debris and shrapnel, as a shell fired
from a Syrian Army tank hits the wall above them.

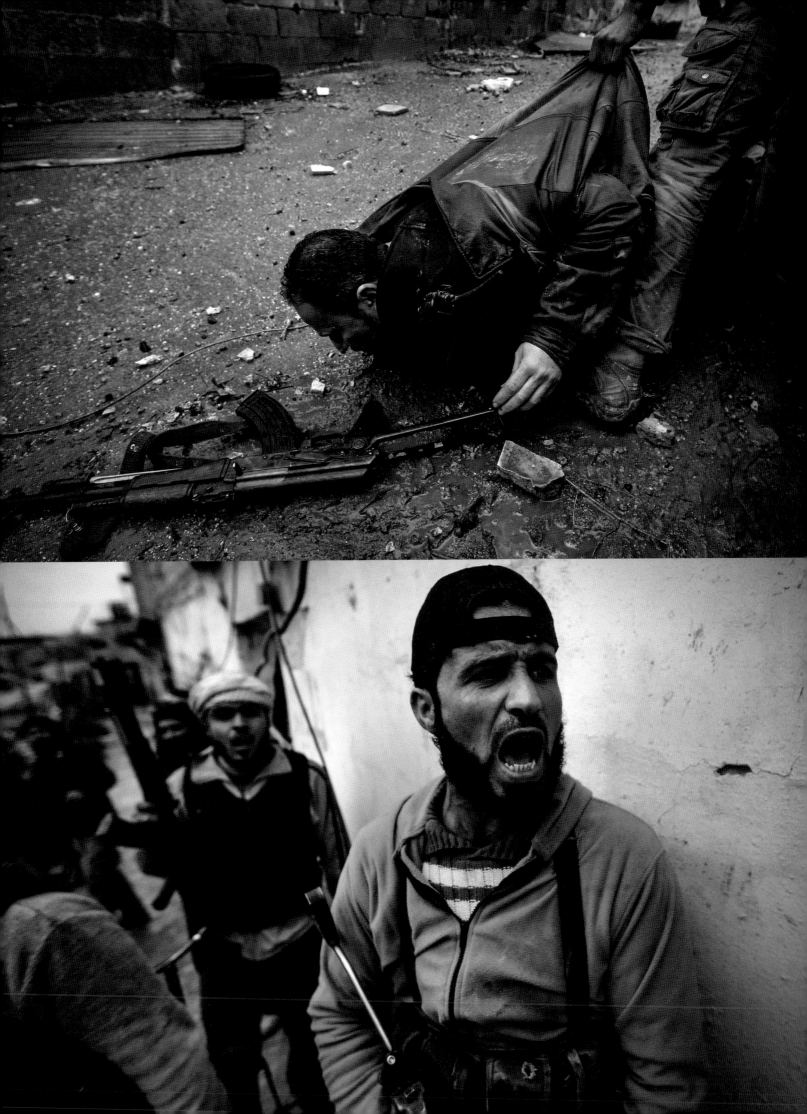

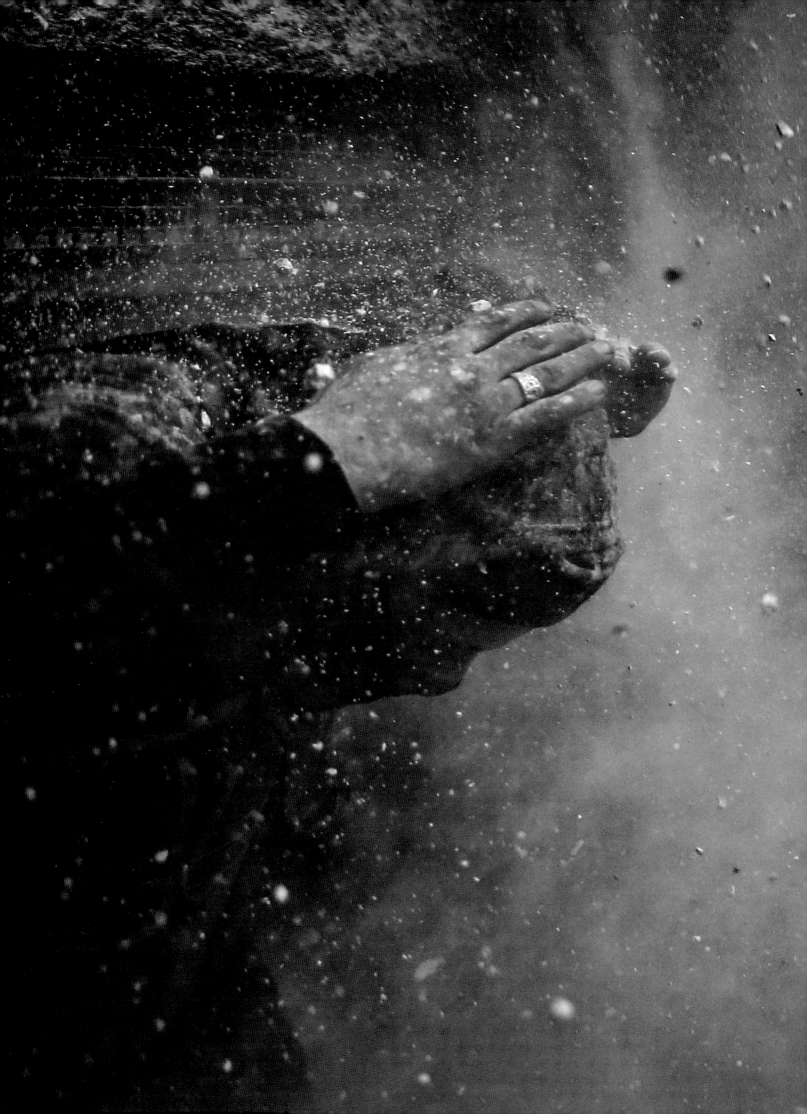

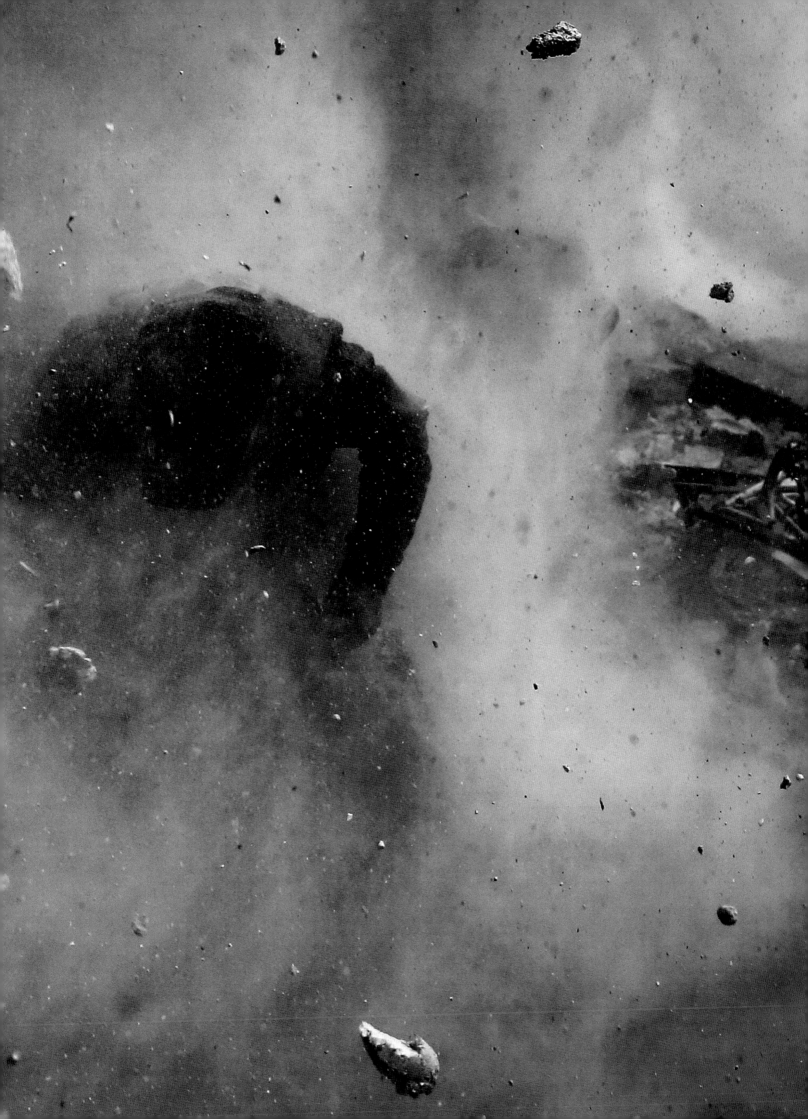

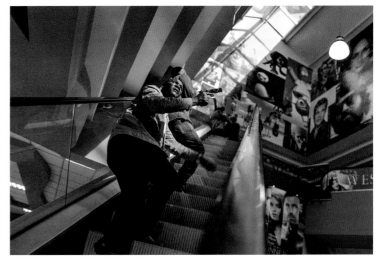
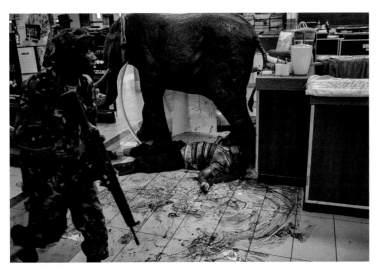
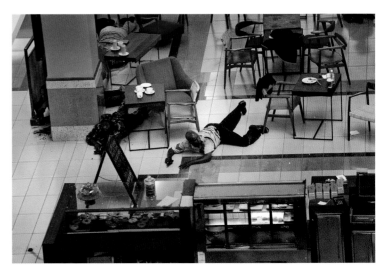

On 21 September, masked gunmen opened fire at the Westgate shopping mall, in Nairobi, Kenya. The upmarket mall was popular among expats and the Kenyan elite. In a siege that lasted four days, at least 60 people died and up to 200 were injured. The four main perpetrators of the attack were killed, and a number of other men were later tried as accomplices. The four gunmen were all of Somali origin. The Somali jihadist group al-Shabaab claimed responsibility for the attack, saying it was a warning to Kenya to pull its troops out of Somalia, where they were part of an African Union peacekeeping force in conflict with the militants. This page, top: A woman and two children hide during the attack. They eventually escaped unharmed. Right: Plainclothes police officers search the mall floor by floor. Bottom row, left: A member of the security forces pursues the assailants. Facing page, top row, left: Police officers search for the gunmen in the mall. Bottom row: Hostages are helped to safety.

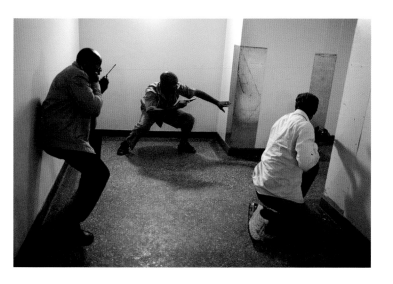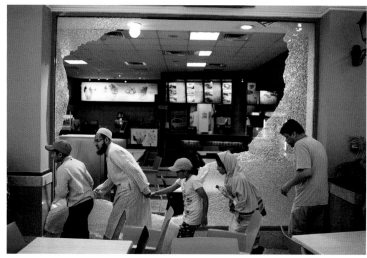

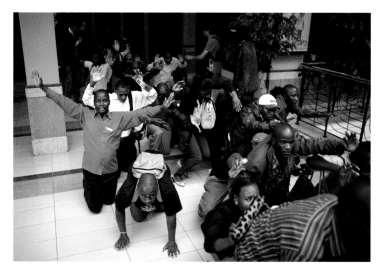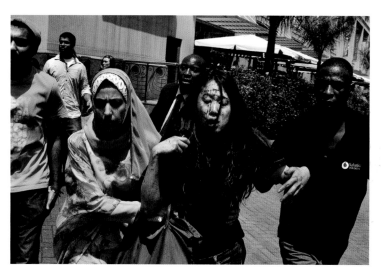

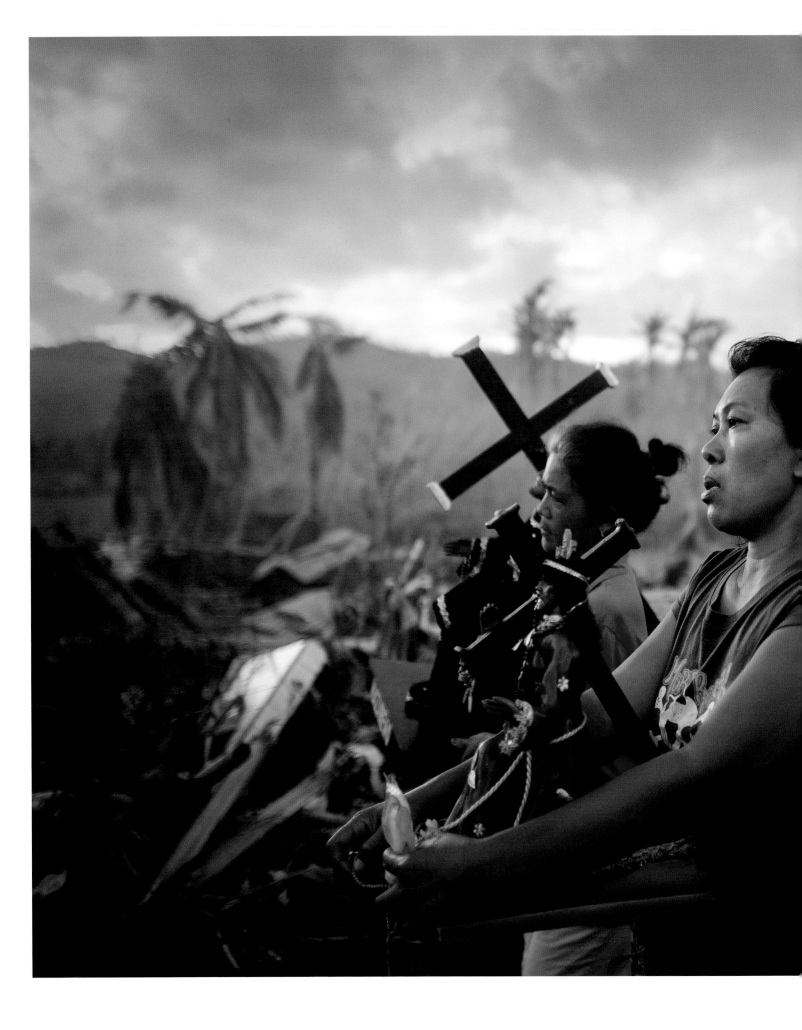

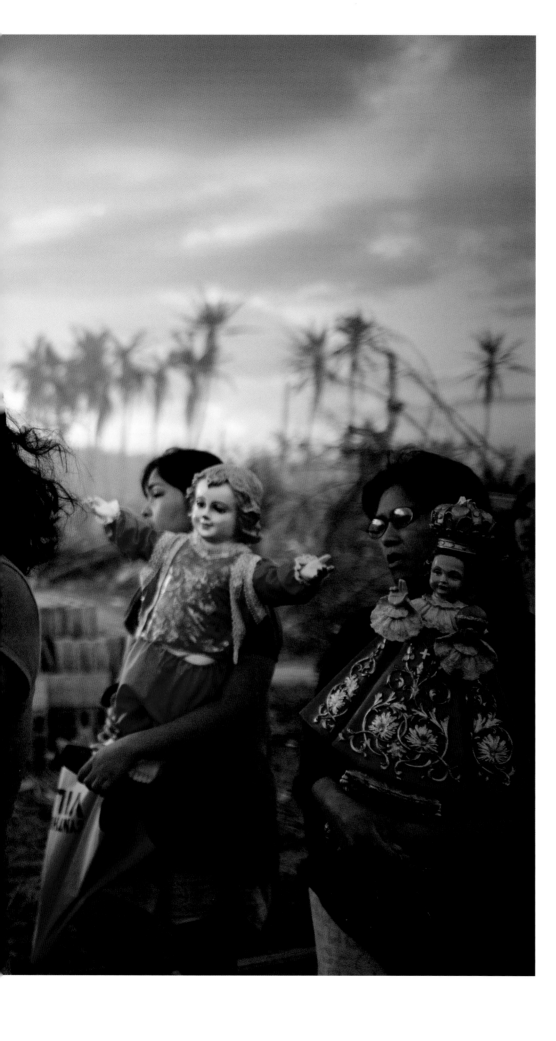

Ten days after Typhoon Haiyan made landfall, survivors carry religious images in Tolosa, on the island of Leyte, in central Philippines. One of the strongest typhoons ever recorded, Haiyan raged through 47 provinces, causing immense destruction. Over a million houses were damaged, half of them totally destroyed, and more than 4 million people were displaced. Large areas were left without electricity or an adequate water supply for weeks, and the devastation of infrastructure made food distribution and medical services difficult. Many people made their way to less-affected areas, such as the capital Manila, and some cities reported a near doubling of their populations.

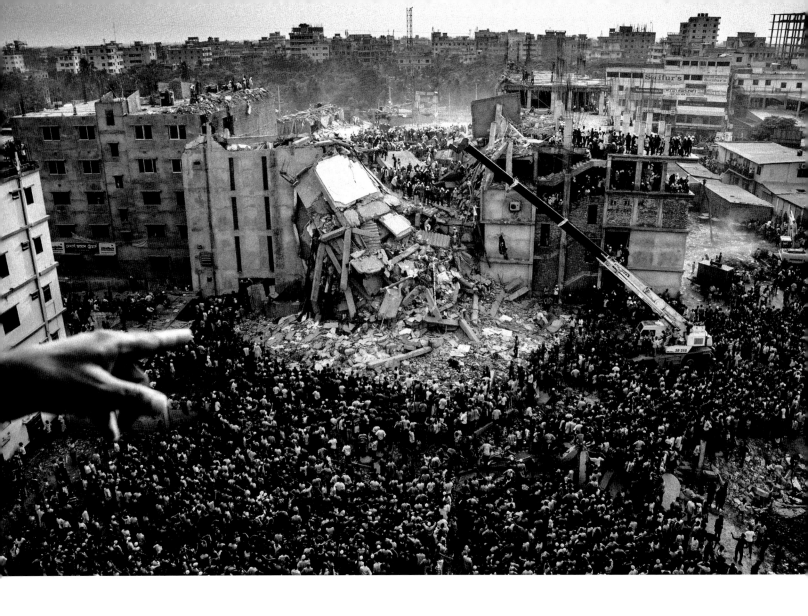

On 24 April, an eight-story building collapsed in Savar, near Dhaka, Bangladesh, killing more than 1,100 people. Rana Plaza, which housed five garment factories, was designed with only six stories and intended for shops and offices only. Two further stories had been added, and the collapse was in part blamed on the weight and vibration of the garment factories' heavy machinery. Rana Plaza had been briefly shut down the day before, when cracks appeared in its walls and pillars, but factory workers were called back in, hours before the building fell. Rescue operations took nearly three weeks. Facing page: Rescue workers dig tunnels through collapsed floors in an attempt to find survivors. (continues)

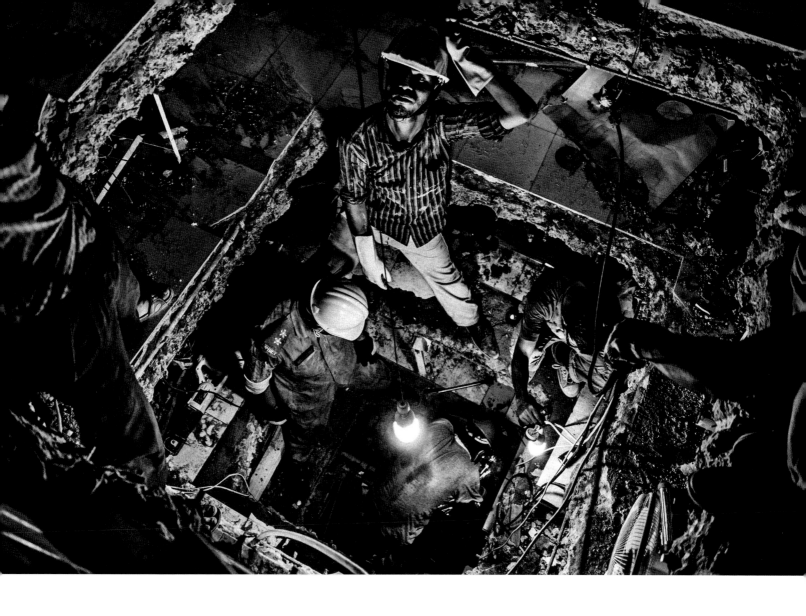

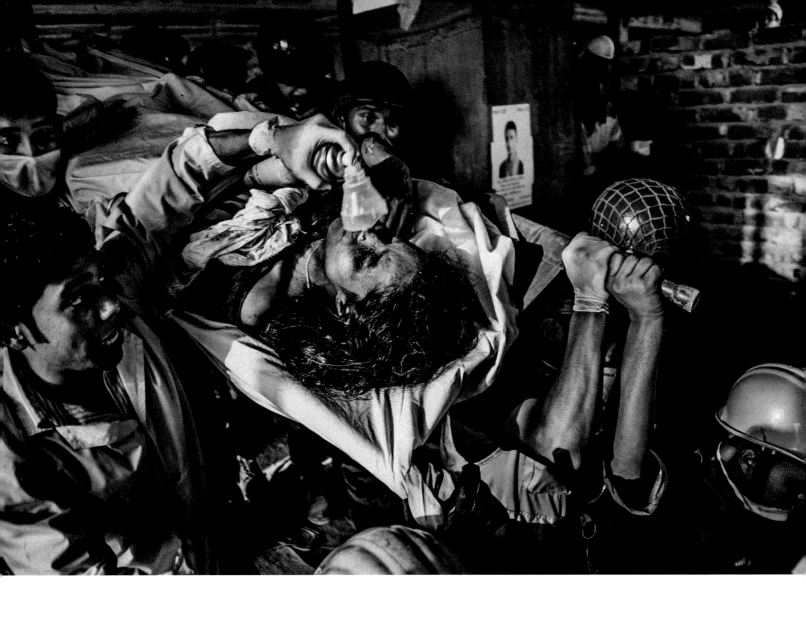

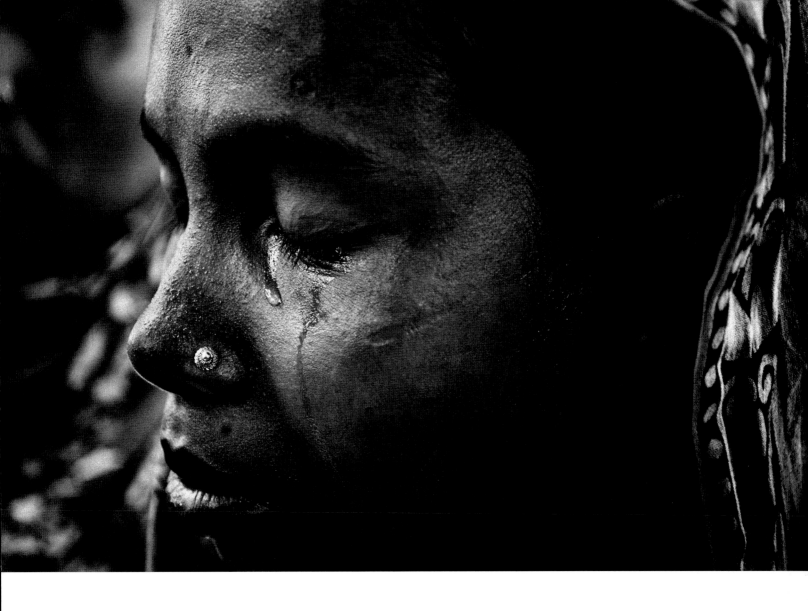

(continued) Workers in Rana Plaza made clothes for popular Western brands. The disaster highlighted the hazardous conditions workers face in Bangladesh's €16 billion garment industry, where many are paid as little as €30 a month. Only a few of the brands using the factories attended a meeting of the world's largest retailers in Geneva, in the aftermath of the Rana Plaza collapse, and four made contributions to a compensation fund for victims and their families. Facing page: Rescuers carry an unconscious garment worker, 78 hours after the collapse. Above: A woman grieves for a missing family member, who worked in a Rana Plaza factory.

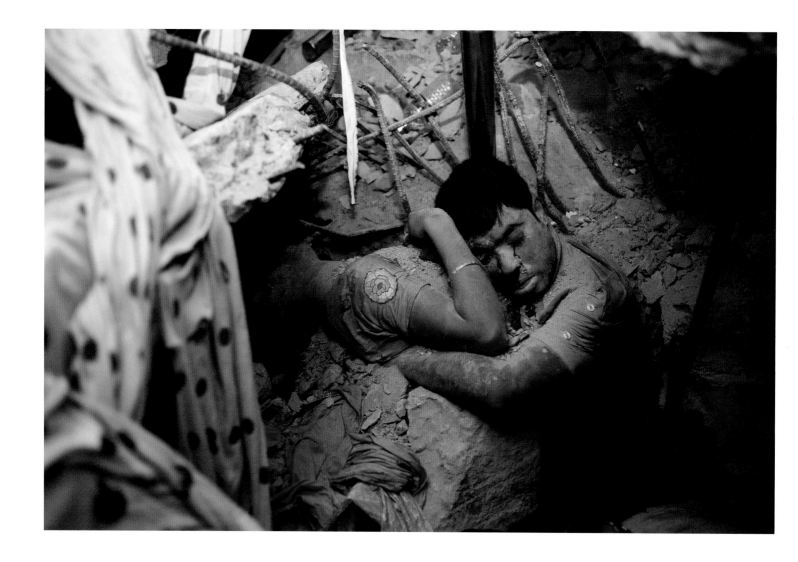

Victims lie in the rubble, on the day after the Rana Plaza building in Savar, Bangladesh, which accommodated five garment factories, collapsed. The relationship between the two people is not known. In the days following the disaster, more than 800 bodies were visually identified by relatives, or by using ID cards or personal possessions. Relatives of others had to give DNA samples, but months after the incident many had still not been able to identify missing family members. The collapse of the Rana Plaza ranks as one of the worst industrial accidents in history.

PEOPLE
OBSERVED
PORTRAITS

SINGLES
1st Prize / **Markus Schreiber**
2nd Prize / **Rena Effendi**
3rd Prize / **Pau Barrena**
STORIES
1st Prize / **Carla Kogelman**
2nd Prize / **Peter van Agtmael**
3rd Prize / **Rena Effendi**

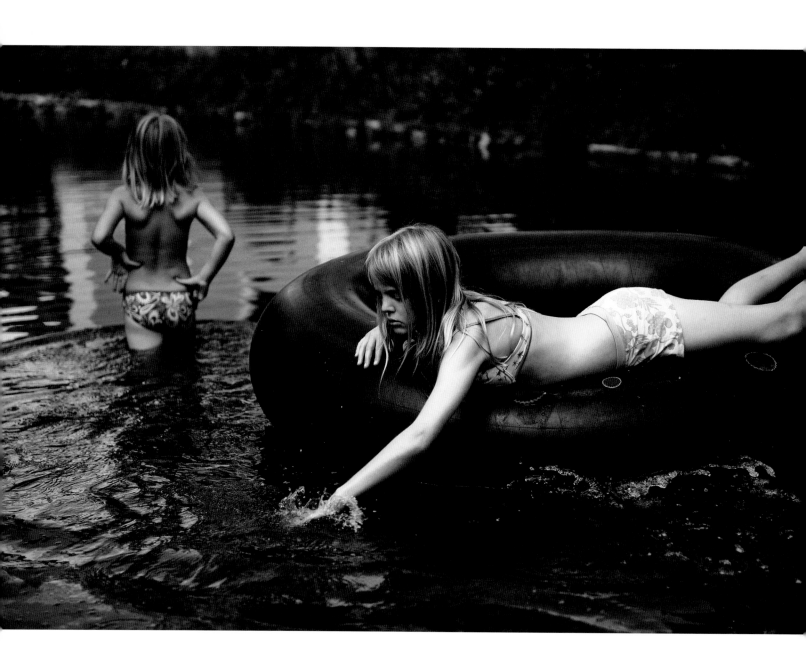

Hannah (7) and Alena (9) are two sisters who live in Merkenbrechts, a village of 170 inhabitants in Waldviertel, an isolated rural area of Austria, near the Czech border. (continues)

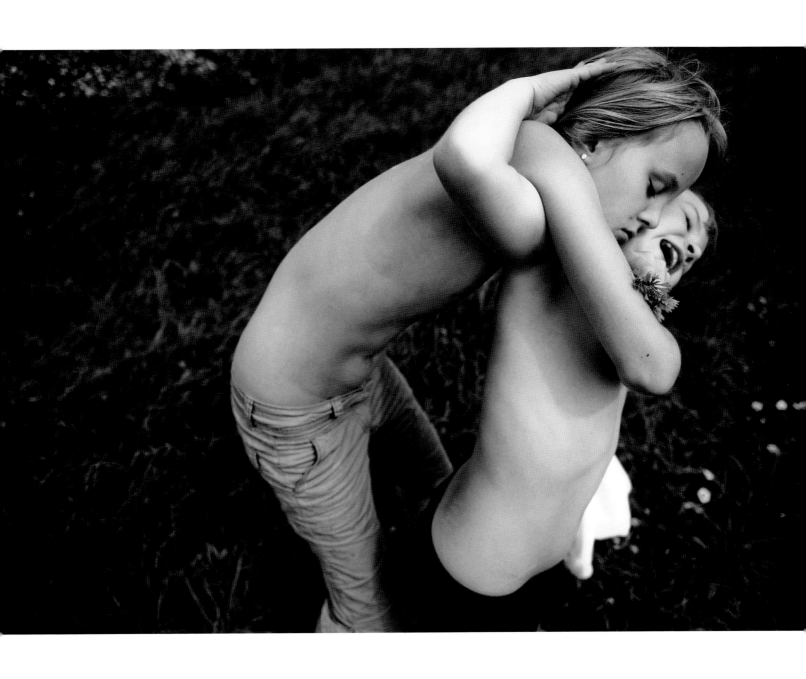

(continued) Hannah and Alena have two older brothers, but spend much of their time together in a carefree life: swimming, playing outdoors, and engrossed in games around the house.

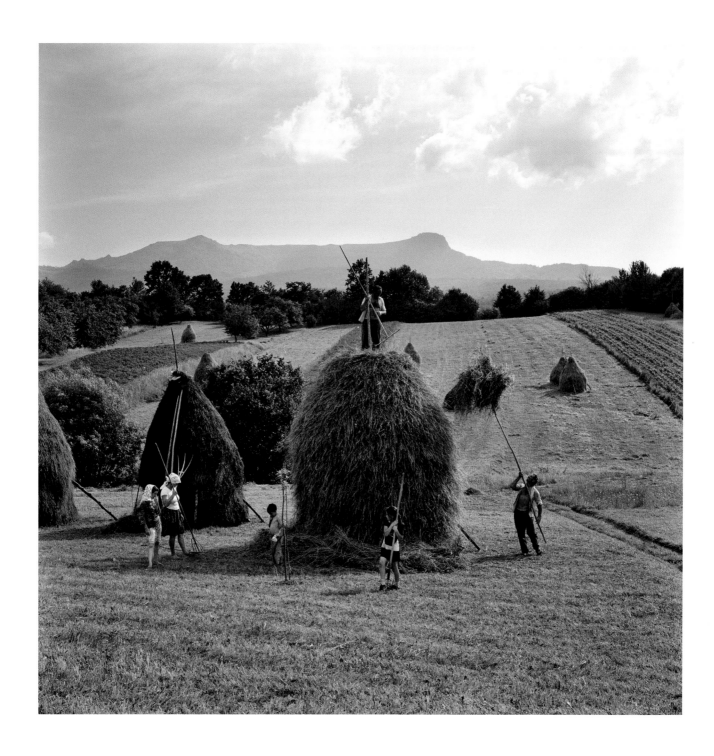

In Transylvania and other remote areas of Romania, many people farm on a small scale, in ways unchanged for centuries. Their farms have among the lowest yields in Europe, but also some of the highest levels of self-sufficiency. Lack of money and suspicion of unfamiliar methods mean that few chemicals and artificial fertilizers are used. Above: The Borca family, from the village of Breb, put finishing touches to one of the 40 or so haystacks they make each summer. Facing page: The family relaxes after an early start to the working day. (continues)

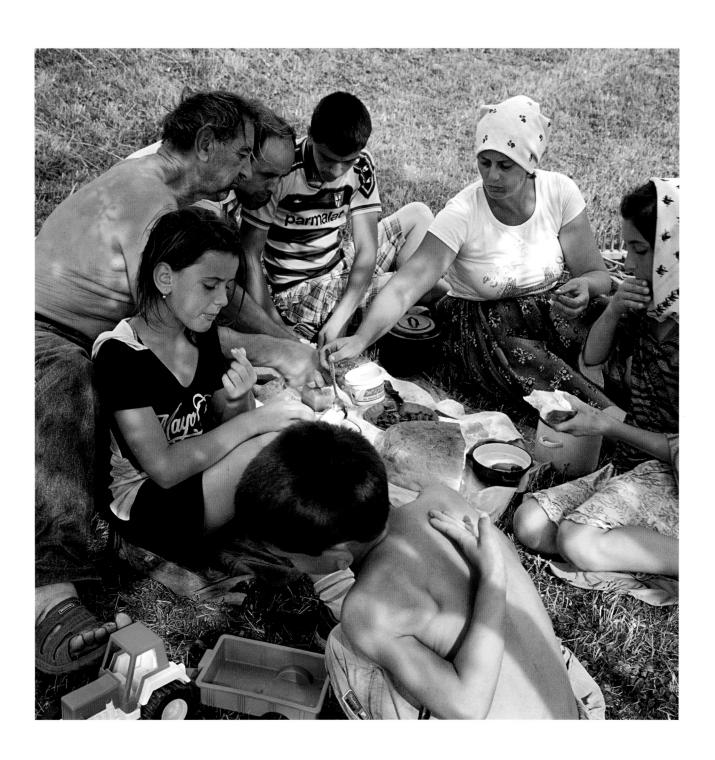

(continued) Farming families can expect an income of around €4,000 a year, often supplemented with earnings from other sources. Many are abandoning their farms for at least part of the year to work in cities abroad. Romania's 2007 entry into the European Union also threatens this traditional way of life, as farmers cannot compete with European imports, and the small size of farms means they are not eligible for EU subsidies. Facing page: A man from the village of Sarbi makes plum jam—traditionally a male activity, involving eight to ten hours of continuous stirring. Above: Maria Vraja and Adriana Tantas (7) shell corn from the cob.

A woman is turned away disappointed at the close of the third and final day of the lying-in-state of former South African president Nelson Mandela, at the Union Buildings in Pretoria, on 13 December. Nelson Mandela had died on 5 December at the age of 95, after a prolonged respiratory infection. Over 100,000 people lined up to pay respects to the former leader, but many were unable to gain access in time to file past the casket.

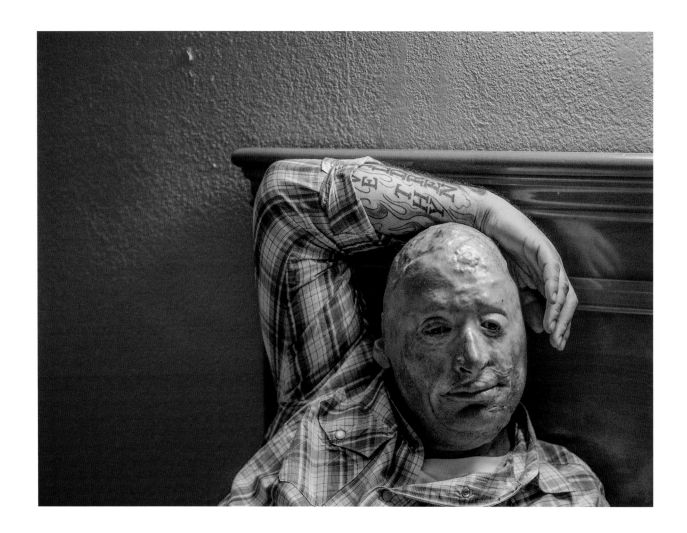

Bobby Henline (42) was the sole survivor when the humvee in which he was traveling was blown up, during his fourth tour to Iraq, on 7 April 2007. Bones in his face fractured, burns covered close to 40 percent of his body, and his left hand later had to be amputated. During the recovery process, he kept up the spirits of other wounded soldiers by telling jokes, and his therapist encouraged him to take up stand-up comedy. He now makes a living as a comedian, with a routine that focuses on his own injuries. Above: Bobby relaxes at a motel in Dallas, Texas. Facing page, top: Bobby performs his routine at the Uptown 78 Lounge, in San Antonio, Texas. Below: He walks along the beach in Galveston, after visiting a 12-year-old who was burned as a toddler. Following spread: Bobby takes a swim in a motel pool.

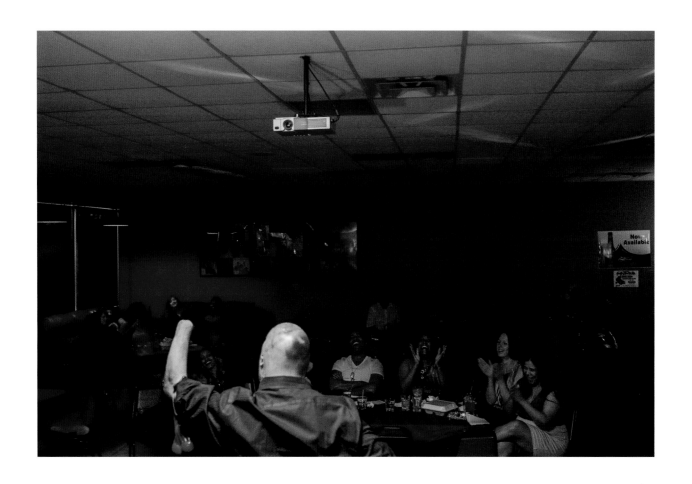

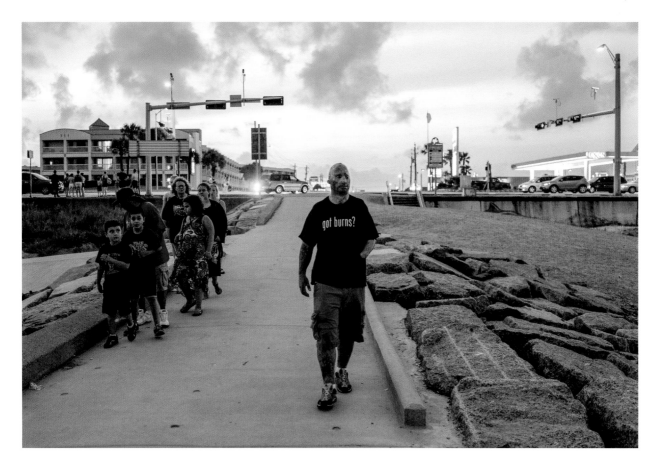

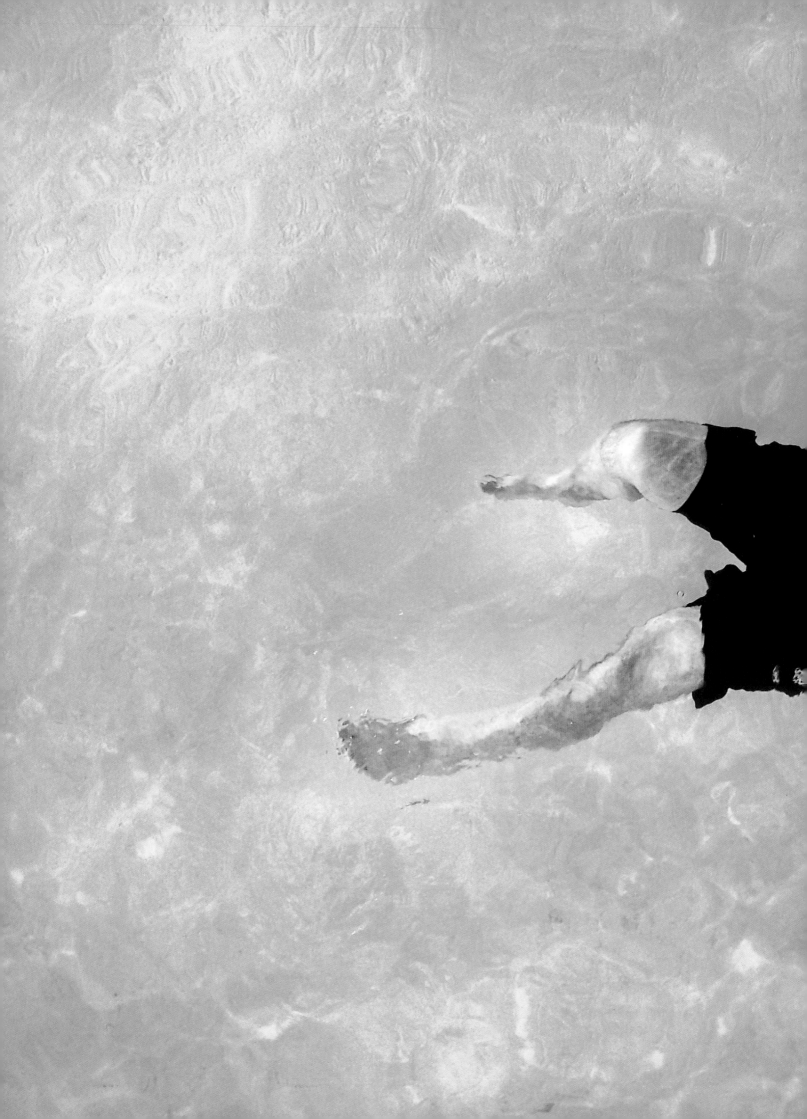

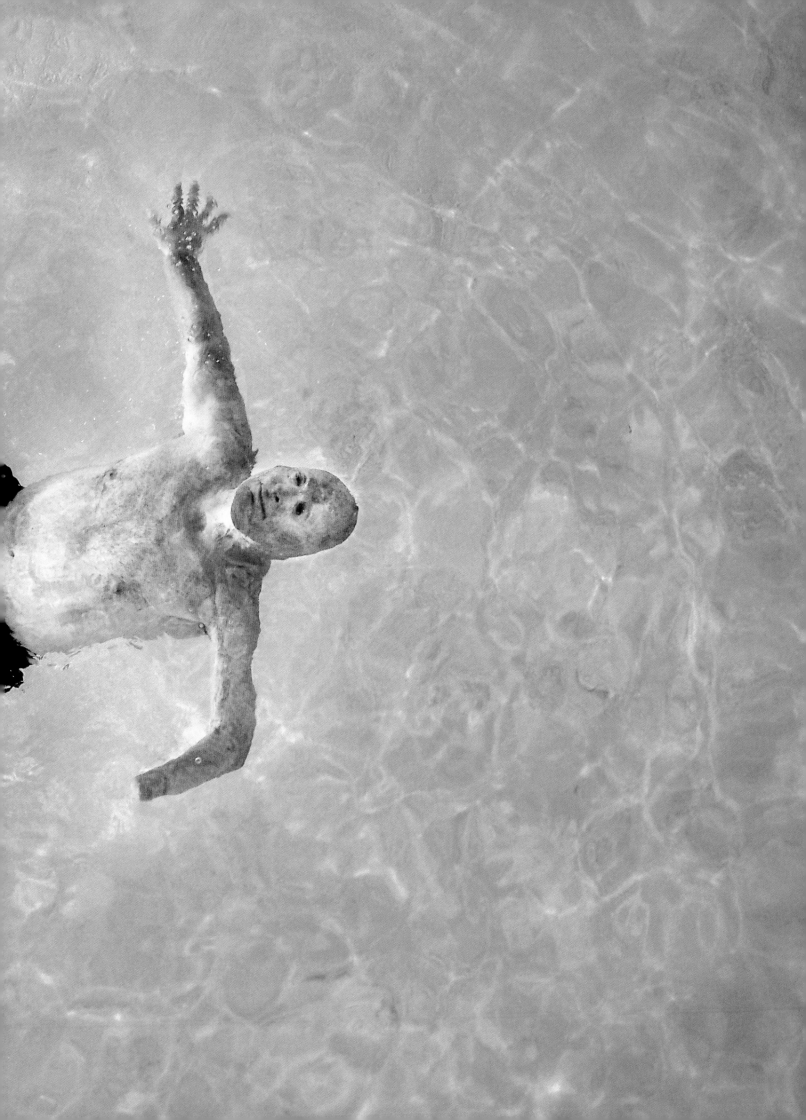

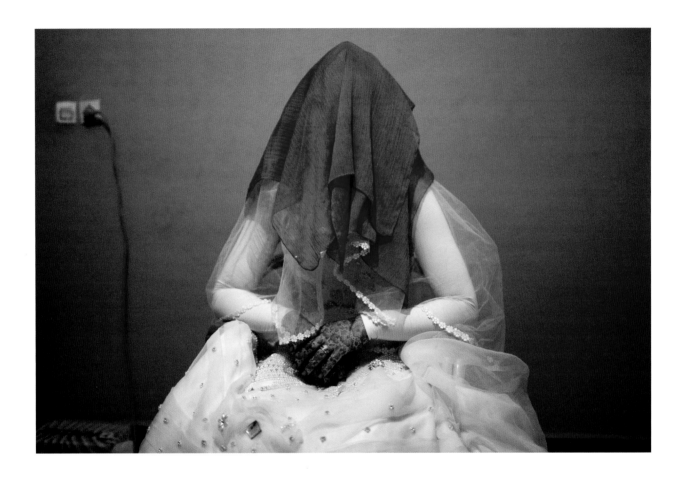

Lubna, a Berber bride from the Tinghir region of Morocco, south of the High Atlas mountains, waits ready for the wedding ceremony. According to Berber tradition, no-one may see the bride's face before the groom does.

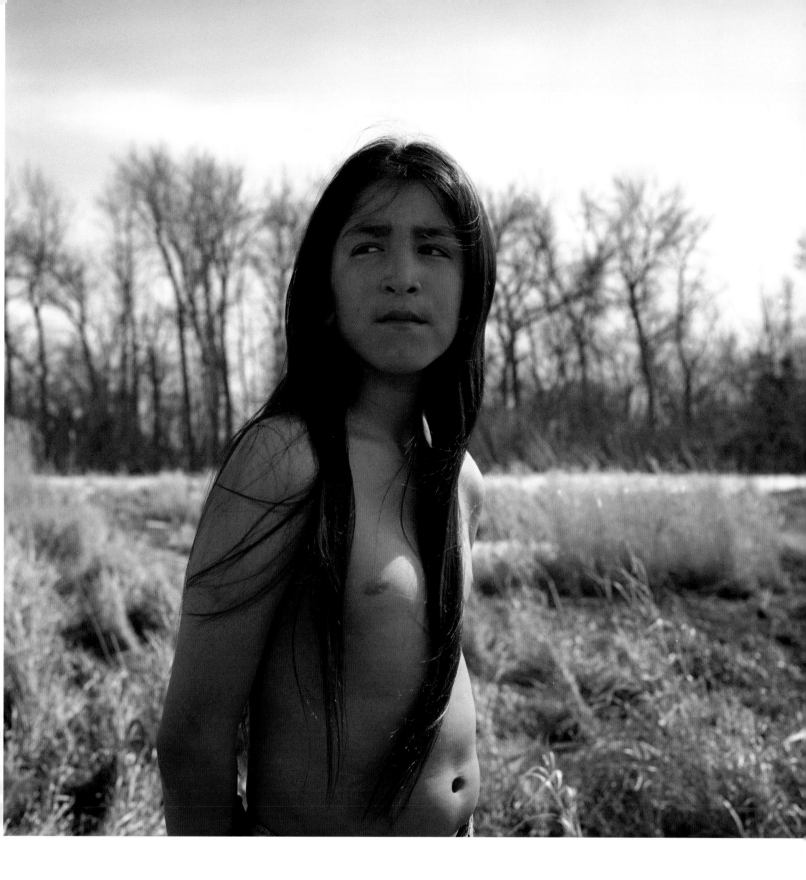

Dasan Cavanaugh (10), of the Spirit Lake reservation in North Dakota, USA, has not cut his hair since he was born. Spirit Lake is home to some 6,200 Sioux American Indians, who live in an area that covers over 1,000 square kilometers.

PEOPLE
STAGED
PORTRAITS

SINGLES
1st Prize / **Brent Stirton**
2nd Prize / **Abbie Trayler-Smith**
3rd Prize / **Nadav Kander**
STORIES
1st Prize / **Danila Tkachenko**
2nd Prize / **Denis Dailleux**
3rd Prize / **Nikita Shokhov**

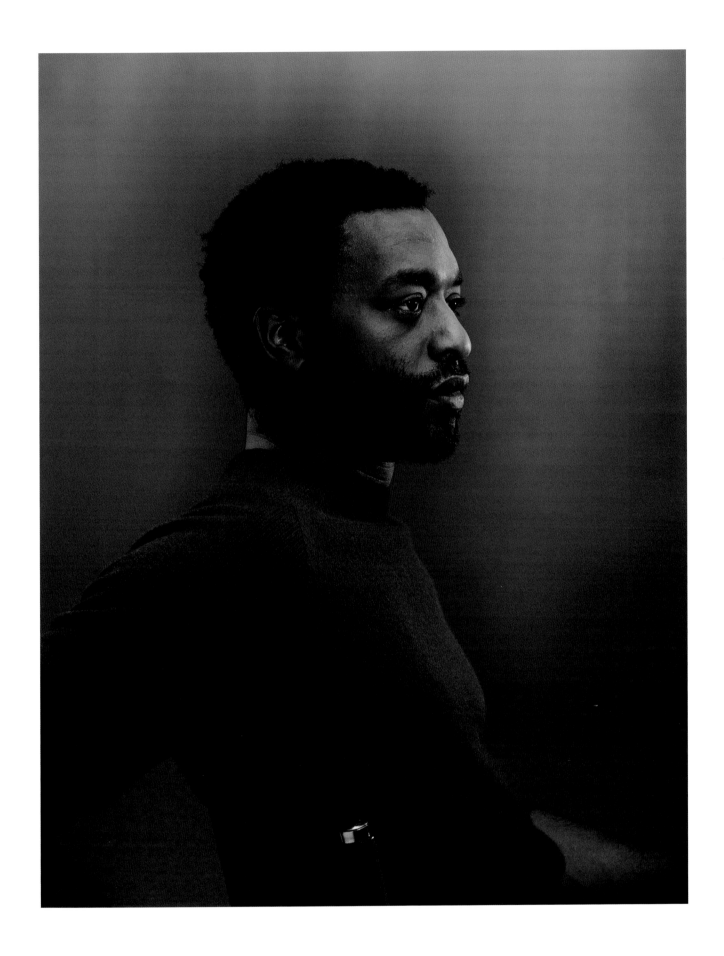

British actor Chiwetel Ejiofor (36) played a man kidnapped in 1841 and sold into the slave trade, in the film *12 Years a Slave*. He won Best Actor at the BAFTA awards for the role, and was also nominated for an Oscar.

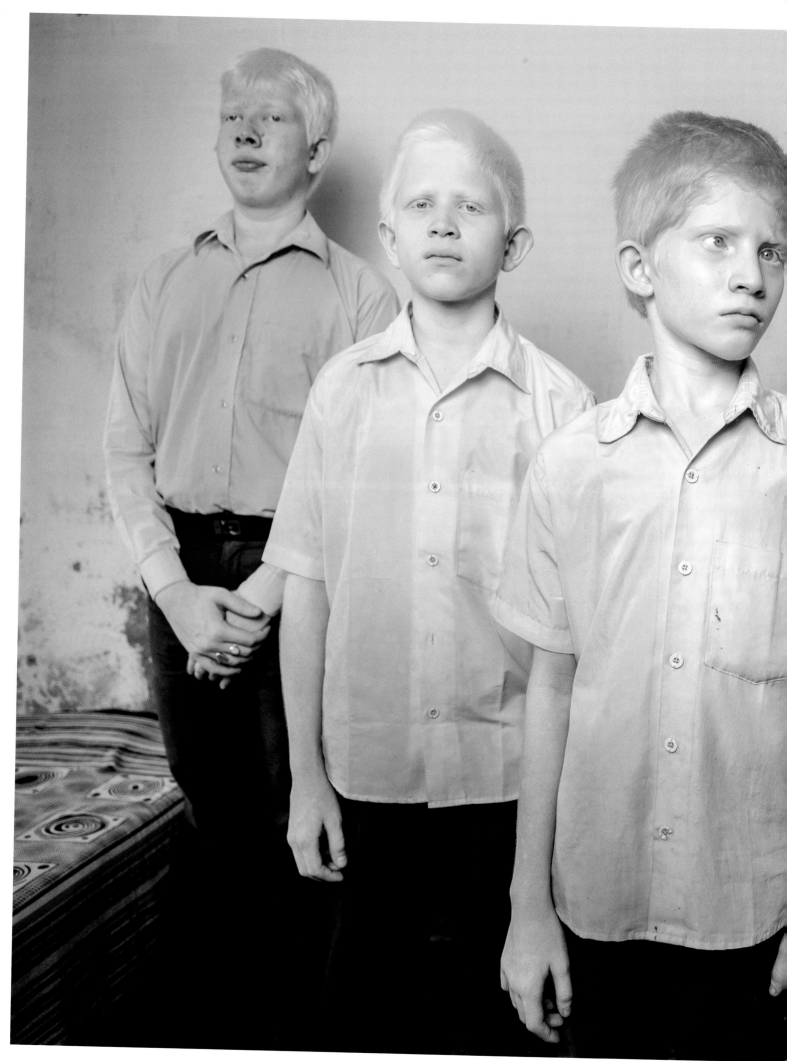

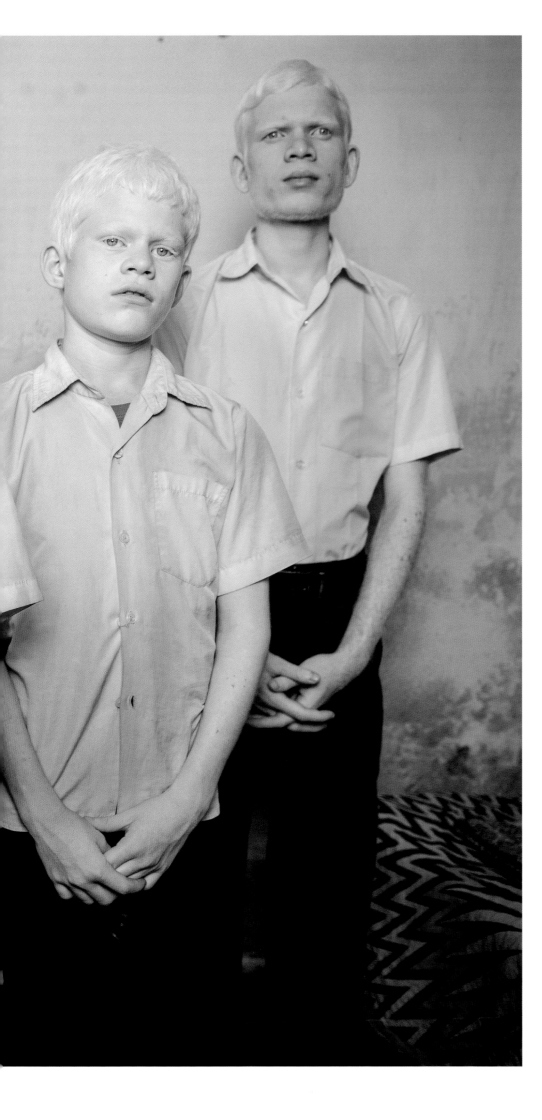

Blind albino students stand in a dorm at the Vivekananda Mission School, a boarding school for the blind, in West Bengal, India. The school teaches vital skills to blind children from underprivileged backgrounds, who might otherwise have to beg for a living.

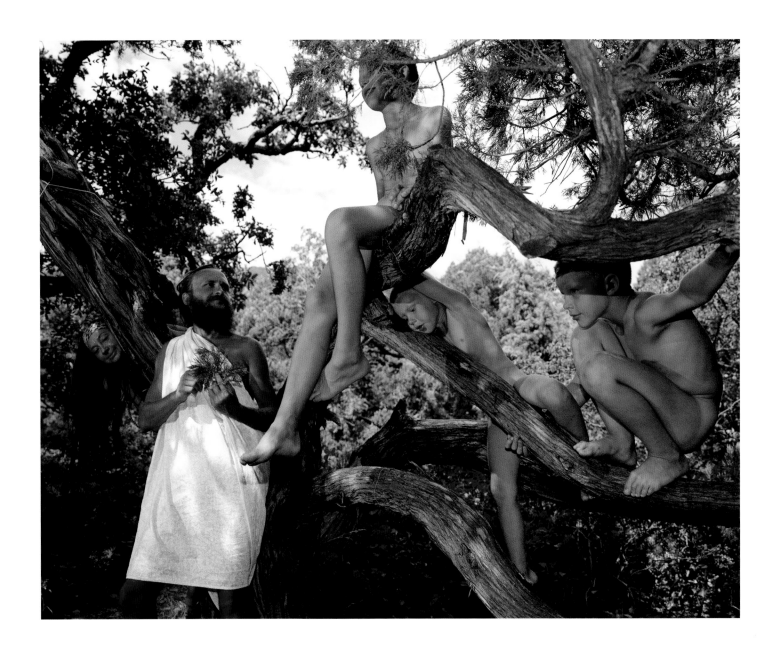

Utrish national park, on the northern shores of the Black Sea, has been a favorite spot for nudists since the 1960s. Nudism was frowned upon by Soviet society, but there was a resurgence in naturist clubs and beaches after the collapse of the Soviet Union.

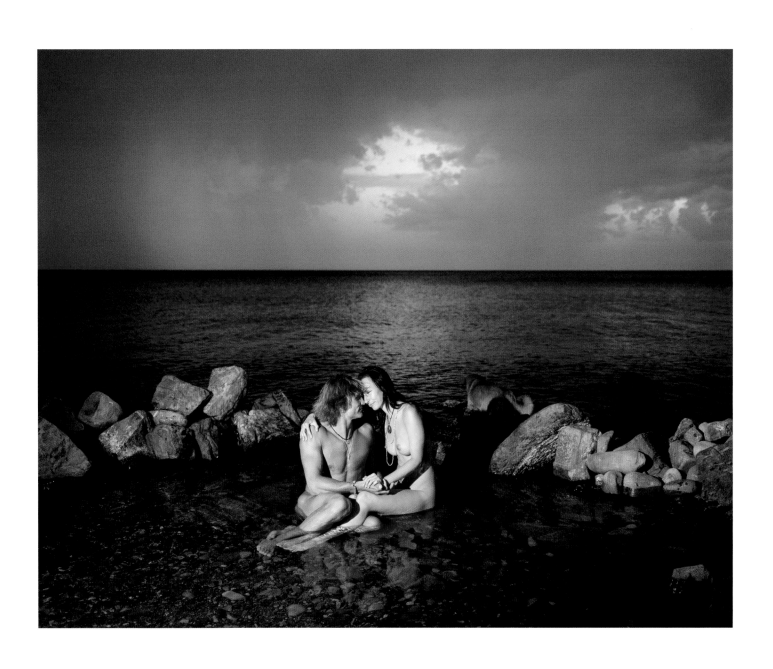

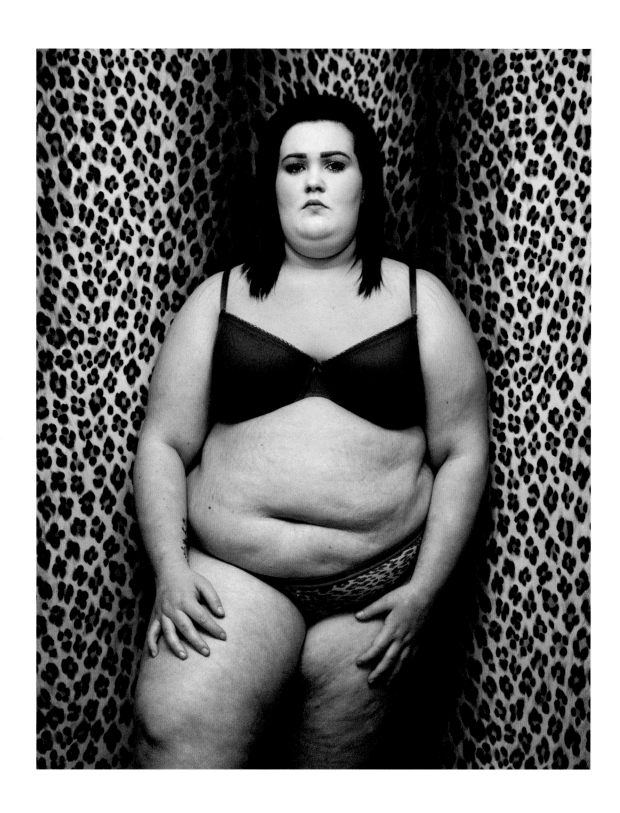

Shannon, who has recently turned 16, has chosen to have a balloon inserted into her stomach for six months, to help her lose weight. A 2012 government survey classed 28 percent of English children between the ages of 2 and 15 as overweight or obese.

NATURE

SINGLES
1st Prize / **Bruno D'Amicis**
2nd Prize / **Markus Varesvuo**
3rd Prize / **Shangzhen Fan**
STORIES
1st Prize / **Steve Winter**
2nd Prize / **Kacper Kowalski**
3rd Prize / **Christian Ziegler**

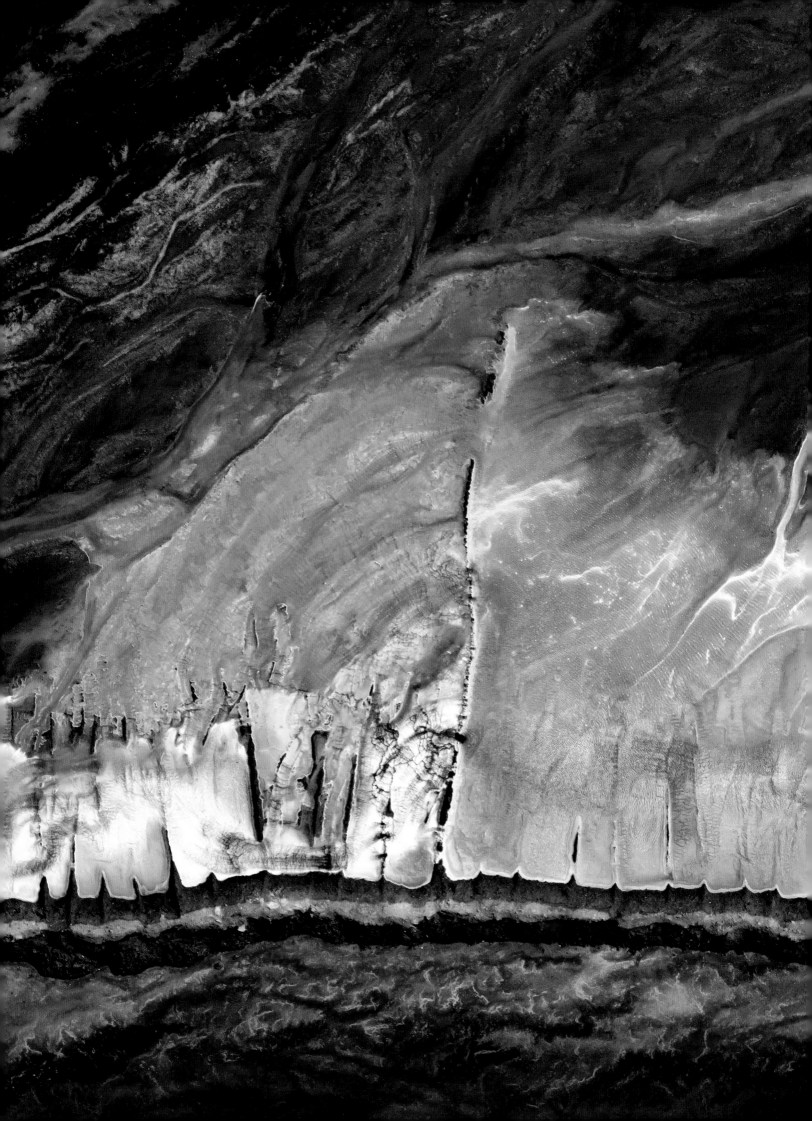

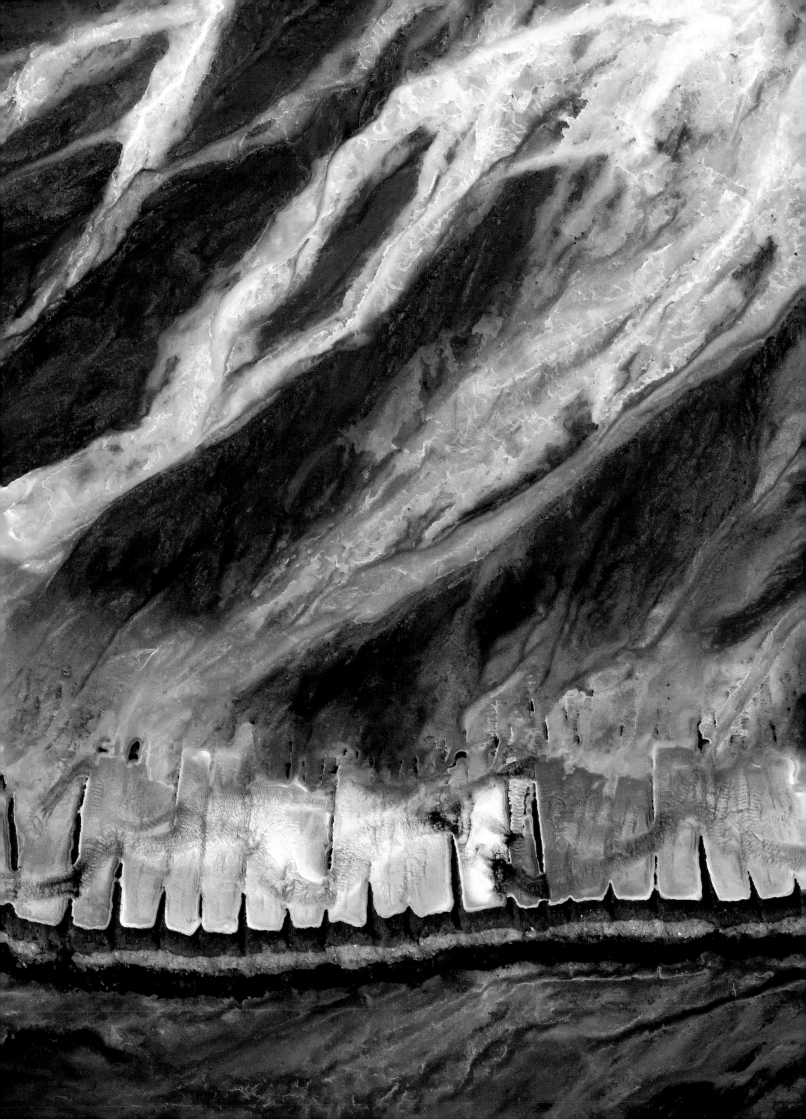

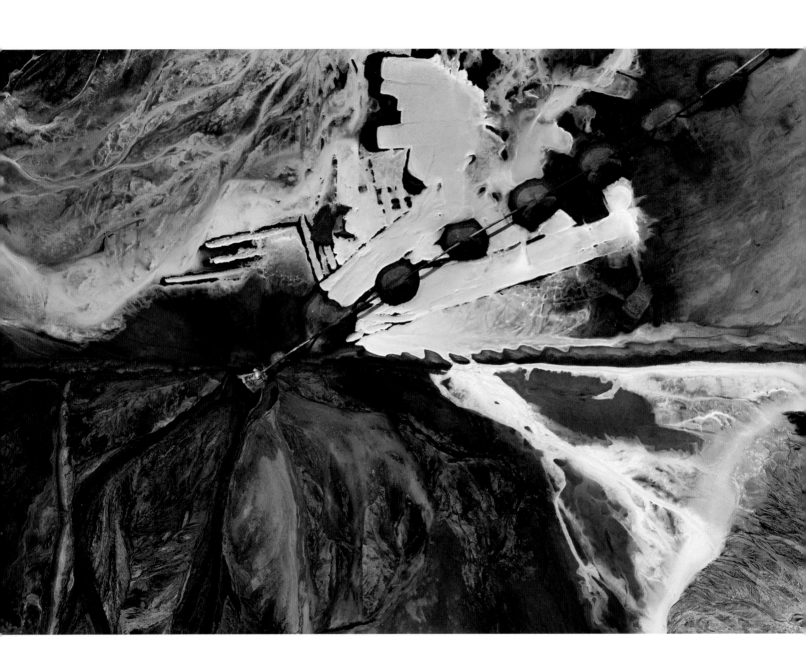

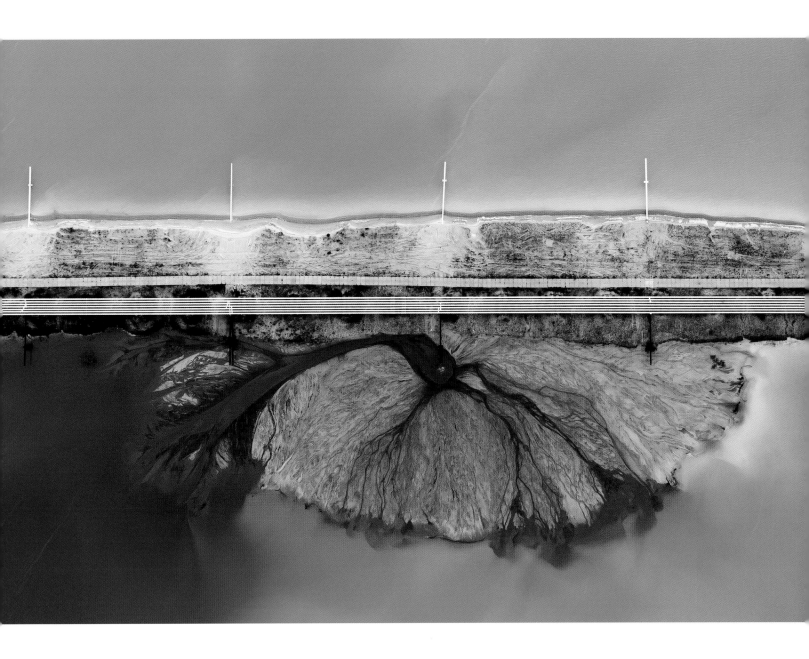

Views from the air reveal an impact on the environment that is hard to see from the ground. Effluent containing coal ash from power stations leeches into the Polish landscape. Coal ash is the waste that remains after coal is combusted, and contains toxic heavy metals. Facing page, and previous spread: Waste from the Adamóv power station, in Turek. Above: Effluent from the Belchatów power station, the largest coal-fueled thermal plant in Europe, and one of the highest emitters of CO_2 among power stations worldwide.

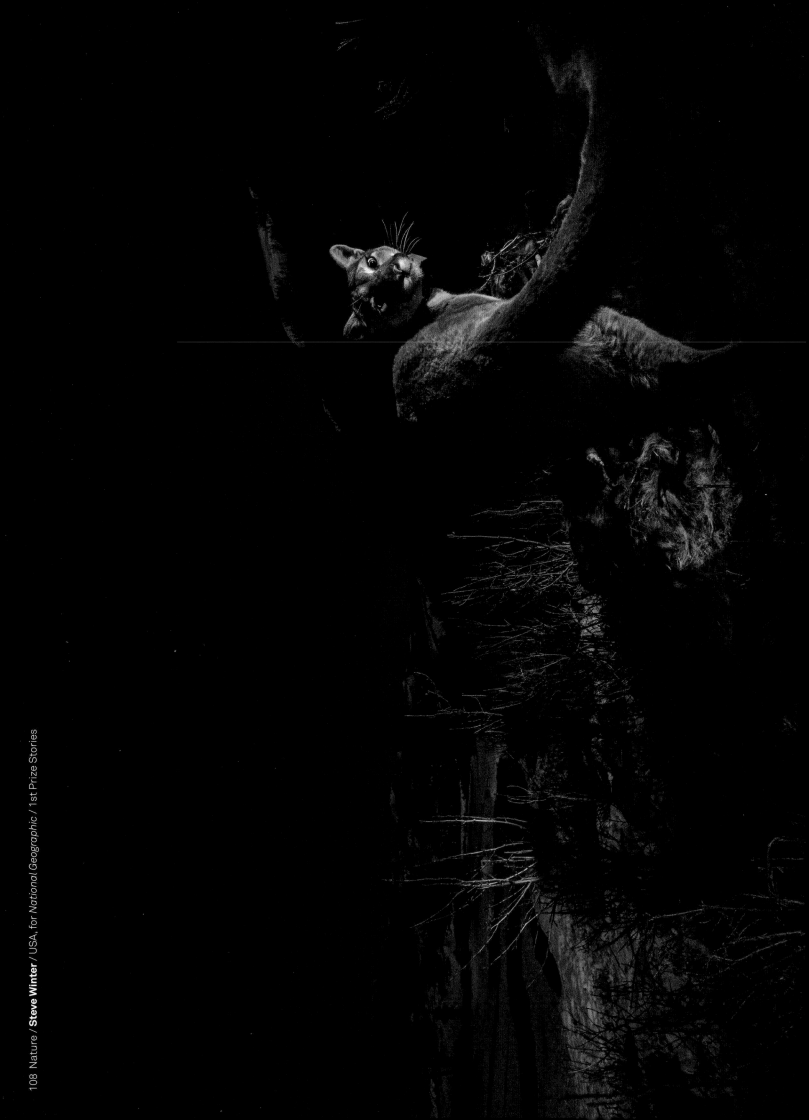

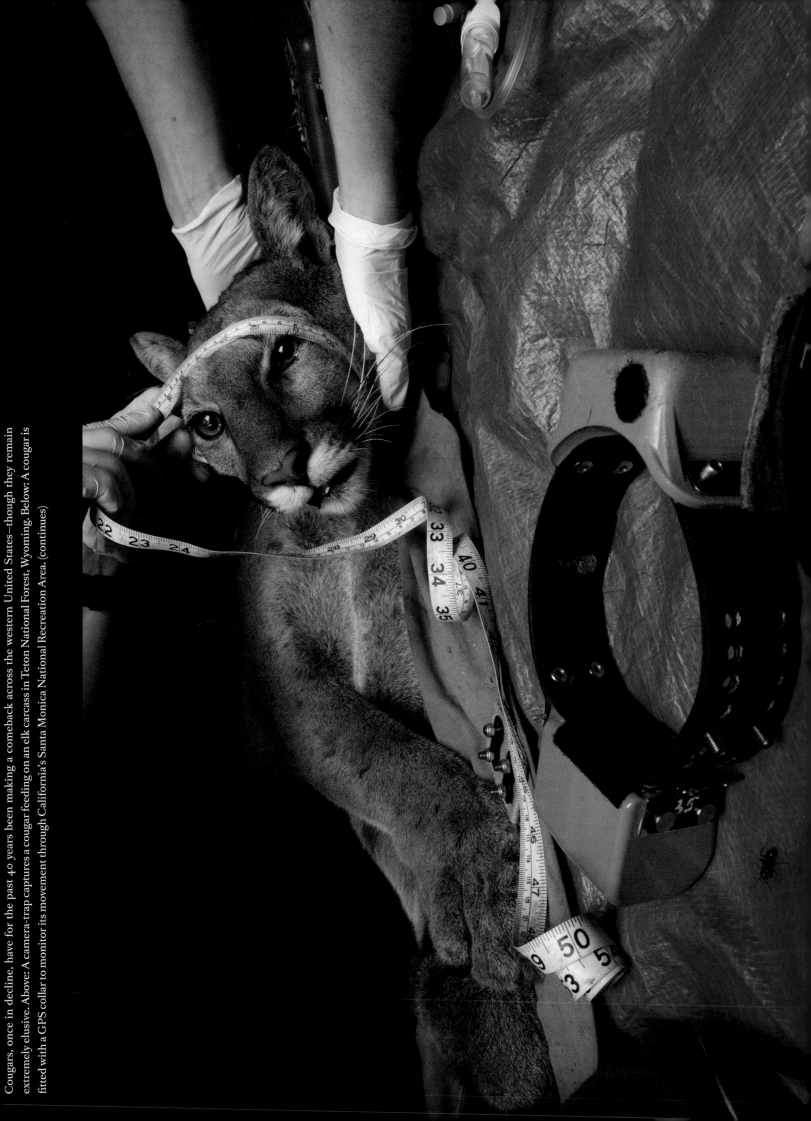

Cougars, once in decline, have for the past 40 years been making a comeback across the western United States—though they remain extremely elusive. Above: A camera-trap captures a cougar feeding on an elk carcass in Teton National Forest, Wyoming. Below: A cougar is fitted with a GPS collar to monitor its movement through California's Santa Monica National Recreation Area. (continues)

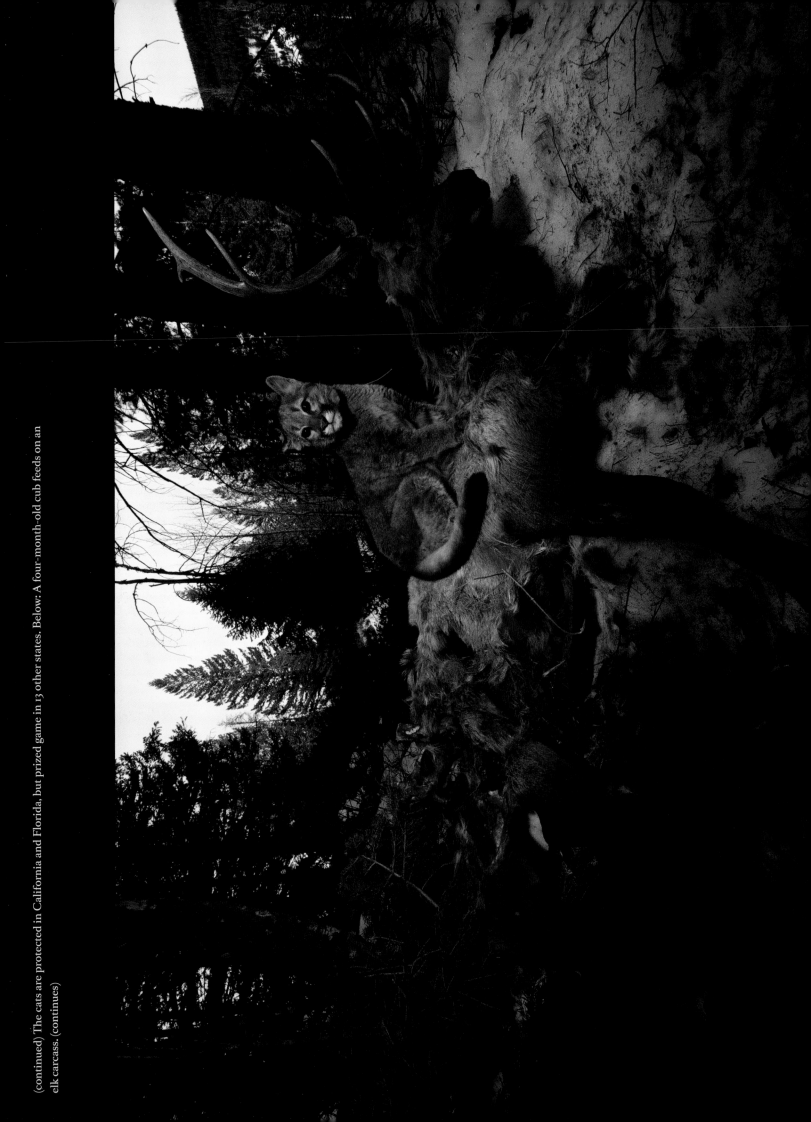

(continued) The cats are protected in California and Florida, but prized game in 13 other states. Below: A four-month-old cub feeds on an elk carcass. (continues)

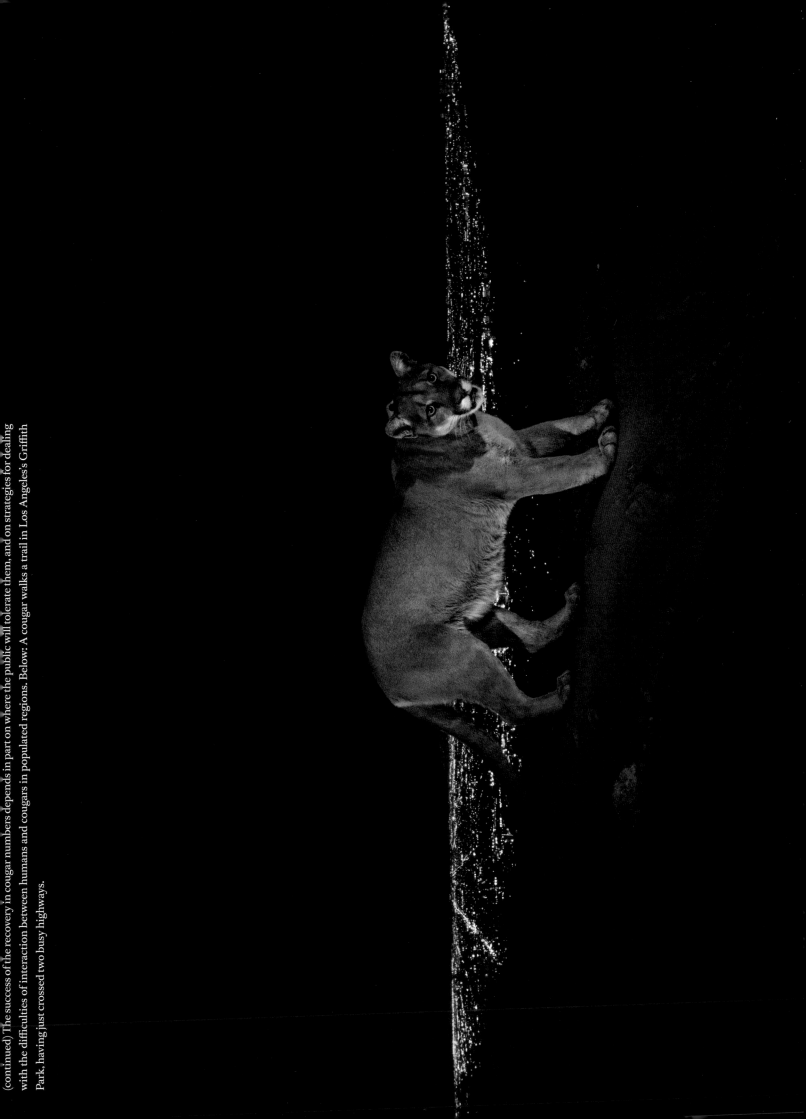

(continued) The success of the recovery in cougar numbers depends in part on where the public will tolerate them, and on strategies for dealing with the difficulties of interaction between humans and cougars in populated regions. Below: A cougar walks a trail in Los Angeles's Griffith Park, having just crossed two busy highways.

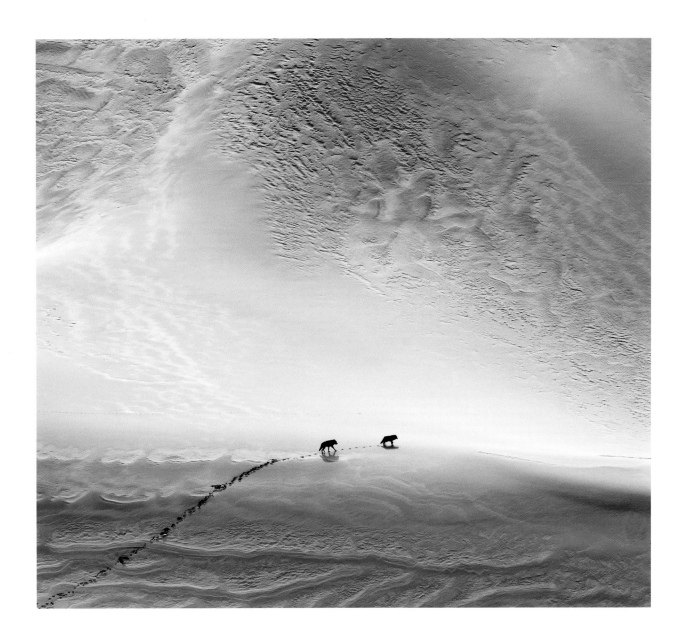

Wolves cross the desert snow, in Xinjiang, northwestern China. Wild animals such as wolves and boar are thriving in the region. Wolves are legally protected in China, though in some areas the law is not rigorously enforced. Herders in Xinjiang have called for hunting to be resumed, as wolves are killing livestock.

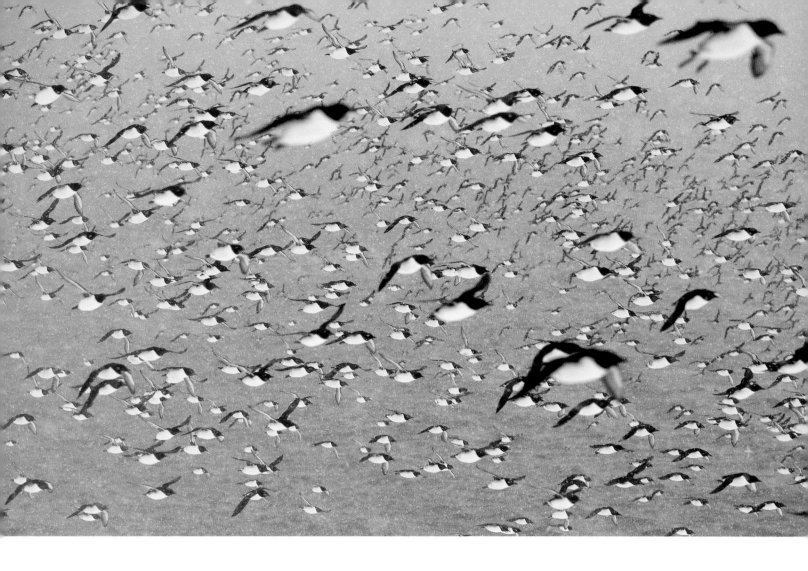

Common guillemots (*Uria aalge*) fly over Vardø, in northeastern Norway. The largest of the auk species, guillemots are one of the most abundant seabirds in temperate and colder parts of the northern hemisphere. The bird is gregarious, and breeds in colonies that can number into the tens of thousands.

Bonobos, along with chimpanzees, are our closest living relatives. They are also among the least-studied of primates. Unlike chimpanzees, who are territorial and combative, bonobos are relatively peaceful creatures, and appear to use sex as a means of social communication. Sex, for bonobos, is not restricted to male-female copulation during the female's fertile period, but includes various gender combinations, and occurs in a variety of situations, including greeting, relieving tension, and as an expression of reconciliation. Facing page, below: An infant rides on its mother's back, as they travel between fruit trees at the Salonga National Park, in the Democratic Republic of Congo (DRC). Following spread, top left: A five-year-old infant bonobo appears curious at being observed, near Kokolopori, DRC. Below: A mother shares food with her offspring and its playmate, while a male looks on but is not allowed to eat. Top, right: A female takes a midday nap in a nest she has just built. Below: A young male runs through foliage at a bonobo sanctuary near Kinshasa.

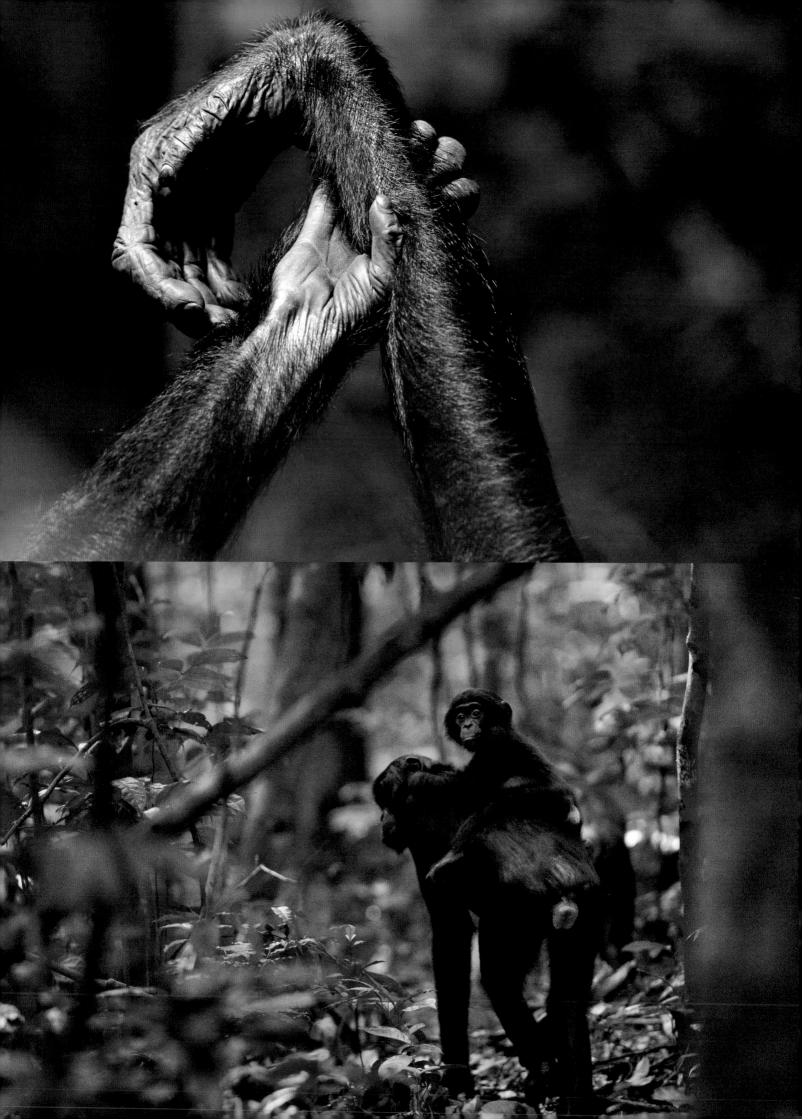

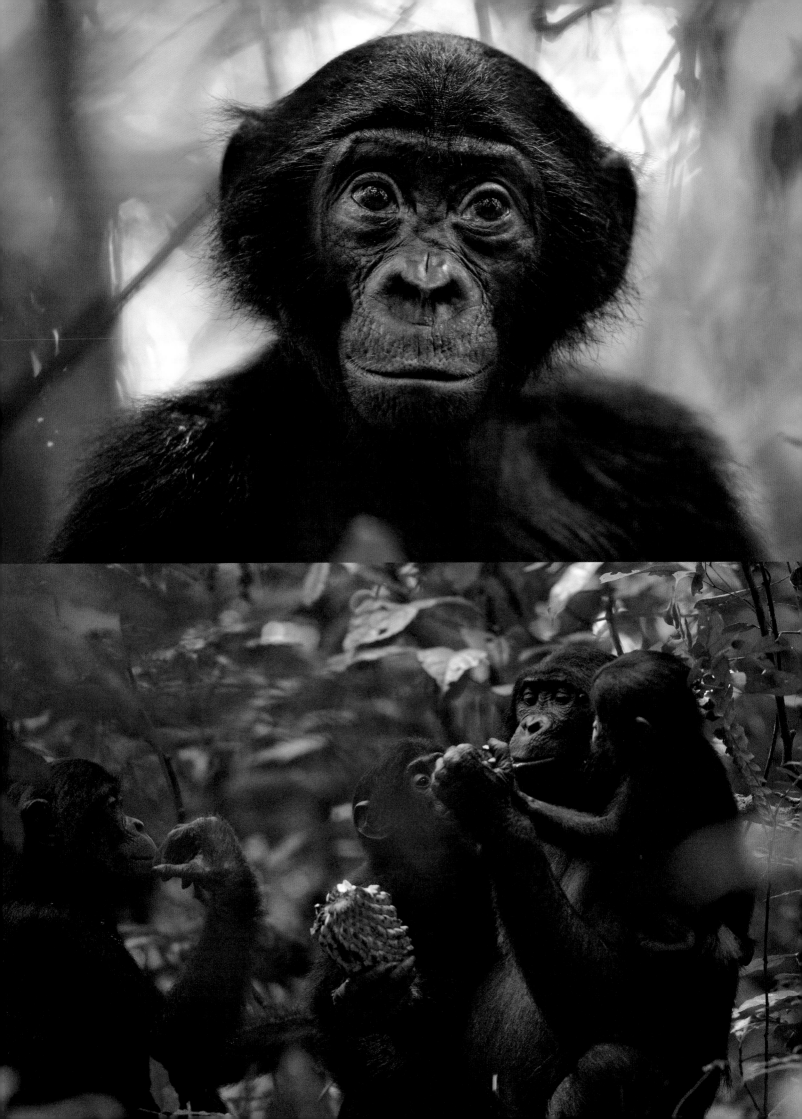

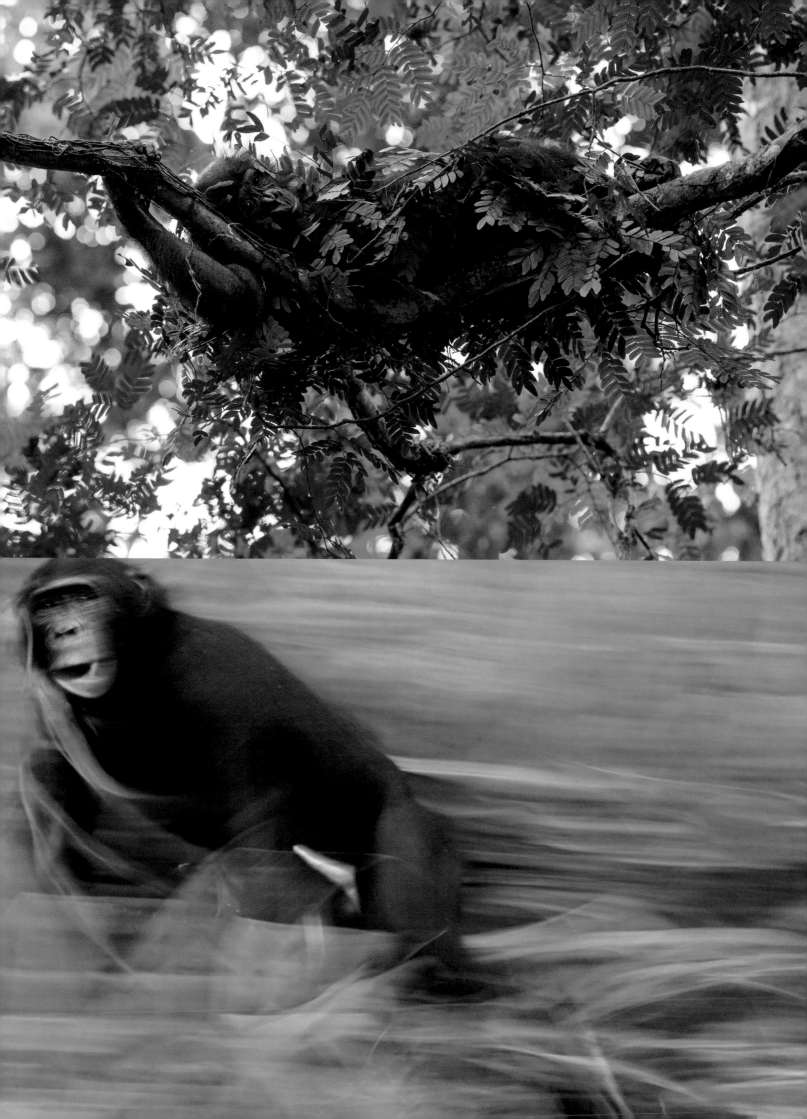

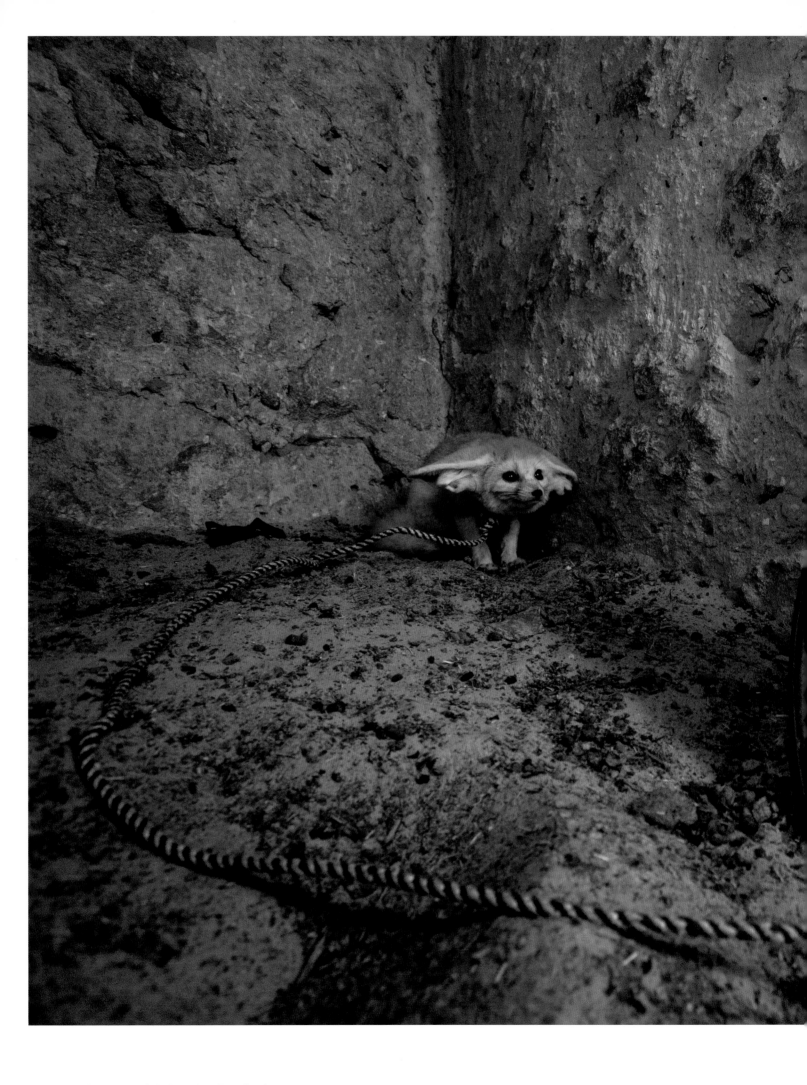

An adult fennec fox crouches in a sheep pen in a village in the Kebili region of Tunisia. The fox had been captured as a cub, and kept as a pet for over a year. The fennec is the smallest of the Canidae (dog family) and is found in desert and semi-desert areas of North Africa. It is particularly well-adapted to desert conditions—its large ears help dissipate heat, furry under-paws provide insulation against hot sands, and it can live without water for long periods, deriving all it needs from its prey. Fennecs are not an endangered species, but— prized for their appearance— they are systematically being captured to be sold as pets, or used to make money from tourists wishing to pose for souvenir photographs.

SPORTS
ACTION

SINGLES

1st Prize / **Emiliano Lasalvia**

2nd Prize / **Andrzej Grygiel**

3rd Prize / **Al Bello**

STORIES

1st Prize / **Jia Guorong**

2nd Prize / **Ezra Shaw**

3rd Prize / **Quinn Rooney**

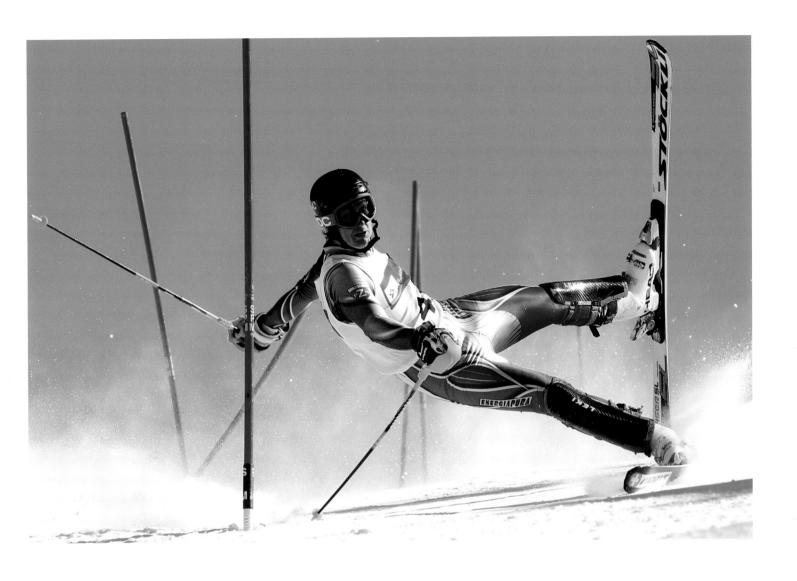

Pawel Starzyk of Poland competes in the slalom of the men's super-combined at the International Polish Alpine Skiing Championship, on 24 March. Super-combined consists of a single run of slalom, and a shortened normal downhill ski run. Starzyk had successfully completed the downhill race, but fell and did not complete the slalom run.

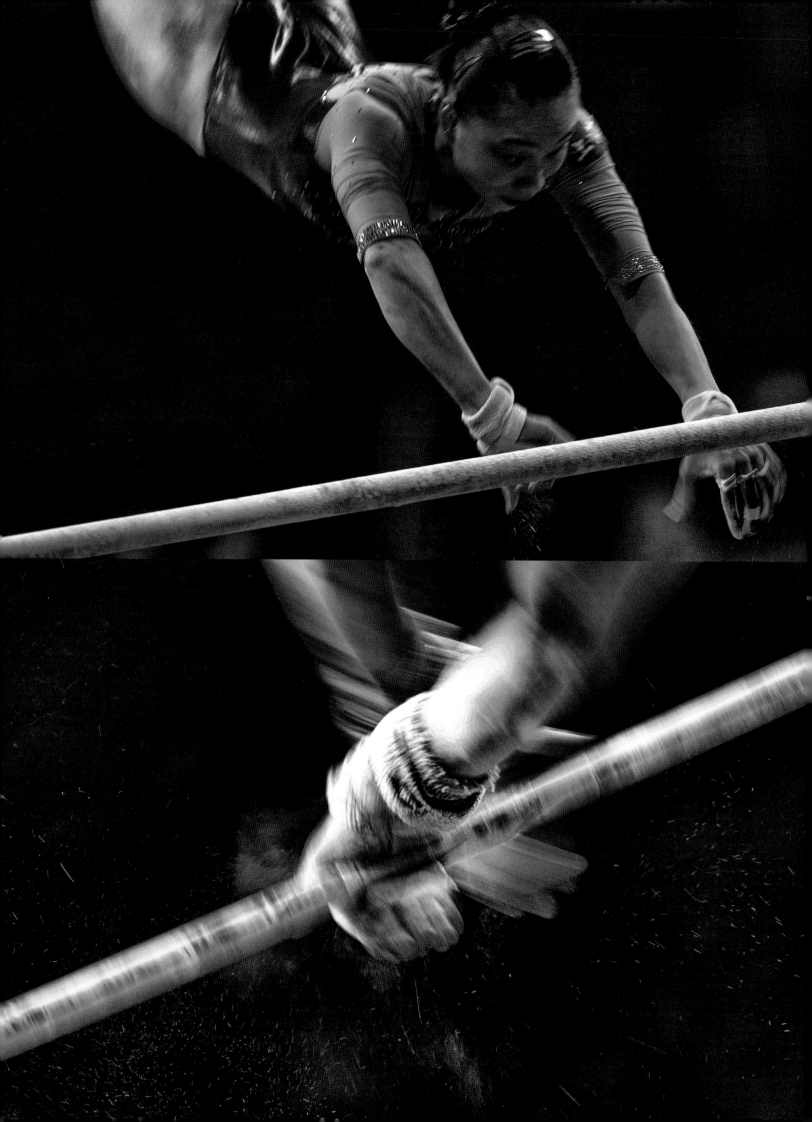

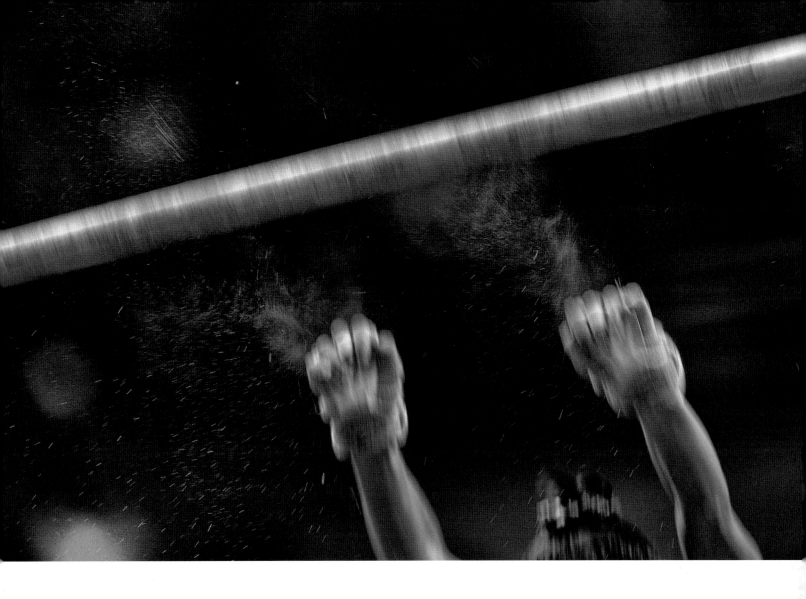

(These images and previous spread.) Athletes compete in different events on the bars during the artistic gymnastics competition at the 12th National Games of the People's Republic of China, held in the northeastern province of Liaoning from 31 August to 12 September. Gymnasts are judged for execution, degree of difficulty, and overall presentation skills on the parallel bars, high bar, and uneven bars.

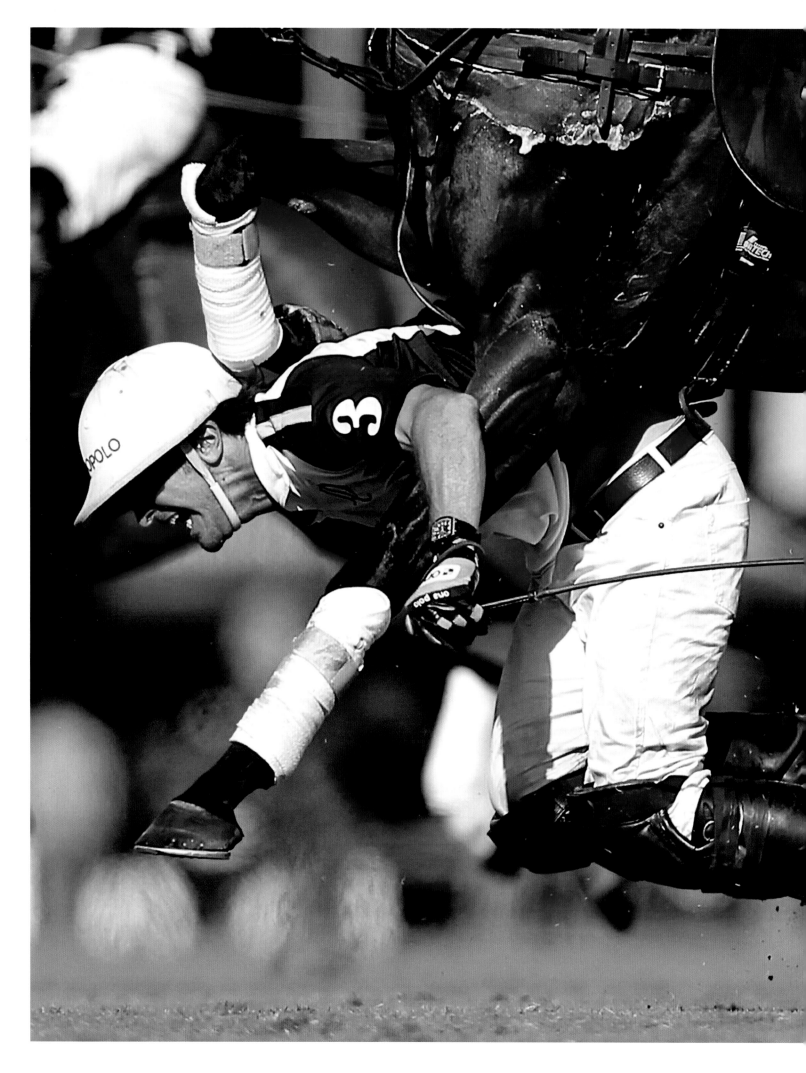

Pablo MacDonough falls at a match during the Argentine Polo Open Championship, on 1 December. Part of the international polo Grand Slam, the competition is the world's most important polo championship at club level, and has been held annually since 1893. As an individual, MacDonough was ranked fifth in the world. His team, La Dolfina, won the championship.

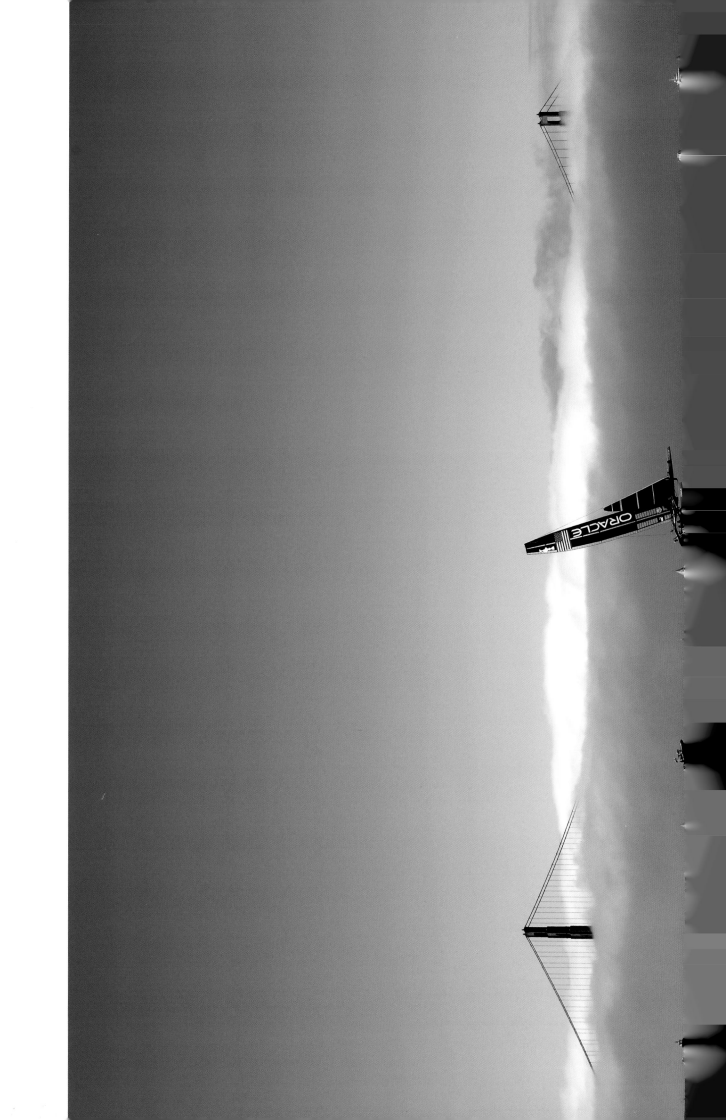

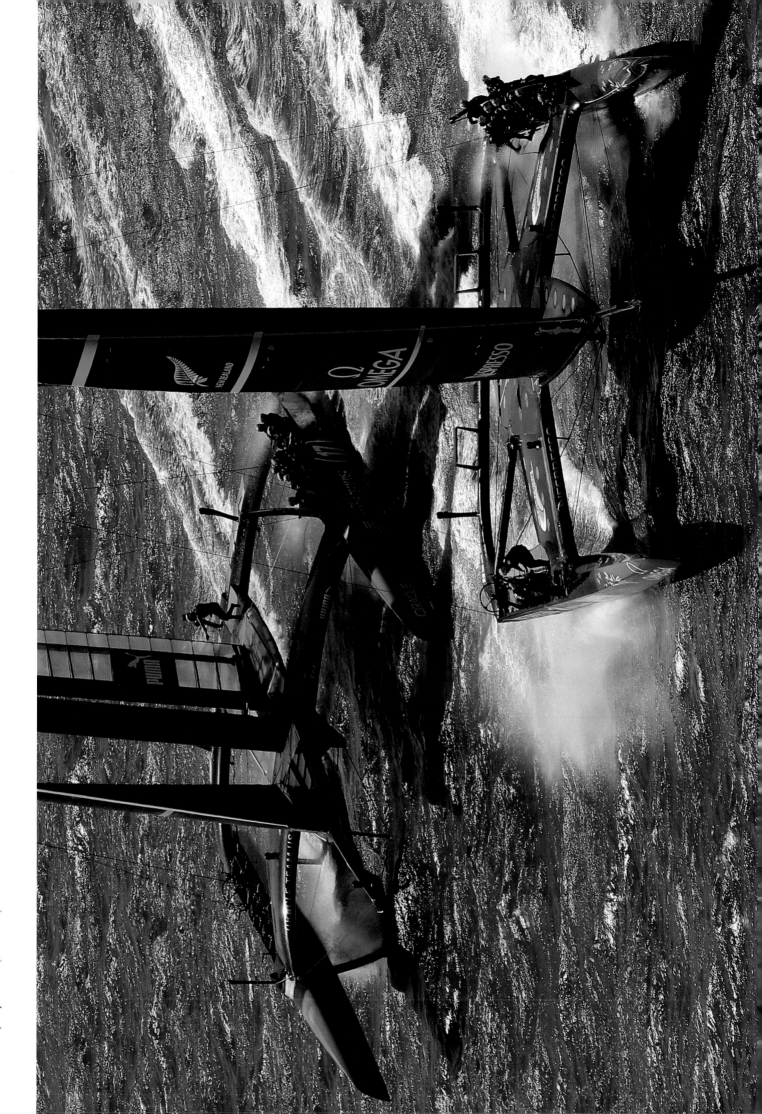

The 34th America's Cup was held in San Francisco Bay in September. Oracle Team USA had to defend their title against challengers Emirates Team New Zealand. Above: Oracle Team warms up before the 14th race. Below: Emirates Team speeds towards the bottom mark during the first race, on 7 September. (continues)

(continued) A team needs to win a total of nine races to secure the cup. By the eleventh day of the contest, the New Zealand team, skippered by Dean Barker, led 8–1. Below: Oracle Team USA leads Emirates Team New Zealand during the tenth race. (continues)

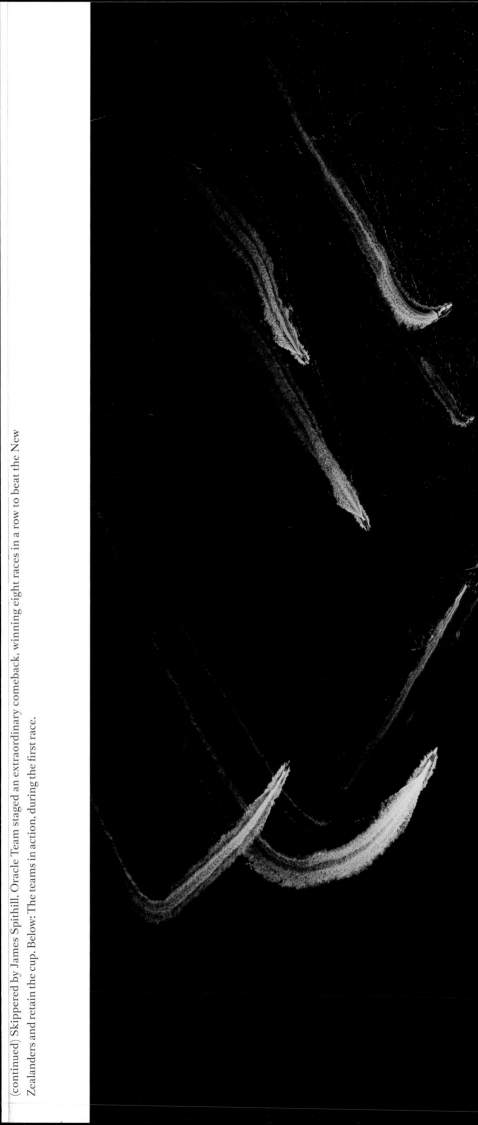

(continued) Skippered by James Spithill, Oracle Team staged an extraordinary comeback, winning eight races in a row to beat the New Zealanders and retain the cup. Below: The teams in action, during the first race.

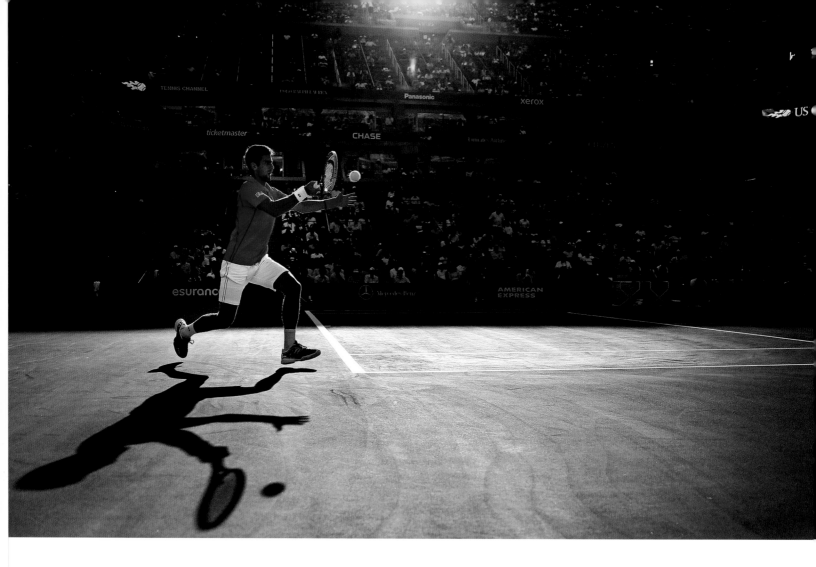

Novak Djokovic of Serbia plays a forehand during his men's singles match against Marcel Granollers of Spain, during the fourth round of the 2013 US Open at the Billie Jean King National Tennis Center, in Queens, New York City, on 3 September. First-seed Djokovic dispatched his unseeded opponent 6-3, 6-0, 6-0, but later had to cede the final to Spaniard Rafael Nadal.

SPORTS FEATURE

SINGLES
1st Prize / **Jeff Pachoud**
2nd Prize / **Anastas Tarpanov**
3rd Prize / **Donald Miralle**
STORIES
1st Prize / **Peter Holgersson**
2nd Prize / **Kunrong Chen**
3rd Prize / **Alyssa Schukar**

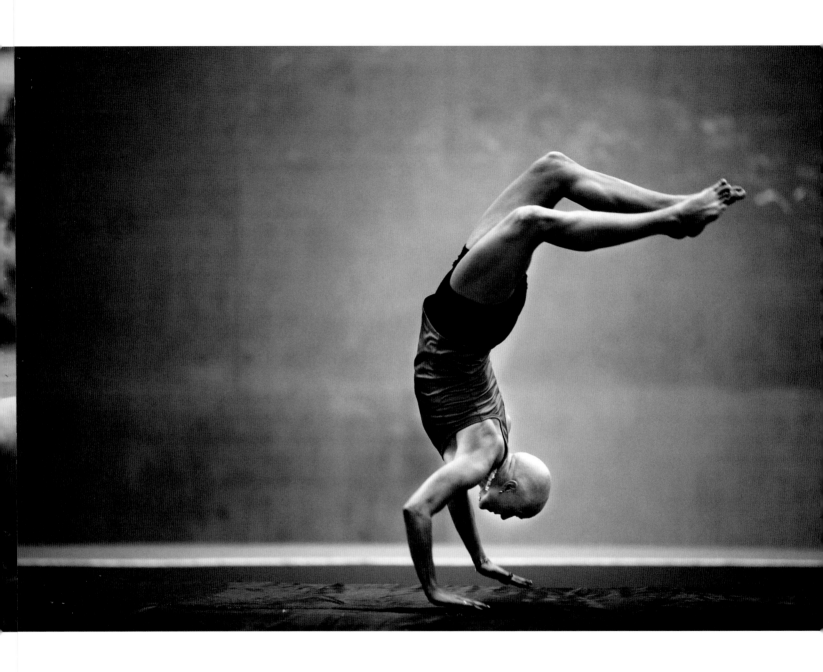

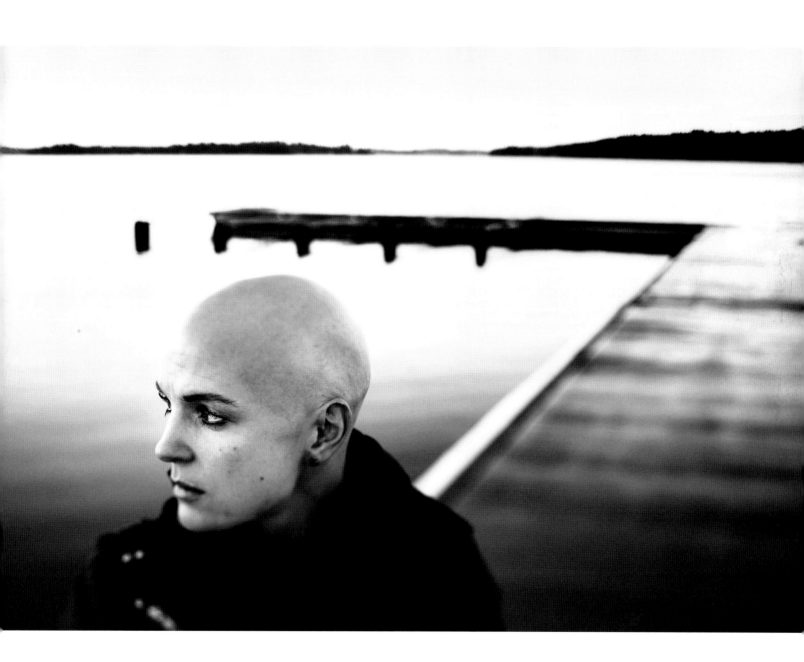

(continued) The heptathlon is a grueling two-day event that includes hurdles, high jump, long jump, shot put, javelin, and both 200m and 800m running. Casadei kept up her regime and her spirits during her period of chemotherapy, and declared her intention to try for the 2016 Rio de Janeiro Olympics.

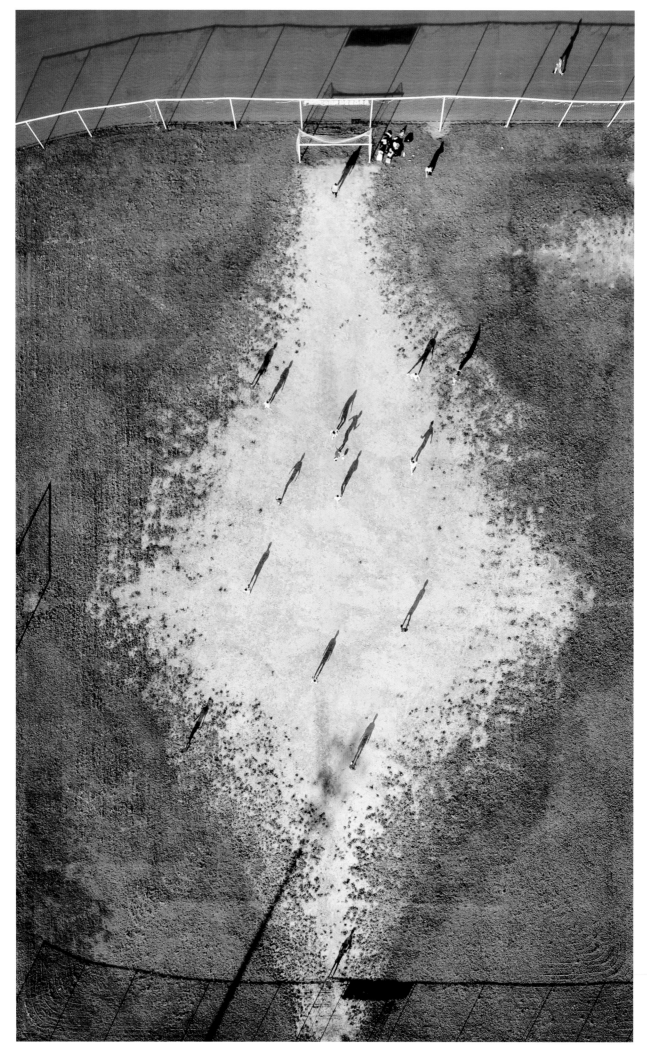

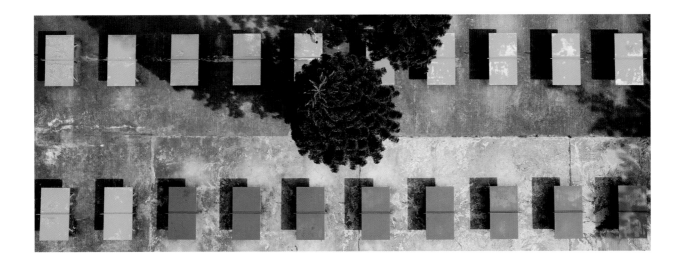

People in Zhuhai, Guandong, China, are viewed taking their daily exercise, from a drone. Facing page: Soccer, at the end of the working week. This page, top: Table tennis, in the shade under hot sun. Below: Beach volley ball, after a spring rain shower.

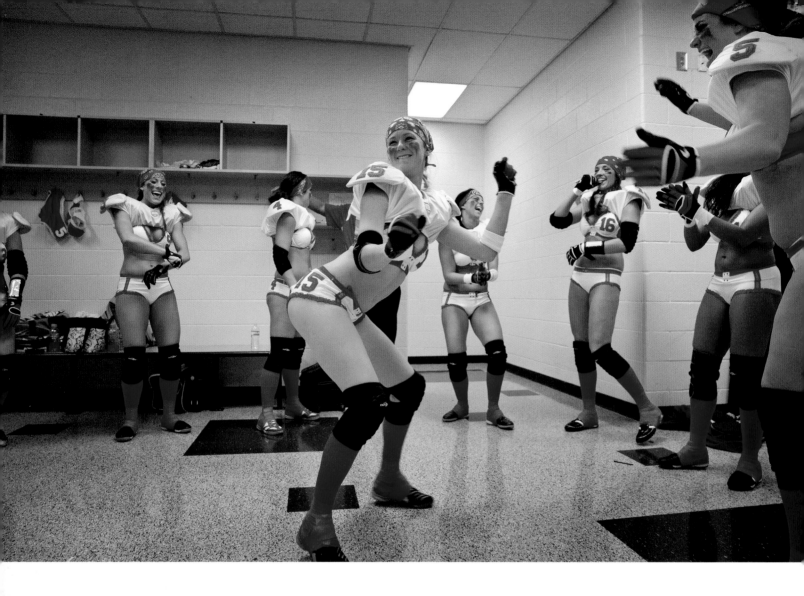

Members of the Legends Football League hope to help establish American football for women not only in the US, but in Australia and Europe as well. The league was formerly known as the Lingerie Football League, but players say they hope that in the future games won't be about sex appeal, but a showcase for women's sport. They have changed their slogan from 'True Fantasy Football' to 'Women of the Gridiron', and say they will no longer compete while wearing only lingerie. Above: Omaha Heart team members dance before a match with Atlanta Steam. Facing page, top: Leslie Walls plays with her sons, two weeks after surgery for an injury. Below: Jacqueline Smyth slams into the wall as she and Morgan Anderson (right) tackle Atlanta Steam's Nasira Johnson.

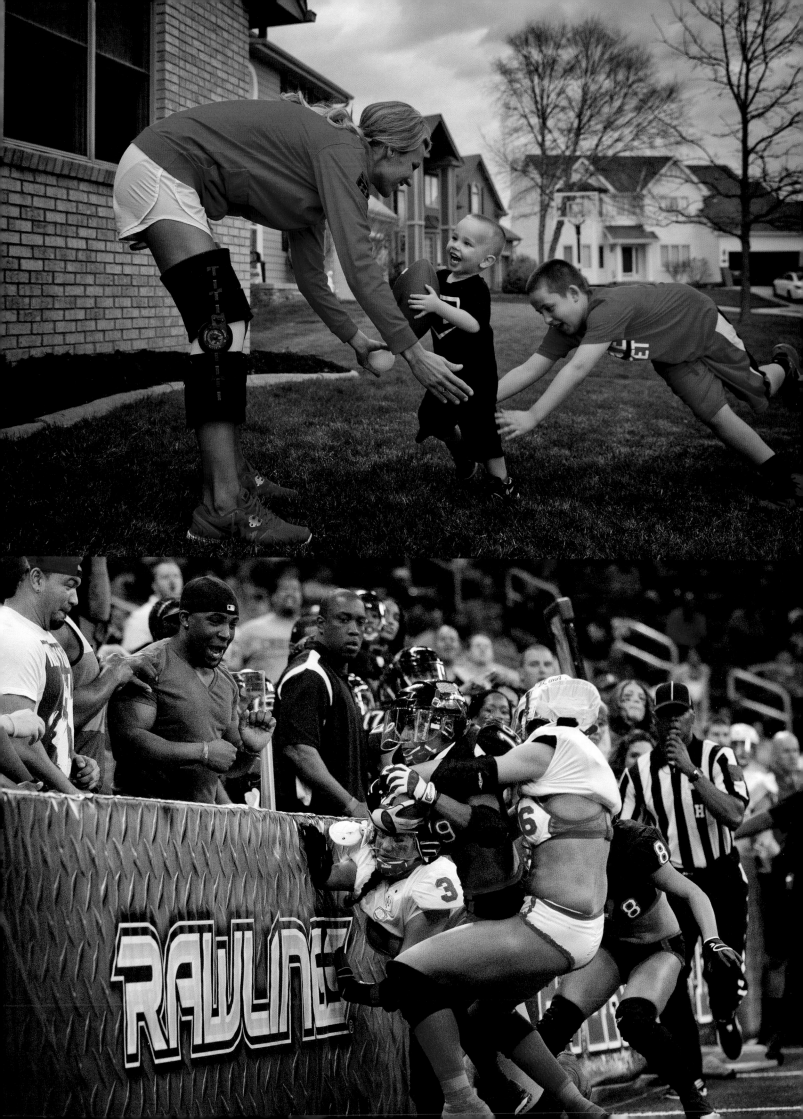

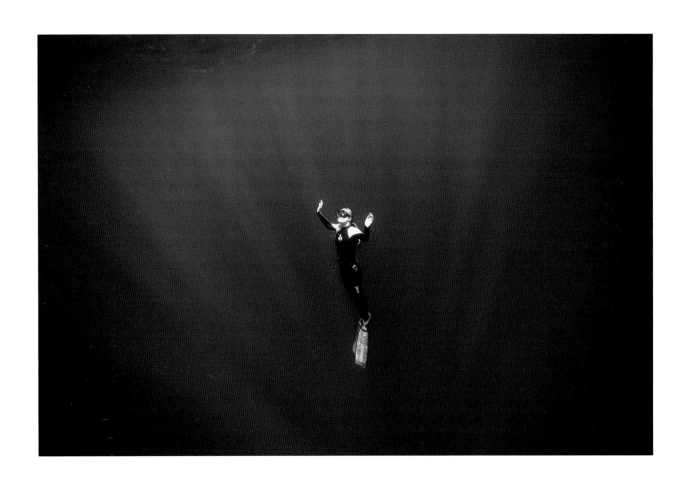

Conservationist and dive safety officer Ocean Ramsey surfaces, while free diving off the coast of Haleiwa, Oahu, Hawaii. Free diving is done without scuba gear, and requires divers to hold and control their breath for extended periods. Ramsey dives without a cage among sharks. She hopes to change public perception of the predators.

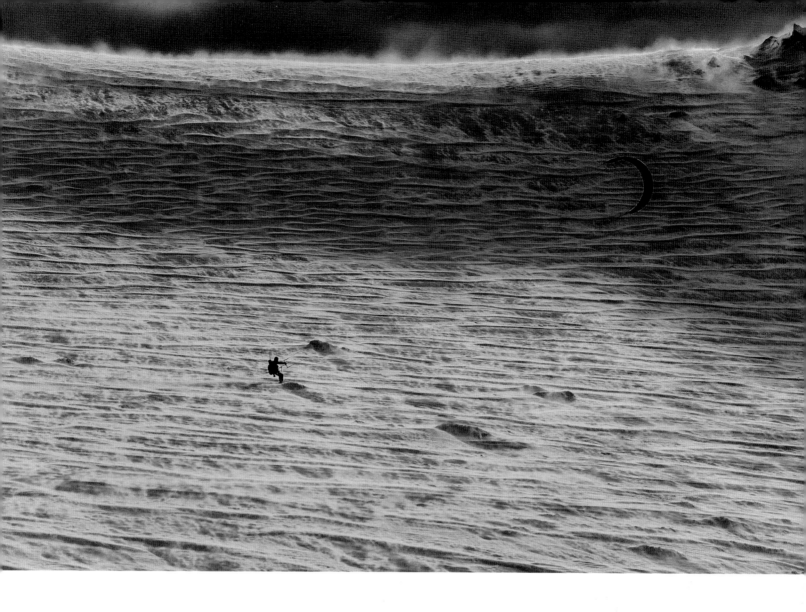

A kite skier catches the wind on the slopes of Mount Vitosha, south of Sofia, Bulgaria. The driving force for kite-skiing comes from the kite, and the sport has more in common with cross-country than downhill skiing, where gravity provides the main impetus. It can take place on snow, ice, land or water.

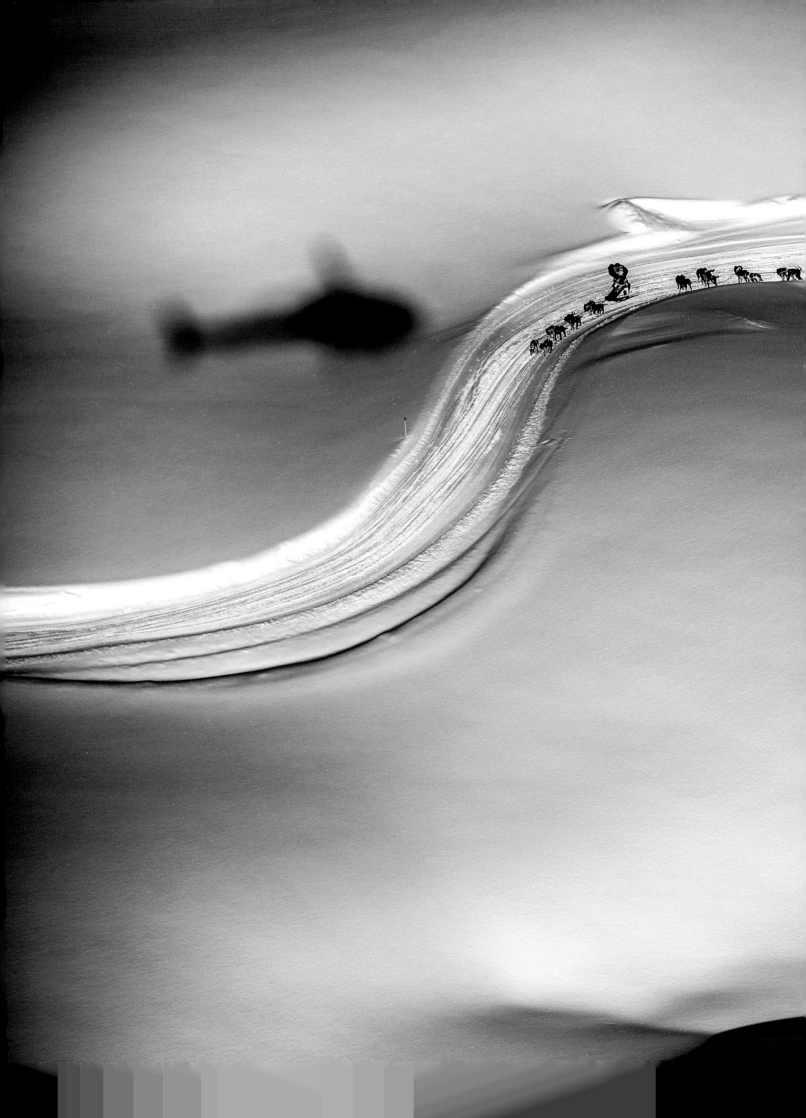

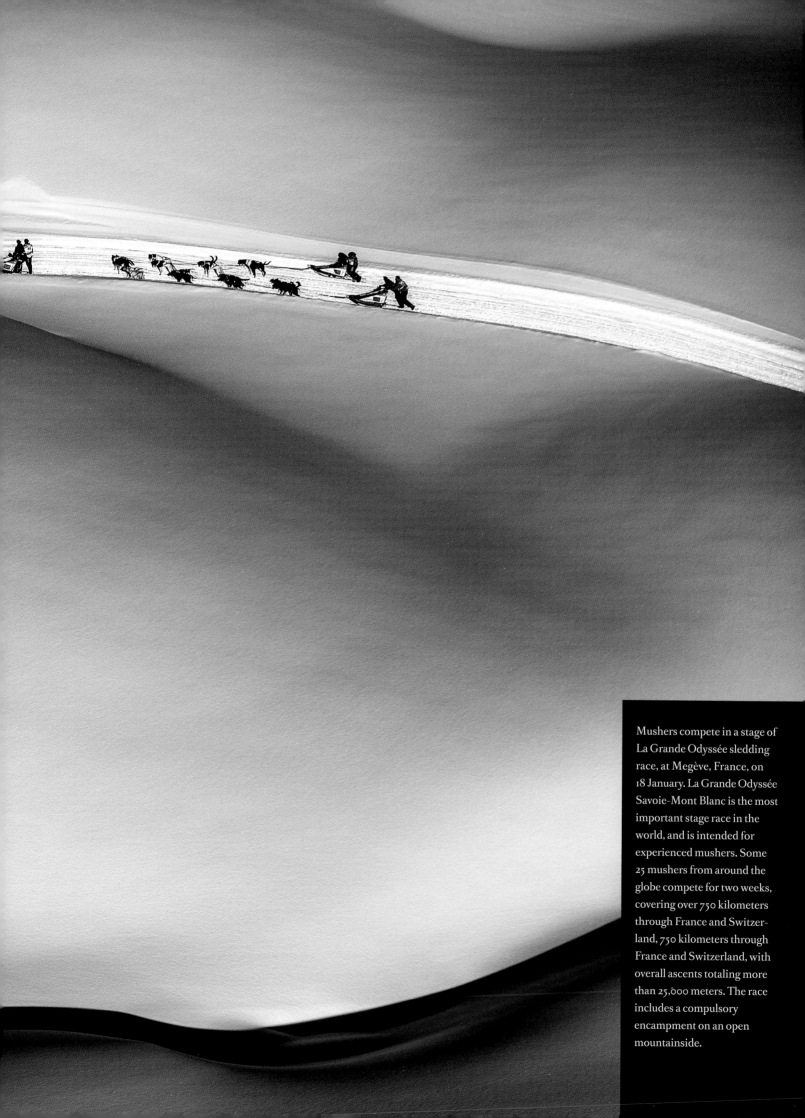

Mushers compete in a stage of La Grande Odyssée sledding race, at Megève, France, on 18 January. La Grande Odyssée Savoie-Mont Blanc is the most important stage race in the world, and is intended for experienced mushers. Some 25 mushers from around the globe compete for two weeks, covering over 750 kilometers through France and Switzerland, 750 kilometers through France and Switzerland, with overall ascents totaling more than 25,000 meters. The race includes a compulsory encampment on an open mountainside.

The 2014 Jury

Photos: Michael Kooren / Hollandse Hoogte

Chair:
Gary Knight, UK,
founder photographer
VII Photo Agency

Hideko Kataoka, Japan,
director of photography
Newsweek Japan

Kerim Okten, Turkey,
photographer

Daniel Beltrá, Spain/USA,
photographer

Rosamund Kidman Cox, UK,
editor

Terence Pepper, UK,
senior special advisor National
Portrait Gallery

Luciano Candisani, Brazil,
nature photojournalist

Koyo Kouoh, Cameroon,
founder and artistic director
Raw Material Company

Marie Sumalla, France,
photo editor *Le Monde*

Jillian Edelstein, UK/South Africa,
photographer

Adrees Latif, Pakistan/USA,
photographer and editor in charge
US pictures Reuters

Newsha Tavakolian, Iran,
photographer

Alessia Glaviano, Italy,
senior photo editor *Vogue Italia* and
L'Uomo Vogue

Susie Linfield, USA,
associate professor and director of
the cultural reporting and criticism
program, New York University

Francesco Zizola, Italy,
photojournalist Noor Images

David Guttenfelder, USA,
chief Asia photographer
The Associated Press

Miriam Marseu, USA,
photo editor *Sports Illustrated*

Secretary:
David Campbell, Australia,
independent writer, researcher,
lecturer and producer

Tom Jenkins, UK,
sports photographer

Daniel Merle, Argentina,
picture editor and curator

Secretary:
Simon Njami, Cameroon,
independent curator, lecturer and
art critic

Special Mention

Following the judging of the 2014 contest, the jury decided to give a Special Mention to a five-image series from the town of Dunalley, Tasmania, Australia, where 90 homes were destroyed by wildfires during a period of record high temperatures. The series of pictures, shot by Tim Holmes on 4 January, show his wife Tammy and their five grandchildren as they take refuge under a jetty, as a wildfire rages nearby.

The jury said:
"None of the entries to the competition addressed the issue of the wildfires with such a sense of proximity. We are used to people these days documenting their own lives, and we are used to journalists documenting calamities that affect others, but here these two intersect—a family is documenting its own calamity, in a way we can easily relate to."

The jury may consider a visual document for a Special Mention when it has played an essential role in the news reporting of the previous year and could not have been made by a professional photographer.

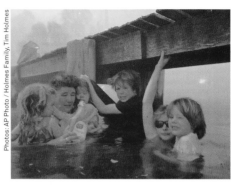

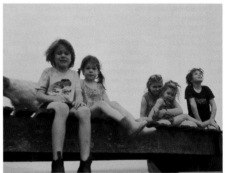

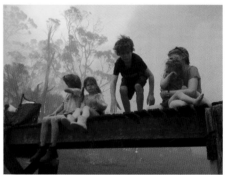

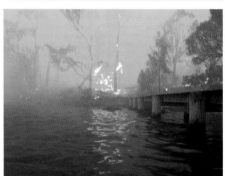

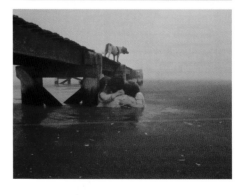

José Jácome
Andres Molestina
Diego Pallero
Alejandro Reinoso

Egypt
Mahmoud Bakkar
Essam Abd Elmonem
Ahmed Abdel Fattah Ahmed
Mohammed Abdel Moneim
Beshoy Abdo
Sameh Abo Elhassan
Mohamed Ali Eddin
Ali Almalky
Roger Anis
Ahmed Arab
Ahmed Ashraf
Kim Badawi
Sara Magdi Bayoumi
Eman Bedir
Nour El Refai
Khaled Elfiqi
Nariman El-Mofty
Mohamed El-Shahed
Mohammed Elshamy
Mosa'ab Elshamy
Mostafa Darwish
Motaz Ahmed Gebrel
Ahmed Mahmoud Gomaa
Ahmed Hayman Hafez
Aly Hazzaa
Eman Helal
Mohamed Hesham
Mohamed Hossam El-Din
Nameer Mohamed Galal
Amr Nabil
Ahmed Ramadan
Jonathan Rashad
Ayman Aref Saad
Amru Salahuddien
Khaled Basyouny
Hussein Tailal
Ahmed Taranh
Tarek Wajeh

El Salvador
Juan Carlos
Mauricio Cáceres
José Cabezas
Yuri Cortez
Giovanni E. Lemus Fuentes
Lissette Lemus
Alvaro López
Frederick Meza
Fred Ramos
Marvin Recinos
Luis Angel Umaña
Douglas Alberto Urquilla
Miguel Villalta

Estonia
Timo Anis
Evelin Kask
Eeva Kaun
Birgit Püve
Jekaterina Saveljeva

Faroe Islands
Benjamin Rasmussen

Finland
Ville Asikainen
Esko Jämsä
Petteri Kokkonen
Tanja Konstenius
Kari Kuukka
Laura Larmo
Timo Marttila
Niklas Meltio
Soili Mustapää
Juhani Niiranen
Jussi Nukari
Kimmo Penttinen
Anna Pesonen-Smith
Aleksi Poutanen
Timo Pyykkö
Kaisa Rautaheimo
Ville Rinne
Aino Salmi
Johan Sandberg
Antti Sepponen
Maija Tammi
Petri Uutela
Mikko Vähäniitty
Markus Varesvuo
Juuso Westerlund

France
Emmanuel Aguirre
Pascal Aimar
Matthieu Alexandre
Stéphane Allaman
Jody Amiet
Arnaud Andrieu
Christophe Archambault
Gema Arrugaeta
Patrick Artinian
Martin Barzilai
Pascal Beaudenon

Salah Benacer
Amel Pain
Jean-Jacques Bernard
Pauline Bernard
Stephanie Berton
Guillaume Binet
Cyril Bitton
Patrick Blanche
Romain Blanquart
Olivier Boëls
Samuel Bollendorff
Guillaume Bonn
Régis Bonnerot
Jérôme Bonnet
Yohan Bonnet
Carlo Borlenghi
Pierre Boutier
Franck Boutonnet
Eric Bouvet
Philippe Brault
Clea Broadhurst
Patrick Bruchet
Christian Brun
Axelle de Russé
Alain Buu
Sandra Calligaro
Sarah Caron
Juan Manuel Castro-Prieto
Emmanuelle Charmant
Lionel Charrier
Mehdi Chebil
Olivier Chouchana
Frederique Cifuentes
Virginie Clavières
Thomas Coex
Lenny-Baptiste Conil
Olivier Corsan
Olivier Coulange
Julie Coustarot
Stéphane Coutteel
Pierre Crom
Denis Dailleux
Julien Daniel
William Daniels
Guillaume Darribau
Nicolas Datiche
Georges Dayan
James Keogh
Matthieu de Martignac
Philippe De Poulpiquet
Veronique de Viguerie
Jerome Delay
Pascal Della Zuana
Mathias Depardon
Xavier Desmier
Bénédicte Desrus
Agnes Dherbeys
Fabrice Dimier
Stephen Dock
Marie Dorigny
Corinne Dubreuil
Pierre Duffour
Fred Dufour
Richard Dumas
Emmanuel Dunand
Edouard Elias
Alain Ernoult
Isabelle Eshraghi
Jean-Eric Fabre
Eric Facon
Hubert Fanthomme
Bruno Fert
Corentin Fohlen
Eric Gaillard
Guillaume Garvanèse
Grégory Gérault
Baptiste Giroudon
Julien Goldstein
Capucine Granier-Deferre
Gerard Gratadour
Frederic Grimaud
Olivier Grunewald
Jeoffrey Guillemard
Jean-Paul Guilloteau
Pascal Guyot
Valery Hache
Guillaume Herbaut
Benjamin Hoffman
Chris Huby
Romain Jacquet-Lagreze
Fred Jagueneau
Patrick James
Pascale Jausserand
Fabrice Catérini
Olivier Jobard
Boris Joseph
Jérémie Jung
Daniel Karmann
Vincent Kessler
Alexander Klein
Benedicte Kurzen
Olivier Laban-Mattei
Guillaume Lacourt
Frederic Lafargue
Lam Duc Hiên
Etienne Laurent
Le Gall
Ulrich Lebeuf
Laurence Leblanc

Camille Lepage
Herve Lequeux
Lewkowicz
Vincent Lignier
Philippe Lopez
Tony Lopez
Amélie Losier
Pascal Maître
Ehsan Maleki
Frédéric Marie
François-Xavier Marit
Pierre Marsaut
Jean Dominique Martin
Catalina Martin-Chico
Didier Mayhew
Valérian Mazataud
Miguel Medina
Isabelle Merminod
Nicolas Messyasz
Grégory Michenaud
Jc Milhet
Clément Morin
Olivier Morin
Vincent Munier
Jean-Francois Mutzig
Jacky Naegelen
Roberto Neumiller
Alain Noguès
Frederic Noy
Hector Olguin
Jeff Pachoud
Tadeusz Paczula
Franck Paubel
Federico Pestellini
Joel Peyrou
Jacques Pion
Melanie Dornier
Frédéric Mery Poplimont
Cyprien Clément-Delmas
Antoine Rambourg
Rijasolo
Alexis Réau
Eric Rechsteiner
Hugo Ribes
Franck Robichon
Emmanuel Rondeau
Agustine Sacha
Alexis Rosenfeld
Marc Roussel
Denis Rouvre
Guillaume Ruoppolo
Joel Saget
Gérard Sanz
Alexandre Sargos
Franck Seguin
Jérôme Sessini
Christophe Simon
Hedi Slimane
Eleonora Strano
Frédéric Stucin
Mehdi Taamallah
Pierre Terdjman
Olivier Thomas
Gia To
Eric Tourneret
Gerard Uferas
Emilien Urbano
Laurent Van der Stockt
Eric Vandeville
Christophe Viseux
Franck Vogel
Laurent Weyl
Laurent Zabulon
Mylène Zizzo

Gambia
Dawda Bayo

Georgia
Temo Bardzimashvili
Dato Daraselia
Levan Kherkheulidze
Michael Korkia
Ketevan Mghebrishvili
Mzia Saganelidze
Maiko Tochilashvili
Olga Tsiskarishvili-Soselia

Germany
Valeska Achenbach
Anne Ackermann
Ingo Arndt
Bernd Arnold
Frank Augstein
Marc Baechtold
Thorsten Baering
Lajos-Eric Balogh
David Baltzer
Lars Baron
Gil Bartz
Kathrin Baumbach
Ralf Baumgarten
Marion Beckhäuser
Marc Beckmann
Fabrizio Bensch
Gösta Berwing
Jodi Bieber
Toby Binder
Joerg Boethling

Stefan Boness
Wolfgang Borm
Hubert Brand
Hermann Bredehorst
Gero Breloer
Philipp Breu
Hansjürgen Britsch
Britta Pedersen
Ingo Brockerhoff
Michał Buettner
Sabine Bungert
Hans-Jürgen Burkard
Dominik Butzmann
Dirk Claus
Sven Creutzmann
Peter Dammann
Stefan Dauth
Oliver Dietze
Barbara Dombrowski
Christopher Dömges
Birgit-Cathrin Duval
Ole Elfenkämper
Andreas Ellinger
Stephan Engler
Daniel Etter
Enrico Fabian
Bettina Flitner
Kilian Foerster
Sascha Fromm
Frank Gehrmann
Olli Geibel
Christoph Gerigk
Mario Gerth
Thomas Grabka
Marcel Gräfenstein
Ben Grna
Chris Grodotzki
Jens Grossmann
Waltraud Grubitzsch
Mareike Guensche
Julia Gunther
Patrick Haar
Michael R. Hagedorn
Gerrit Hahn
Matthias Hangst
Martin Hartmann
Alexander Hassenstein
Thilo Remini
Marc Heiligenstein
Axel Heimken
Katja Heinemann
Falk Heller
Ilja C. Hendel
Paul Henschel
Claudia Henzler
Juliane Herrmann
Katharina Hesse
Benjamin Hiller
Helge Holz
Sandra Hoyn
Tobias Hutzler
Florian Jaenicke
Claudia Janke
Britta Jaschinski
Jens Jeske
Hannes Jung
Kati Jurischka
Andree Kaiser
Enno Kapitza
Sebastian Keitel
Tobias Keunecke
Claus Kiefer
Dagmar Kielhorn
Lorenz Kienzle
Björn Kietzmann
Thorsten Klapsch
Christian Klein
Wolfgang B. Kleiner
Robert Kluba
Marco Kneise
Stephan Knoblauch
Stefan Koch
Katrin Koenning
Alexander Koerner
Bjorn Eric Kohnen
Gert Krautbauer
David Kregenow
Andreas Krufczik
Dirk Krüll
Moritz Küstner
Bartek Langer
Martin U. K. Lengemann
Matthias Ley
Christoph Lienert
Ralf Lienert
Konrad Lippert
Kai Löffelbein
Lukas Lowack
Sabine Ludwig
Werner Mansholt
Helena Schaetzle
Noel Tovia Matoff
Dieter Menne
T.E.O. Metelmann
T. Metelmann
Jens Meyer
Sascha Montag
Cathrin Mueller
Mareike Mueller

Daniel Müller
Peter Müller
Lene Münch
Ruben Neugebauer
Simone M. Neumann
Anja Niedringhaus
Joanna Nottebrock
Geert Oeser
Ingo Otto
Isabela Pacini
Günter Passage
Britta Pedersen
Laci Perenyi
Thomas P. Peschak
Carsten Peter
Thomas Peter
Kai Pfaffenbach
Christoph Pueschner
Jean-Paul Raabe
Stephan Rabold
Thomas Rabsch
Julia Rahn
Rassloff
Hanne Rauchensteiner
Michael Rauschendorfer
Martin Rehm
Julian Reichelt
Philipp Jonas Reiss
Sascha Rheker
Alex Ribowski
Astrid Riecken
Moritz Roeder
Jens Rosbach
Martin Rose
Julian J. Rossig
Kaveh Rostamkhani
Martin Sasse
Peter Schatz
Dietmar Scherf
Nanni Schiffl-Deiler
Günter Schiffmann
Roberto Schmidt
Steffen Schmidt
Harald Schmitt
Charlotte Schmitz
Willi Schneider
Martin Schoeller
Julius Schrank
Markus Schreiber
Annette Schreyer
Thomas Schreyer
Olaf Schuelke
Frank Schultze
Claudius Schulze
Hartmut Schwarzbach
Yvonne Seidel
Stefan Seip
Marcus Simaitis
Oliver Sittel
Michael Sohn
Philipp Spalek
René Spalek
Martin Specht
Kim Sperling
Andy Spyra
Christof Stache
Martin Steffen
Berthold Steinhilber
Björn Steinz
Benjamin Stöß
Patrik Stollarz
Carsten Stormer
Michaela Strassmair
Bettina Strenske
Phil Louis
Olaf Tamm
Guenay Ulutuncok
Marc-Steffen Unger
Ryu Voelkel
Mika Volkmann
Philipp von Ditfurth
Marc Vorwerk
Anke Waelischmiller
Edith Wagner
Uwe Weber
Frank Wechsel
Oliver Weiken
Fabian Weiss
Bernd Weissbrod
Ludwig Welnicki
Gordon Welters
Christian Werner
Mario Wezel
Sebastian Widmann
Rainer Windhorst
Ann-Christine Woehrl
Jonas Wresch
Solvin Zankl
Frank Zauritz
Sven Zellner
Christian Ziegler
Tamina-Florentine Zuch

Ghana
Geoffrey Buta
Nyani Quarmyne

Gibraltar
Donovan Torres

Greece
Socrates Baltagiannis
Yannis Behrakis
Yiannis Biliris
Evangelos Bougiotis
Androniki Christodoulou
Dimitris Galanakis
Yannis Galanopoulos
Petros Giannakouris
Angelos Giotopoulos
Iakovos Hatzistavrou
Petros Karadijas
Yorgos Karahalis
Zisis Kardianos
Yiannis Katsaris
Alexandros Katsis
Alexandros Katsis
Gerasimos Koilakos
Yannis Kolesidis
Alkis Konstantinidis
Yannis Kontos
Stefanos Kouratzis
Maro Kouri
Dionysis Kouris
Yiannis Kourtoglou
Michele A. Macrakis
Vassilis Makris
Kostas Mantziaris
Aris Messinis
Dimitris Michalakis
Stefania Mizara
Giorgos Moutafis
Menelaos Myrillas
Ntamplis Vasilis
Spyridon Paloukis
Angeliki Panagiotou
Giannis Papanikos
Nikos Pilos
Lefteris Pitarakis
Orestis Seferoglou
Andrea Shkreli
Grigoris Siamadis
Olga Stefatou
Theofan
Konstantinos Tsakalidis
Sofia Tsampara
Kostas Tsironis
Panayiotis Tzamaros
Angelos Tzortzinis
Aristidis Vafeiadakis
Eirini Vourloumis
Evi Zoupanos

Guam
Ed Crisostomo

Guatemala
Moises Castillo
Esteban Biba
Enrique Hernandez Avila
Saul Martinez
Ricardo Ramírez Arriola
Deccio Lizzardy Serrano
Luis Soto

Haiti
Homere Cardichon
Dieu Nalio Chery

Honduras
Gustavo Amador
RaJo

Hong Kong
Kin Pong Cheung
Chung Ming Ko
Leo Kwok
Lam Yik Fei
Jih Sheng Lei
Li Chak Tung
Lui Siu Wai
Luo Kanglin
Robert Ng
Tyrone Siu
Eric Tsang
Aanchal Wadhani
Phoebe Yeung
Bobby Yip
Vincent Yu

Hungary
Bacsi Robert Laszlo
Attila Balazs
Hamvas Balint
Zoltán Balogh
Andras Bankuti
Cosmicbunuel
István Bielik
Krisztián Bócsi
János Bődey
Kinga Böjtös
Gyula Czimbal
Bela Doka
Gabor Dvornik
Berci Feher
Isidora Gajic
Balazs Gardi
Glázer Attila
H.Szabó Sándor

Hajdu Andras
András Hajdú
Hernad Geza
Tibor Illyes
Szabolcs Ivan
András Jóri
Marton Kallai
Peter Komka
Szilard Koszticsak
Nikolett Kovacs
Andrea Kövesdi
Zsolt Kudich
Janos Kummer
Péter Lakatos
Gergely Lantai-Csont
Zoltan Molnar
Simon Móricz
Robert Nemeti
Paczai Tamas
Pajor András
Zsolt Repasy
Tamas Revesz
Zsolt Reviczky
Sánta István Csaba
Tamas Schild
Janos M Schmidt
Balazs Simonyi
Lajos Soos
Akos Stiller
Sulaci
Peter Szalmas
Robert Szaniszlo
Joe Petersburger
Zsolt Szigetváry
Laszlo Szirtesi
Gabor Turcsi
Adam Urban
Laszlo Vegh

Iceland
Ragnar Axelsson
Vilhelm Gunnarsson
Heiða Helgadóttir
Brynjar Gauti
Arni Torfason

India
Abhimanyu Kumar Sharma
Abid Bhat
Adnan Abidi
Jagadeesh Acharya
Mukhtar Ahamed Khan
Ahmed Kamal
Abhijit Alka Anil
Kulendu Kalita
Gemunu Amarasinghe
Channi Anand
Bindu Arora
Mahesh Kumar A.
Pratik Dutta Babu
Sundeep Bali
Suman Ballav
Pritam Bandyopadhyay
Subhashis Basu
Salil Bera
Kamalendu Bhadra
Ramakrishna Bhat
Subhasish Bhattacharjee
Piyal Bhattacharjee
Biju Boro
A.K. BijuRaj
Kishor Kumar Bolar
Debajyoti Chakraborty
Ranjan Basu Bulbul
Burhaan Kinu
Munish Byalaa
Basheer Chambel
Ashoke Chakrabarty
Rana Chakraborty
Amit Chakravarty
Ch. Vijaya Bhaskar
Puneet Chandhok
Bhanu Prakash Chandra
Anindya Chattopadhyay
C. Suresh Kumar
K.K. Choudhary
Rupak De Chowdhuri
Arul Danam Horizon
Dar Yasin
Sanjit Das
Saurabh Das
Sucheta Das
Sudipto Das
Sujanya Das
Arko Datto
Amit Rameshchandra
Mukunda De
Mandar Deodhar
Uday Deolekar
Arindam Dey
Debasish Dey
Karen Dias
Sandesh Rokade
Bishwarup Dutta
Raja Abhimannyu
Neelesh Ek
Pattabi Raman
Tara Chand Gawariya
Vasantha Kumar Ghantasala

Eivind H. Natvig
Rune Petter Ness
Aleksander Nordahl
Ken Opprann
Javad Parsa
Espen Rasmussen
Kristian Skeie
Helge Skodvin
Jo Straube
Otto von Münchow

Pakistan
Irfan Ali
Arshad Arbab
Ali
B.K. Bangash
Abdul Baqi
K.M. Chaudary
Asif Hassan
Muhammad Javaid
Fareed Khan
Mukhtar Khan
Umar Qayyum
Rana Sajid Hussain
Omer Saleem
Murtaza Ali

Palestinian Territories
Mohammed Abed
Ezz Al Zanoon
Eyad Al-Baba
Osama Silwadi
Laura Boushnak
Ahmed Deeb
Momen Faiz
Mahmoud Hamda
Khalil Hamra
Mahmud Hams
Adel Hana
Mustafa Hassona
Ahmed Jadallah
Ali Jadallah
Hatem Moussa
Mohammed Asad
Wissam Nassar
Ali Noureldine
Issam Rimawi
Mohammed Salem
Suhaib Salem
Ibraheem Abu Mustafa
Mohammed Talatene
Ahmed Zakot

Panama
Adriano Duff Leslie
Alexander Arosemena
David Mesa Jaen
Essdras M. Suarez
Mauricio Valenzuela

Peru
Solange Adum
Ernesto Arias
Giancarlo Avila
Miguel Angel Bellido Almeyda
Ernesto Benavides
Manuel Berrios
Max Cabello Orcasitas
Sebastian Castaneda
Ana Castañeda Cano
Sharon Castellanos Tuesta
Enrique Castro-Mendivil
Oscar Durand
Gladys Alvarado Jourde
Luis Alfonso Elias Alfageme
Hector Emanuel
Carlos Garcia Granthon
Marco Garro
Cecilia Herrera
David Huamani
Silvia Izquierdo
Franz Krajnik
Rochi León
Rómulo Luján
Luis Sergio
Martin Mejia
Miguel Mejía Castro
Karina Mendoza
Sebastian Montalvo Gray
Karel Keil Navarro Pando
Musuk Nolte
Rodrigo Rodrich
Leslie Searles
Daniel Silva Yoshisato
Manuel Milko
Gihan Tubbeh
Ian Tevo
Victor Vasquez Figueroa
Jose Vidal Jordan
Victor Zea

Philippines
Joe Arazas
Jes Aznar
Keith Bacongco
Richard Balonglong
Ruston
Pol Briana, jr.
Estan Cabigas

Ramon I. Castillo
Noel Cellis
Arnold Conlu Jumpay
Revoli Cortez
Michael D Varcas
Gregorio B.
Venecio Datan
Tammy David
Erik De Castro
Linus Guardian Escandor II
Aaron Favila
Carlo Gabuco
Oliver Y. Garcia
Edgardo Gumban
Hadrian Hernandez
John Javellana
Victor Kintanar
Francis Malasig
Karlos Manlupig
Bullit Marquez
Nino Jesus Orbeta
LJ Pasion
Bj. A. Patino
Dennis M. Sabangan
Jake Salvador
J Gerard Seguia
Fernando G. Sepe, Jr.
Bernard Testa
Ritchie B. Tongo
Jet Velas
Aaron Vicencio
Veejay Villafranca
Reynan Villena
Rem Zamora

Poland
Adameq
Michal Adamski
Anna Musiałówna
Peter Andrews
Mateusz Baj
Anna Bedyńska
Marek M. Berezowski
Marcin Bielecki
Maciej Billewicz
Piotr Bławicki
Aleksander Bochenek
Andrzej Bochenski
Aneta Bochnacka
Michał Buczek
Maciek Butkowski
Grzegorz Celejewski
Paweł Charkiewicz
Roman Chelmowski
Piotr Cieśla
Maciej Cieślak
Kiko
Filip Cwik
Łukasz Cynalewski
Wiktor Dabkowski
Maciej Dakowicz
Konstancja Nowina Konopka
Grzegorz Dembinski
Krystian Dobuszynski
Irek Dorozanski
Sebastian Dziekoński
Ewa Figaszewska
Michal Fludra
Jacek Fota
Ania Freindorf
Pawel Frenczak
Jacek Gasiorowski
Maciej Gillert
Marcin Filip Gizycki
Arkadiusz Gola
Tomek Gola
Andrzej Grygiel
Wojciech Grzedzinski
Tomasz Gudzowaty
Paweł Gulewicz
Dariusz Hermiersz
Jan Klos
Ryszard Poprawski
Mariusz Janiszewski
Hanna Jarzabek
Paweł Jędrusik
Bartlomiej Jurecki
Maciej Kaczanowski
Marcin Kadziolka
Marcin Kalinski
Janusz Kaminski
Kuba Kaminski
Łukasz Kaminski
Mariusz Kapala
Patryk Karbowski
Maja Kaszkur
Alik Keplicz
Filip Klimaszewski
Luc Kordas
Michal Korta
Michal Kosc
Kacper Kowalski
Michał Kowalski
Andrzej Kozioł
Tomek Kozlowski
Kacper Kubiak
Arkadiusz Kubisiak
Adam Lach
Pawel Lączny

Marek Lapis
Tomasz Laptaszynski
Arkadiusz Lawrywianiec
Tomasz Lazar
Robles
Tomasz Liboska
Anna Liminowicz
Gabor Lorinczy
Maciej Grzybowski
Aleksander Majdanski
Piotr Malecki
Rafal Malko
Katarzyna Maługa
Krzysztof Maniocha
Katarzyna Markusz
Bogusław Masłak
Wojciech Matusik
Pawel Matyka
Rafal Mikolajczuk
Rafal Milach
Adrian Mirgos
Marcin Miroslawski
Karolina Misztal
Grzegorz Momot
Maciej Moskwa
Piotr Dyba
Maciek Nabrdalik
Andrzej Nasciszewski
Borys Niespielak
Mikolaj Nowacki
Piotr Nowak
Bartosz Nowicki
Adam Nurkiewicz
Grzegorz Olkowski
Zbigniew Osiowy
Mieczyslaw Pawlowicz
Elzbieta Piekacz
Leszek Pilichowski
Piotr Tarasewicz
Robert Pipała
Radek Polak
Krzysztof Racoń
Artur Radecki
Magda Rakita
Agnieszka Rayss
Piotr Redinski
Maksymilian Rigamonti
Magdalena Rodziewicz
Karol Rutkowski
Marcin Ryczek
Bartek Sadowski
Dominik Sadowski
Katarzyna Sagatowska
Mateusz Sarello
Karolina Sekuła
Maciej Skawinski
Bart Skowron
Slawek Skrobala
Dominik Śmiałowski
Michal Solarski
Filip Springer
Mieszko Stanisławski
Piotr Stasiuk
Dariusz Stepien
Bartosz Stróżyński
Dawid Stube
Waldek Stube
Mikolaj Suchan
Marcin Suder
PSP Lukasz Swiderek
Przemęk Swiderski
Jacek Świerczyński
Lucas Szelemej
Michal Szlaga
Jacek Szust
Tomasz Szustek
Ilona Szwarc
Jakub Szymczuk
Dawid Tatarkiewicz
Piotr Tracz
Piotr Tumidajski
Jacekt Turczyk
Przemek Walocha
Adam Warżawa
Tomasz Wiech
Piotr Wittman
Grzegorz Wójcik
Tomasz Wozny
Adrian Wykrota
Tomasz Wysocki
Marcin Wziontek
Marcin Zaborowski
Marek Zakrzewski
Albert Zawada
Filip Zawada
Jacek Zentkowski
Tomasz Ziober
Marta Zubrzycka

Portugal
Baleixo
Rodrigo Cabrita
Ana Baião
Diogo Baptista
Schwantz
Carlos Barroso
Ana Brígida
Rui Caria
Antonio Carrapato

José Carlos Carvalho
Vladimir Rodas
Vítor Cid
Bruno Colaço
Mário Cruz
Nuno Guimaraes
Gonçalo Delgado
Filipe Amorim
Paulo Duarte
Rui Duarte Silva
Rui Farinha
João Cláudio Fernandes
José Fernandes
Jose Ferreira
Nuno André Ferreira
Pedro Fiúza
Bruno Fonseca
Pedro Saraiva
Luís Guerreiro
Lara Jacinto
Eduardo Leal
Francisco Leong
Cláudia Lima da Costa
Nuno Lobito
Renato Lopes
Miguel Barreira
Artur Machado
Ana Maia
Tiago Maya
Ruben Mália
Joana Maltez
Adelino Meireles
Luis Melo
Pedro Nunes
Paulo Nunes dos Santos
Rui Oliveira
Octávio Passos
Pedro Patricio
Antonio Pedrosa
Luis Barbosa
Ceci de F
Paulo Pimenta
João Pina
Rui Pires
Luciano Reis
Daniel Rodrigues
Francisco Salgueiro
Paulo Escoto
Bruno Simões Castanheira
Pedro Simões
Gonçalo Lobo Pinheiro
Marcos Sobral
Paulo Alexandrino
Raquel Wise
Miguel Veterano Junior
Tó Mané

Puerto Rico
Carlos Javier Ortiz
Erika P. Rodriguez

Romania
Mihaela Agarici
Petrut Calinescu
Odeta Catana
Corneliu Cazacu
Bogdan Chesaru
Tal Cohen
Bogdan Cristel
Daniel Nicolae Djamo
Mircea Gherase
Cornel Gingarasu
Stefan Jora
Liviu Maftei
Adrian Martalogu
Ioana Moldovan
Andrei Pungovschi
Mircea Restea
Raul Stef
Attila Szabo
Mugur Varzariu
Tudor Vintiloiu

Russia
Fail Absatarov
Vadim Achmetov
Serge Andreev
Andrey Arkhipov
Armen Asratyan
Dmitry Azarov
Bakhtadze Dmitriy
Uldus Bakhtiozina
Vyacheslav Bakin
Dmitry Beliakov
Victor Berezkin
Dmitry Berkut
Nigina Beroeva
Vladimir Bezverhij
Aleksey Bochin
Alexei Boitsov
Viktor Borovskikh
Den Butin
Andrey Chepakin
Alexander Chernavsky
Elena Chernyshova
Churackoff
Alexander Demianchuk
Konstantin Dikovsky
Misha Domozhilov

Dzhavakhadze Zurab
Evgeniy Epanchintsev
Sergey Ermokhin
Ershova Inna
Ilias Farkhutdinov
Vladimir Fedorenko
Filippov Alexey
Vladimir Finogenov
Sergey Gagauzov
Andrey Golovanov
Pavel Golovkin
Sergey Gorshkov
Mikhail Grebenshchikov
Solmaz Guseynova
Sergei Ilnitsky
Anatoly Lolis
Evgenii Ivanov
Yuriy Ivaschenko
Victoria Ivleva
Misha Japaridze
Fauziia Kabulova
Elena Kanysheva
Oleg Kargapolov
Anton Karliner
Dinara Kasimova
Kasyanov Vyacheslav
Gulnara Khamatova
Natasha Kharlamova
Yury Khodzitskiy
Kirill Kudryavtsev
Sergei Kivrin
Oleg Klimov
Alexey Kompaniychenko
Sergey A. Kompaniychenko
Alex Kondratyk
Eduard Korniyenko
Yury Koryakovskiy
Artemy Kostrov
Dmitry Kostyukov
Ludmila Kovaleva
Yuri Kozyrev
Rostislav Krasnoperov
Alexandr Kryazhev
Ira Zimina
Alex Kudenko
Alexey Kunilov
Vladimir Lamzin
Oleg Lastochkin
Dmitry Lebedev
Kirill Lebedev
Fedoseyev Lev
Sergey Lidov
Alexey Loshchilov
Lukin Andrey
Natalia Ivova
Anastasia Makarycheva
Marina Makovetskaya
Manolova Olga
Areg Manvelyan
Vita Maslii
Sergey Maximishin
Ekaterina Maximova
Valery Melnikov
Svetlana Melnikova
Andrew Mireyko
Viatcheslav Mitrokhin
Sayana Mongush
Mikhail Mordasov
Anton Mukhametchin
Alexander Nemenov
Arseniy Neskhodimov
Juri Nesterenko
Gontar Nikolai
Andrey Nikolskiy
Sergey Novikov
Natalya Onishchenko
Alexander Oreshnikov
Vladimir Orlov
Kirill Ovchinnikov
Ivan Pantyushin
Valentinas Pecininas
Vladimir Pesnya
Alexander Petrosyan
Alexander Petrov
Sergey Petrov
Ilya Pitalev
Maria Pleshkova
Maria Plotnikova
Tatiana Plotnikova
Pochuev Mikhail
Natasha Podunova
Vova Pomortzeff
Sergey Ponomarev
Pronin Andrey
Pavel Prosyanov
Vladimir Rodionov
Dmitry Rogulin
Maria Romakina
Andrey Rudakov
Vladimir Rudakov
AnaStasia Rudenko
Sergei Sablin
Salavat Safiullin
Konstantin Salomatin
Pavel 'PaaLadin' Semenov
Semen Dumov
Vladimir Syomin
Sergey Shchekotov
Ivan Shapovalov

Dmitry Sharomov
Maxim Shipenkov
Zalman Shklyar
Salt Images
Denis Sinyakov
Vlad Sokhin
Ekaterina Solovieva
Alexander Sorin
Andrey Stenin
Alexander Stepanenko
Fedor Stepanyuk
Sergey Stroitelev
Julia Sundukova
Andrey Svitailo
Katya Sytnik
Alexander Taran
Fyodor Telkov
Ilia Teplov
Vasiliy Tikhomirov
Danila Tkachenko
Maria Turchenkova
Anton Tushin
Yuri Tutov
Alexander Utkin
Grigoriy Yaroshenko
Viktor Vasenin
Andrey Vasilchenko
Vasilyeff
Pavel Vasilyev
Sergey Pyatakov
Sergey Vdovin
Ekaterina Vedenina
Vladimir Velengurin
Pavel Volkov
Maxim Vorotovov
Vladimir Vyatkin
Vyshinskiy Denis
Anastasya Yerofeyeva
Sveta Yuferova
Victor Yuliev
Oksana Yushko
Jegor Zaika
Konstantin Zavrazhin
Alexander Zaytsev
Valeriy Zaytsev
Anatoly Zhdanov
Valery Zhelezniakov

Saint Kitts and Nevis
Wayne Lawrence

Saudi Arabia
Iman Al-Dabbagh

Senegal
Behan Touré

Serbia
Sasha Colic
Aleksandar Dimitrijevic
Marko Djurica
Dragomir Vukovic
GerJo
Srdjan Ilic
Sanja Jovanović
Lekic Dragan
Nebojsa Markovic
Nemanja Pancic
Igor Pavicevic
Marko Rupena
Dragoljub
Srdjan Suki
Goran Tomasevic
Tamás Tóth
Darko Vojinovic

Singapore
Suhaimi Abdullah
Alphonsus Chern
Jonathan Choo
Chua Chin Hon
Gavin Foo
Ernest Goh
How Hwee Young
Zann Huizhen Huang
Paul Khoo
Edwin Koo
Kevin Lim
Lim Yaohui
Nicky Loh
Patrick Low Kai Seng
Joseph Nair
Leonard Phuah H G
Seah Kwang Peng
Sim Chi Yin
Darren Soh
Edgar Su
Chih Wey Then
Desmond Wee Teck Yew
Maye-E Wong
Jonathan Yeap

Slovakia
Vlado Baca
Victor Breiner
Gabriela Bulisova
Martin Cervenansky
Maros Herc
Joe Klamar

Martin Kollar
Peter Mercel
Lucia Nimcová
Michal Šebeňa
Vladimir Simicek
Vaculikova Silvia

Slovenia
Nina Blaž
Luka Dakskobler
Jošt Franko
Jaka Gasar
Maja Hitij
Ciril Jazbec
Manca Juvan
Matjaz Kacicnik
Miro Majcen
Blaz Samec
Matjaz Tancic
Tadej Znidarcic
Matic Zorman
Simen Zupancic

Somalia
Mohamed Abdiwahab

South Africa
Neil Aldridge
Mark Andrews
Michel Bega
Daniel Born
Nic Bothma
Theana Breugem
Rob Brown
Jennifer Bruce
Jay Caboz
Shelley Christians
Julia Cumes
Matthew de Jager
Adrian de Kock
Antoine de Ras
Felix Dlangamandla
Otmar Dresel
Paul Botes
Brenton Geach
Ilan Godfrey
Julian Goldswain
Themba Hadebe
David Harrison
Sumaya Hisham
Dean Hutton
Iga Motylska
Sue Kramer
Halden Krog
Henk Kruger
David Larsen
Francisco Little
Kim Ludbrook
Lungelo Mbulwana
Neil McCartney
Gideon Mendel
Joy Meyer
Eric Miller
Refilwe Modise
Ayanda Ndamane
Nonhlanhla Kambule Makbati
James Oatway
Alet Pretorius
Nelius Rademan
Shaun Roy
Mujahid Safodien
Sydney Seshibedi
Marc Shoul
Siphiwe Sibeko
Alon Skuy
Gareth Iain Smit
Chris Stamatiou
Tracy Lee Stark
Brent Stirton
Giordano Stolley
Kevin Sutherland
Caroline Suzman
Waldo Swiegers
Paballo Thekiso
Thomas Holder
Liza van Deventer
Cornél van Heerden
Schalk van Zuydam
Herman Verwey
Deaan Vivier
Michael Walker
Rogan Ward
Alexia Webster
Mark Wessels
Graeme Williams

South Korea
Kin Cheung
Seong Joon Cho
Woohae Cho
Choi Hyungrak
Shin Dong Phil
Nam Y. Huh
Jeon Heon-Kyun
Chris Jung
Ha Dong Kim
Kim Jung-hyo
Koo Sung Chan
Jin-man Lee

Lee Jae-Won
Lee Yu-Kyung
Truth Leem
Andrew Lim
Daniel Sangjib Min
Jong-Shik Park
S.Y Shin
Shin Woong-jae
Yoon Min Son
Yeong-Ung Yang

Spain
Laia Abril
Maysun
Javier Acebal
BielAlino
Joan Alvado
Delmi Alvarez
Samuel Aranda
Celestino Arce
Javier Arcenillas
Pablo Argente
Xoan A. Soler
Bernat Armangue
Maria Arranz
Pablo Artero
Joan Manuel Baliellas
Manuel Ballesteros Roque
Marc Balló
Berta Banacloche
JC Barberá
Raul Barbero Carmena
Pau Barrena
Sergio Barrenechea
Alvaro Barrientos
Jonás Bel
Clemente Bernad
Xavier Bertral Gallardo
Jesús Blesa Sahuquillo
Enric Boixadós
Jordi Boixareu
Pep Bonet
Albert Bonsfills
Jordi Borràs
Manu Brabo
Daniel Burgui Iguzkiza
Jordi Busque
Jordi Busquets
Albert Busquets
Eduardo Buxens
Biel Calderon
Carlos Calleja Goñi
Marta Tucci
Álvaro Calvo
Olmo Calvo
Sergi Camara
Miguel Candela
Santi Carneri
Felipe Carnotto
Sergio Caro
Miguel Castro
José Cendón
Guillermo Cervera
Xavier Cervera
Oriol Clavera
Pablo Cobos
Jordi Cohen
Jose Colon
Pep Cortés
Matias Costa
Joan Costa
Ramon Costa
Jose Luis Cuesta
Victor Lafuente
Jose Antonio de Lamadrid
Francisco de las Heras
Ofelia de Pablo
Marcelo del Pozo
Oscar del Pozo
EmDelgado
Alvaro Deprit
Alberto Di Lolli
Eduardo Diaz
Nacho Doce
Luis Domingo
Adrián Domínguez
Rosa Maria Duaso
Sergio Enríquez-Nistal
Ramon Espinosa
Rafa Estévez
Rafael S. Fabrés
Quim Farrero
Marc Femenia
Erasmo Fenoy Nuñez
Aitor Fernández
Hugo Fernández
Claudio de la Cal
J.M. Fernandez de Velasco
Monica Vila Ferreiros
Edu Ferrer Alcover
Luana Fischer
Angel M. Fitor
Juan Flor
Gari Garaialde
Jon Nazca
Quico Garcia
Jordi Play
Alvaro Garcia
Albert Garcia

Xoan García Huguet
Ángel García
J.F. Garrido Sanchez Toledo
Juli Garzon
Rafa Gassó
Eugeni Gay Marín
Albert Gea
Ander Gillenea
Arianna Giménez Beltrán
Susana Girón
Joaquin Gomez Sastre
Mdolors Gonzalez-Luumkab
Daniel González Acuña
Albert Gonzalez Farran
Pedro Armestre
Gabriel González-Andrío
Anna Huix
Jorge Guerrero
Javier Corso
Rafa Gutiérrez
Jose Haro
Antonio Heredia
Elena Hermosa
Nacho Hernandez
Diego Ibarra
David Airob
Ivan Llop
Jose Luis Jaime
Czuko Williams
Adrián Julián Francisco
Álvaro Laiz
Emilio Lavandeira Villar
Daniel Leal-Olivas
Laura Leon
Sebastian Liste
Miki López
Alex Llovet
Baruc Francesc
JM Lopez
Ángel López Soto
Núria López Torres
Andoni Lubaki
Javier Luengo
Manuel Zamora
Rafael Marchante
Juanjo Martin
Guillermo Martínez
Andrés Martinez Casares
Andres Martinez Sutil
Albert Masias
Jordi Matas Castelló
Hector Mediavilla
Jacobo Medrano
Patrick Meinhardt
J. Merelo de Barbera Llobet
Daniel Merino
Francisco Mingorance
Alvaro Minguito
Peppino Molina
Alfonso Moral Rodriguez
Freya Morales
Emilio Morenatti
Marcos Moreno
Janire Najera
Emilio Naranjo
Angel Navarrete
Eduardo Nave
Daniel Ochoa de Olza
Rodrigo Ordóñez
Alex Rivera
Nathalie Paco
Oscar Palomares
Antonio Pampliega
Ivan Pascual
Pere Pascual
Eva Parey
Juan Pelegrín
Jordi Perdigó
Francis Pérez
Xavier P. Moure
Miguel Pérez Pichel
Jose Pesquero Gomez
Maria Pisaca
Jordi Pizarro
Joan Planas
Edu Ponces
Elisenda Pons
Mónica Prat
Luis Quintanal
Manel Quiros
David Ramos
Markel Redondo Larrea
Eli Regueira
Pau Rigol
Eduardo Ripoll
Eva Ripoll
Selvua
Gustavo Rivas
Txema Rodríguez
Samuel Rodriguez Aguilar
Alfons Rodriguez
Arturo Rodríguez
Manuel Romaris
Jordi Ruiz Cirera
Abel Ruiz de Leon Trespando
Luis Miguel Ruiz Gordón
Aitor Sáez
Mireia Salgado
Ana Salvá

Moises Saman
Ralph Schneider
Edu León
Javier Sanchez Martinez
Joaquin Sánchez
Josu Santesteban
Andrea Santolaya
Ervin Sarkisov
Fransisco Seco
Lourdes Segade
Oriol Segon Torra
Diario de Navarra
Jose Silveira
David Simon Martret
Anna Soldevila
Tino Soriano
Carlos Spottorno
Anna Surinyach
Kike Taberner Tarazona
Pablo Tarrero Segarra
Gabriel Tizón
Juan Carlos Tomasi
Miguel Toña Olaortua
Maria Torres-Solanot
Rafael Trapiello
Anibal Trejo
Eliseo Trigo
Enrique Truchuelo Ramirez
Josu Trueba Leiva
Francis Tsang
Txomin Txueka
Patxi Uriz
Quintina Valero
Guillem Valle
Joan Valls
Jairo Vargas
Antonio Vázquez
Mingo Venero
Jöel Ventura
Susana Vera
Jordi Vidal Cotrina
Miguel Vidal
Roser Vilallonga Tena
Jaime Villanueva
Enric Vives-Rubio
Alvaro Ybarra Zavala
Valentí Zapater
Miguel Zavala
Javier Zurita

Sri Lanka
Buddhika Weerasinghe

Sudan
Mohamed Nureldin Abdallah
Ahmad Mahmoud
Osman Okasha
Ashraf Shazly

Surinam
Roy Ritfeld

Sweden
Henry Arvidsson
Christian Aslund
Andreas Bardell
Johan Bävman
Henrik Brunnsgård
Maja Daniels
Lars Dareberg
Carl de Souza
Martin Edström
Åke Ericson
Jonas Eriksson
Jan Fleischmann
Anders Forngren
Linda Forsell
Viktor Fremling
Jessica Gow
Lena Gunnarsson
Jeppe Gustafsson
Niclas Hammarström
Paul Hansen
Charlotta Härdelin
Casper Hedberg
Robert Henriksson
Christoffer Hjalmarsson
Peter Holgersson
Hussein Elalawi
Eva-Lotta Jansson
Olof Jarlbro
Stefan Jerrevång
Jörgen Johansson
Christina Kronér
Stefan Bladh
Niklas Larsson
Roger Larsson
Björn Larsson Rosvall
Magnus Laupa
Jonas Lemberg
Julia Lindemalm
Jonas Lindkvist
Beatrice Lundborg
Hampus Lundgren
Joachim Lundgren
Magnus Lundgren
Alexander Mahmoud
Emil Malmborg
Chris Maluszynski

Joel Marklund
Paul Mattsson
Linus Meyer
Jack Mikrut
Jonathan Nackstrand
Anette Nantell
Andreas Nilsson
Nils Petter Nilsson
Thomas Nilsson
Loulou d'Aki
Axel Oberg
Robin Aron
Matso Pamucina
Per-Anders Pettersson
Lennart Rehnman
Håkan Röjder
Ann-Sofi Rosenkvist
Carl Sandin
Torbjörn Selander
Sheena Skoglund
Anna Simonsson
Åsa Mikaela Sjöström
Sanna Sjoswärd
Patrick Sörquist
Linus Sundahl-Djerf
Pontus Tideman
Ola Torkelsson
Lars Tunbjörk
Roger Turesson
Martin von Krogh
Anna Wahlgren
Sydsvenska Bild
Magnus Wennman
Staffan Widstrand
Sara Winsnes
Jacob Zocherman

Switzerland
Denis Balibouse
Fabian Biasio
Monica Boirar
Stephanie Borcard
Pit Buehler
Mischa Christen
Pavel Cugini
Andreas Frossard
Yvain Genevay
Marcel Grubenmann
Steeve Luncker
Georgios Kefalas
Thomas Kern
Reza Khatir
Patrick B. Kraemer
Kostas Maros
Alessandra Meniconzi
Nicolas Metraux
Pascal Mora
Jacek Piotr Pulawski
Andri Pol
Jean Revillard
Daniel Rihs
Michel Roggo
Didier Ruef
Meinrad Schade
Philipp Schmidli
Beat Schweizer
Lazar Simeonov
Simon Tanner
Scott Typaldos
Fabian Unternährer
Olivier Vogelsang
Andreas Walker
Stefan Wermuth
Christian Wyss
Luca Zanetti
Matthieu Zellweger
Michaël Zumstein

Syria
Ammar Abd Rabbo
Ammar Abdullah
Mohamed Abdullah
Saad AboBrahim
Khalel Ashawe
Carole AlFarah
Malek Alshemali
Molhem Barakat
Yazan Homsy
Ali Jarekji
Bassam Khabieh
Hamid Khatib
Haleem Al-Halabi
Saleh Laila
Muzaffar Salman
Abo Shuja
Hagop Vanesian
Hisham Zaweet

Taiwan
Keye Chang
Chen Cho Pang
Nana Chen
Yu-Chen Chiu
Pichi Chuang
Fang Chun Che
Fu-Han Lee
Janice Leu
Kanjun Pan
Shen Chao-Liang

Thailand
Piti A Sahakorn
Bundit Chotsuwan
Lek Kiatsirikajorn
Lek Kiatsirikajorn
Pinna Lauhachai
Athit Perawongmetha
Ekkarat Punyatara
Ornin Ruang
Natis Sirivatanacharoen
Yostorn Triyos
Wason Wanichakorn

Trinidad and Tobago
Andrea de Silva

Tunisia
Ons Abid
Chedly Ben Ibrahim
Zied Ben Romdhane
Hamideddine Bouali
Amine Landoulsi
Adel Mhadhebi
Douraïd Souissi

Turkey
Aytunc Akad
Burak Akbulut
Mete Aktas
Abdurrahman Antakyali
Ali Kemal Atik
Ali Atmaca
Erkan Avci
Taner Aydin
Evrim Aydin
Gokhan Balci
Kürsat Bayhan
Umit Bektas
Selim Bostanci
Tolga Bozoglu
Sinan Çakmak
Necdet Canaran
Aydin Çetinbostanoglu
Orhan Cicek
Onur Çoban
Yusuf Darıyerli
Ali Demir
Pari Dukovic
Ahmet Dumanli
Sefa Eyi
Salih Zeki Fazlıoğlu
Cem Genco
Murat Germen
Sait Serkan Gurbuz
Ali Güreli
Mühenna Kahveci
Barbaros Kayan
Bullent Kilic
Ertugrul Kilic
Celil Kırnapcı
Lale Koklu
Ozan Kose
Dilek Mermer
Sahan Nuhoglu
Osman Orsal
Mehmet Ali Özcan
Riza Ozel
Okan Ozer
Emrah Özesen
Emin Özmen
Ali Ihsan Ozturk
Kemal Ozturk
Metin Pala
Mehmet Ali Poyraz
Halil Sagirkaya
Muratsaka
Musa Samur
Mustafa Bilge Satkin
Yusuf Sayman
Murat Sengul
Erhan Sevenler
Emine Gozde Sevim
Isa Simsek
Selahattin Sönmez
Tahir Un
Barişkan Unal
Ali Ünal
Aykut Unlupinar
İz Üstün
Mehmet Yaman
Ilhami
Kadir Yildirim
Sabri Yildirim
Firat Yurdakul

Turkmenistan
Vyacheslav Sarkisian

Uganda
Samuel Kayondo
Martin Kharumwa
Nadinah Nalwanga
Drake Ssentongo

Ukraine
Arthur Bondar
Sergey Dolzhenko

Maxim Dondyuk
Yuriy Dyachyshyn
Alexander Feldman
Alexey Furman
Gleb Garanich
Sergii Kharchenko
Alexander Kharvat
Andrew Kravchenko
Andrew Lubimov
Efrem Lukatsky
Evgeniy Maloletka
Nataliya Kostromina
Vladyslav Musiienko
Zhenya Nesterets
Oleg Nikitenko
Valentyn Ogirenko
Kadnikov Oleksandr
Mikhail Palinchak
Sergii Polezhaka
Stepan Rudik
Genya Savilov
Oleg Shchapov
Zoya Shu
Vladimir Sindeyev
Anatoliy Stepanov
Valerii Tkachenko
Volodymyr Tverdokhlib
Ivan Tykhy
Max Vetrov
Roman R. Yitzhak Vilenskiy
Anna Voitenko
Alexander Yalovoy

United Arab Emirates
Hassan Ammar

United Kingdom
Carl Paris Adams
Rachel Adams
Roderick Aichinger
Andrew Aitchison
Fuat Akyuz
Ed Alcock
Jason Alden
Brian Anderson
Charlotte Anderson
Cedric Arnold
Matthew Aslett
Jocelyn Bain Hogg
Richard Baker
Patrick Baldwin
Thomas Ball
Jane Barlow
Alison Baskerville
Guy Bell
Eleanor Leonne Bennett
Eleanor Bentall
Martin Birchall
Marcus Bleasdale
Will Boase
Harry Borden
Shaun Botterill
Andrew Boyers
Tom Broadbent
Clive Brunskill
Jason Bryant
Tessa Bunney
Gary Calton
Tom Campbell
Richard Cannon
Holly Cant
Michael Carroll
Brian Cassey
Peter Caton
David Chancellor
Anthony Chappel-Ross
Matthew Chattle
James Cheadle
William Cherry
Wattie Cheung
Russell Cheyne
Mark Chilvers
Phil Clarke Hill
Felix Clay
Dolly Clew
Lee Harper
Mia Collis
Christian Cooksey
Andy Couldridge
Jez Coulson
Damon Coulter
Andy Cowie
Rufus Cox
Michael Craig
Alan Crowhurst
Ben Curtis
Simon Dack
Nick Danziger
Simon Dawson
Simon de Trey-White
Adam Dean
Peter Dench
Adrian Dennis
Francis J Dias
Joseph Dias
Alexander Dias
Nigel Dickinson
Kieran Dodds
Luke Duggleby

Matt Dunham
Patrick Eden
Mike Egerton
Neville Elder
Kirk Ellingham
Drew Farrell
Alixandra Fazzina
Tristan Fewings
Anna Filipova
Rick Findler
Julian Finney
David Fitzgerald
Charlie Forgham-Bailey
Stuart Forster
Ian Forsyth
Andrew Fosker
Stuart Franklin
Stuart Freedman
Christopher Furlong
Robert Gallagher
Sean Gallagher
Nick Gammon
Bradley Garret
Dan Giannopoulos
Chris Gibbs
John Giles
Jonathan Goldberg
Gavin Gough
David Graham
Alastair Grant
Michael Grieve
Laurence Griffiths
Paul Hackett
Neil Hall
Johan Hallberg-Campbell
Charlie Hamilton James
Sara Hannant
Olivia Harris
Terry Harris
Richard Heathcote
Scott Heavey
Mark Henley
George Henton
Julian Herbert
Mike Hewitt
Jack Hill
Paul Hilton
Liz Hingley
Jane Hobson
Owen Humphreys
Jeremy Hunter
Mike Hutchings
Thabo Jaiyesimi
David Jay
Will Johnston
Nadav Kander
Stephen Kelly
Eddie Keogh
Glyn Kirk
Antony Kitchener
Dan Kitwood
Colin Lane
Kalpesh Lathigra
Graham M. Lawrence
Jed Leicester
David Levenson
Alex Livesey
David Lornie
Lucy Piper
Lucy Ray
Mikal Ludlow
Daniel Lynch
Luke Macgregor
Ian MacNicol
Guy Martin
Dylan Martinez
Stuart Matthews
David Mbiyu
Alison McCauley
Rachel Megawhat
Julie McGuire
Toby Melville
Jeff Mitchell
Siegfried Modola
Yui Mok
Phil Moore
Steve Morgan
James Abbott
Spike Johnson
Julie Howden
Eddie Mulholland
Vincent Mundy
Leon Neal
William Neill
Lucy Nicholson
Phil Noble
Simon Norfolk
Danny North
Tony O'Brien
Ayman Oghanna
Charles Ommanney
Jeff Overs
Pete Oxford
Sebastian Palmer
Laura Pannack
Peter Parks
David Pearce
John Perkins
Kate Peters

157

Tom Pilston
Platon
Peter Powell
Gar Powell-Evans
Simon Rawles
Carl Recine
Andrew Redington
Michael Regan
Simon Renilson
Ben Roberts
Ian Robinson
Stuart Robinson
Nigel Roddis
Jacob Russell
David Sandison
Oli Scarff
Kevin Scott
Mark Seager
Bradley Secker
Sharron Lovell
Robbie Shone
David Shopland
Nishant Shukla
John Sibley
Guy Smallman
Hannah Lucinda Smith
Toby Smith
Zute Lightfoot
Craig Stennett
Jane Stockdale
Rob Stothard
Chris Stowers
Matt Stuart
Andrew S.T. Wong
Jon Super
Justin Sutcliffe
Sean Sutton
Babak Tafreshi
Justin Tallis
Sam Tarling
Anastasia Taylor-Lind
Edmond Terakopian
Andrew Testa
Ed Thompson
Lee Thompson
Abbie Trayler-Smith
Mary Turner
Steve Ullathorne
Charlie Varley
Joanna Vestey
James Veysey
David Vintiner
Jenny Lynn Walker
Chris Warde-Jones
Craig Watson
Barrie Watts
Richard Wayman
Neil White
Alex Whitehead
Lewis Whyld
Barney Wilczak
Gari Wyn Williams
James Williamson
Will Wintercross
Joseph Wood
Jooney Woodward
Chris Young

United States

Mustafah Abdulaziz
Mark Abouzeid
Jenn Ackerman
Adam Berry
Nick Adams
Lynsey Addario
Karine Aigner
Micah Albert
James Edward Albright Jr.
Pablo Alcala
Alex Goodlett
Ian Allen
Carol Allen-Storey
Maya Alleruzzo
Elise Amendola
Joe Amon
Christopher Anderson
Jason Andrew
Drew Angerer
Bryan Anselm
Charles Rex Arbogast
Christopher T. Assaf
Lacy Atkins
Asca S.R. Aull
Andrew Spear
Erik Hill
Marc Erwin Babej
Zachary Bako
Shawn Baldwin
Bill Bangham
Brendan Bannon
Michael Barkin
Richard Barnes
Will Baxter
Max Becherer
Robyn Beck
Al Bello
Josh Bergeron
Nina Berman
Alan Berner

Paul Bersebach
Charles Bertram
Sasha Bezzubov
Cass Bird
Keith Birmingham
Justin Black
Rebecca Blackwell
Peter Blakely
Victor J. Blue
John Boal
Crush Boone
Nancy Borowick
Rick Bowmer
Anna Boyiazis
Alex Brandon
Brandon Magnus
M. Scott Brauer
Erin Brethauer
Daniel C. Britt
Ben Brody
Paula Bronstein
Kate Brooks
Scott K. Brown
Milbert Brown
Andrea Bruce
Robert F. Bukate
Gregory Bull
Richard Burbridge
Gerard Burkhart
Andrew Burton
Elyse Butler
David Butow
Renée C. Byer
Yoon S. Byun
Andrew Caballero-Reynolds
Rukmini Callimachi
Mary Calvert
Steve Camargo
D. Ross Cameron
Gary A. Cameron
Matt Campbel
Christopher Capozziello
Ricky Carioti
Carl Kiilsgaard
Darren Carroll
J Pat Carter
Lucas Carter
Elinor Carucci
John Castillo
Ken Cedeno
Robert Chamberlin
Columbus Dispatch
Barry Chin
Michael Ciaglo
Daniel Cima
Giles Clarke
Timothy Clary
Jay Clendenin
Nadia Shira Cohen
Alexander Cohn
Kris Conno
Fred R. Conrad
Eduardo Contreras
Nolan Conway
Glen M Cooper
Thomas Cordova
John Costello
Will Cotton
Andrew Craft
Bill Crandall
Johnny Crawford
James Crisp
Maisie Crow
Anne Cusack
Scott Dalton
Jim Damaske
Linda Davidson
Lauren DeCicca
David Degner
James Whitlow Delano
Gabriella Demczuk
Michael DeMocker
Diane Dennerline
Bryan Denton
Chris Detrick
Charles Dharapak
Peter DiCampo
Kevin Dietsch
Martin Dxion
Matt Dixon
Bobby Doherty
Olivier Douliery
Michael Downey
Christena Dowsett
Ruston Drach
Carolyn Drake
Ariana Drehsler
Michel DuCille
Brett Duke
Cody Duty
Michael Dwyer
Dan Eckstein
Aristide Economopoulos
Matt Eich
Sean D. Elliot
Ronald Erdich
Jonathan Ernst
Peter Essick
Josh Estey

Christopher Evans
Mel Evans
Rich-Joseph Facun
Timothy Fadek
Steven M. Falk
Candace Feit
Gina Ferazzi
Don Feria
Jon Ferrey
Abigail Saxton Fisher
Deanne Fitzmaurice
Lauren Fleishman
Kathleen Flynn
Michael Forster Rothbart
Tom Fox
Bill Frakes
Dustin Franz
Ruth Fremson
Michael Friberg
Gary Friedman
Misha Friedman
Noah Friedman-Rudovsky
Mike Fuentes
Modesto Bee
Noam Galai
Phyllis Galembo
Scott. R. Galvin
Preston Gannaway
Alex Garcia
Chris Gardner
Elie Gardner
Morry Gash
Star Tribune
Ken Geiger
Dave Getzschman
David Gilkey
Melissa Golden
David Goldman
Christopher Goodney
Glenna Gordon
Chet Gordon
Chris Granger
Kyle Green
Stanley Greene
Lauren Greenfield
Timothy Greenfield-Sanders
Pat Greenhouse
Michael Greenlar
Amos Gregory
Tim Gruber
David Grunfeld
Timothy L. Hale
Bob Hallinen
Josh Haner
Johnny Hanson
Paul Haring
Andrew Harnik
Amy Nichole Harris
Mark Edward Harris
Darren Hauck
Todd Heisler
Mark Henle
Michael Henninger
Ryan Henriksen
Gerald Herbert
Elizabeth D. Herman
Lauren Hermele
Gabriel Hernandez
Tyler Hicks
James Hill
Ed Hille
Eli C. Hiller
Lee Hoagland
Bill Hoenk
Brendan Hoffman
Darcy Holdorf
Jim Hollander
Josh Holmberg
Loren Holmes
Alex Holt
Jeff Holt
Mark Holtzman
Jae C. Hong
Alexandra Hootnick
Ryan Hoover
Alex Horvath
Sarah Hoskins
Jonathan House
Lester J. Millman
Jabin Botsford
Lucas Jackson
Ted Jackson
Julie Jacobson
Samuel James
Terrence Antonio James
Jay Janner
Monique Jaques
Janet Jarman
Jay Westcott
Ron Jenkins
Shannon Jensen
Chris Fitzgerald
Krisanne Johnson
Joseph Johnston
Eric Michael Jordan
Marvin Fredrick Joseph
Allison Joyce
Julie Bergonz
Zhang Jun

Greg Kahn
Nikki Kahn
Jonathan Kalan
Hyungwon Kang
Anthony Karen
Ivan Kashinsky
Carolyn Kaster
Stephanie Keith
Andrew Russell
Mike Kepka
Laurence Kesterson
Natalie Keyssar
John J. Kim
Yunghi Kim
John Kimmich-Javier
T.J. Kirkpatrick
Paul Kitagaki Jr
Stephanie Klein-Davis
Meridith Kohut
Andreas Laszlo Konrath
Jim Korpi
Jeff Kowalsky
Brooks Kraft
Stacy Kranitz
Lisa Krantz
Adam Krause
Suzanne Kreiter
Charles Krupa
Emin Kuliyev
Teru Kuwayama
David L. Ryan
Levin Lemarque
Rod Lamkey
Justin Lane
Nancy Lane
Jerry Lara
Brad Larrison
Gillian Laub
Michael Leary
David Proeber
Mark Lennihan
Sara Naomi Lewkowicz
Ted Lieverman
Brennan Linsley
Howard Lipin
Dina Litovsky
Jim Lo Scalzo
Jeremy Lock
Rick Loomis
Delcia Lopez
Kevin Lorenzi
Benjamin Lowy
Robin Loznak
Kirsten Luce
Katie Hayes Luke
Erik Lunsford
David Lynch
Patsy Lynch
Tom Lynn
Kelvin Ma
Chris Machian
Michael Macor
Rolf Maeder
Jose Luis Magana
Mark Makela
Yanina Manolova
Melina Mara
Tiana Markova-Gold
Pete Marovich
Dan Marschka
Jacquelyn Martin
Pablo Martinez Monsivais
AJ Mast
Tim Matsui
David Maung
Justin Maxon
Dania Maxwell
Robert Maxwell
G.J. McCarthy
Matthew McClain
John McDermott
Ken McGagh
Lauren McGaughy
Kirk D. McKoy
Win McNamee
Eric Mencher
Justin Merriman
Rory Merry
Kyle Meyer
Nhat Meyer
Sebastian Meyer
Lucas Michael
Mike DeSisti
Leah Millis
Andrew Mills
Doug Mills
Mati Milstein
Lianne Milton
John Minchillo
Donald Miralle, Jr.
Graeme Mitchell
Logan Mock-Bunting
Genaro Molina
M. Scott Moon
Andrew Moore
John Moore
Laura Morton
Stephen Morton
Bonnie Jo Mount

Peter Muhly
Pete Muller
Daniel Murphy
Amanda Mustard
Michael Nagle
Nish Nalbandian
Sol Neelman
Andrew A. Nelles
Grant Lee Neuenburg
Gregg Newton
Michael Nichols
Matthew Niederhauser
James Nielsen
Landon Nordeman
Linka A Odom
Sue Ogrocki
Adriane Ohanesian
Steve Oldfield
Scott Olson
Katie Orlinsky
KC Ortiz
Nick Oza
David Pace
Darcy Padilla
Ilana Panich-Linsman
Yana Paskova
Paul Beaty
Peggy Peattie
Joe Penney
Algerina Perna
John Francis Peters
Brian Peterson
Mark Peterson
David J. Phillip
Holly Pickett
Chad Pilster
Spencer Platt
Suzanne Plunkett
John W. Poole
Gary Porter
Brian Powers
Karen Pulfer Focht
Thomas Boyd
Staton Rabin
Joe Raedle
John Raoux
Anacleto Rapping
Kevin J. Ratermann
Eric Reed
Mona Reeder
Andrea Star Reese
Tom Reese
Sarah Reingewirtz
Edwin Remsberg
Tim Revell
Damaso Reyes
Adam Reynolds
Jeff Rhode
Charles Emir Richards
Eugene Richards
Roger M. Richards
Andy Richter
Charlie Riedel
Jessica Rinaldi
Steve Ringman
Amanda Rivkin
RJ Sangosti
Larry Roberts
Michael Robinson Chávez
Diego James Robles
Rick Rocamora
Paul Rodriguez
Aaron Rosenblatt
Jenny E. Ross
Robert J. Ross
Matt Rourke
Tim Rue
J.B. Russell
Craig Ruttle
Mohammad Sajjad
Mike Sakas
Gulnara Samoilova
Marcio Jose Sanchez
Wally Santana
Aaron Joel Santos
Joel Sartore
April Saul
Matt Sayles
Erich Schlegel
Alyssa Schukar
Camille Seaman
Sean Gallup
Mark Seliger
Patrick Semansky
Bill Serne
Ezra Shaw
Allison Shelley
Charles Shoemaker
Erin Siegal McIntyre
Sam Simmonds
Denny Simmons
Luis Sinco
Ashok Sinha
Paulo Siqueira
Wally Skalij
Laurie Skrivan
Matt Slocum
Brendan Smialowski
Drew Anthony Smith

Larry W. Smith
Patrick Smith
Brian Snyder
Chip Somodevilla
Ted Soqui
Alec Soth
Gail DeMarco
Paul Souders
Tristan Alexei Spinski
Jamie Squire
Andrew Stanbridge
John Stanmeyer
Shannon Stapleton
Susan Stava
Jordan Stead
Herald-Standard
George Steinmetz
Larry Downing
Sean Stipp
Michael Stokes
Robert Stolarik
Rebecca Barnett
Steven Storey
Stephanie Strasburg
Scott Strazzante
Theo Stroomer
Justin Sullivan
Pat Sullivan
Chitose Suzuki
Yusuke Suzuki
Lexey Swall
Chris Sweda
Joseph Sywenkyj
University of Michigan
Kayana Szymczak
John Taggart
Shannon Taggart
Mario Tama
Andri Tambunan
Patrick Tehan
Daniel Tepper
Mark J. Terrill
Shmuel Thaler
Bob Thayer
Eric Thayer
Bryan Thomas
Timothy Thompson
Lonnie Timmons III
John Tlumacki
Tara Todras-Whitehill
Jonathan Torgovnik
Linda Troeller
John Trotter
Scout Tufankjian
Jane Tyska
Dana Ullman
Gregory Urquiaga
Nuri Vallbona
Peter van Agtmael
John R Van Beekum
Will van Overbeek
Streeter Lecka
Alicia Vera
José Luis Villegas
Sarah L. Voisin
Stephen Voss
Craig F. Walker
Jensen Walker
John Wark
Philadelphia Inquirer
Guy Wathen
Jim Watson
Steven Weinberg
Laura Weisman
David H. Wells
Kristyna Wentz-Graff
StateImpact Oklahoma
Chandler West
Andrew White
John H. White
Jared Wickerham
Christian Wilbur
Danny Wilcox Frazier
Rick T. Wilking
Kathy Willens
Matt Lutton
Michael Williamson
Lisa Wiltse
Ed Kashi
Damon Winter
Steve Winter
Tom Winter
Dan Winters
Andrea Wise
Christian Witkin
Sam Wolson
Alex Wong
Alison Wright
Daniella Zalcman
Mark Zaleski
Zhao Jingtao

Uruguay

Leo Barizzoni
Gabriel A. Cusmir Cúneo
Julio Etchart
Quique Kierszenbaum
Christian Rodriguez
Nicolás Scafiezzo

Uzbekistan

Vladimir Jirnov
Elyor Nematov
Dana Oparina
Anzor Bukharsky

Venezuela

Abreu Rondon
Pedro Antonuccio Sanó
Gustavo Bandres
Orlando Baquero
Oscar B. Castillo
Alejandro Cegarra
Luis Cobelo
Sotana Veloz
Ariana Cubillos
Fenelon Diaz
Julie Lemua
Gil Padrino
Andrés Gutiérrez
Juan Carlos Hernandez
Ramon Lepage
Leo Liberman
Jose Lobo
El Chesther
Eduardo Luis Méndez
Nilo Jimenez
Gigi Hope
Carlos Sanchez
Jorge Santos Jr
Emanuele Sorge
Malva Suárez
Jimmy Villalta

Vietnam

Ho Anh Tien
Lai Khanh
Le Anh Dung
Luong Phu Huu
Ly Hoang Long
Mai Loc
Na Son Nguyen
Phan Quang
Tran The Phong
Hoang Minh Tri
Nick Ut

Yemen

Yahya Arhab

Zimbabwe

Angela Jimu
Wallace Munodawafa Mawire
Annie Mpalume
Tsvangirayi Mukwazhi
Zinyange Auntony

Copyright © 2014
Stichting World Press Photo, Amsterdam,
the Netherlands
Schilt Publishing, Amsterdam, the Netherlands
All photography copyrights are held by
the photographers.

First published in Great Britain in 2014 by
Thames & Hudson Ltd,
181A High Holborn, London WC1V 7QX
www.thamesandhudson.com

First published in the United States of America
in 2014 by Thames & Hudson Inc.,
500 Fifth Avenue, New York, New York 10110
www.thamesandhudsonusa.com

Art director
Sandra van der Doelen
Advisors
David Campbell
Teun van der Heijden
Design
Heijdens Karwei
Production coordinator
Femke van der Valk
Picture coordinators
Noortje Gorter
Anne Schaepman
Nina Steinke
Captions and interview
Rodney Bolt
Editorial coordinators
Manja Kamman
Laurens Korteweg
Jennifer Noland
Editor
Kari Lundelin

Color management
Andre Beuving
Eyes On Media, Amsterdam, the Netherlands
www.eyesonmedia.nl

Paper
BVS FSC Mixed Credit 150 g/m², cover 350 g/m²
Print & Logistics Management
KOMESO GmbH, Stuttgart, Germany,
www.komeso.de
Lithography, printing and binding
Offizin Scheufele, Stuttgart, Germany,
www.scheufele.de
Production supervisor
Maarten Schilt
Yasmin Keel
Schilt Publishing, Amsterdam, the Netherlands,
www.schiltpublishing.com

ISBN 978-0-500-97062-1

This book has been published under the auspices
of Stichting World Press Photo, Amsterdam,
the Netherlands.

Cover photograph
John Stanmeyer, USA, VII for *National
Geographic*
Signal, Djibouti City, 26 February
World Press Photo of the Year 2013

Back cover photograph
Philippe Lopez, France, Agence France-Presse
*Typhoon survivors, Tolosa, the Philippines,
18 November*

About World Press Photo

Our aim is to inspire understanding of the world through high-quality photojournalism.

World Press Photo is committed to supporting and advancing high standards in photojournalism and documentary photography worldwide. We strive to generate wide public interest in, and appreciation for, the work of photographers, and to encourage the free exchange of information.

Each year, World Press Photo invites photographers throughout the world to participate in the World Press Photo Contest, the premier international competition in photojournalism. All entries are judged in Amsterdam by an independent international jury composed of 19 experts. The prizewinning images are displayed in an annual exhibition that tours to 100 locations in 45 countries, and is seen by millions of visitors.

Our activities further include an annual contest for multimedia, exhibitions on a variety of current themes, and the stimulation of photojournalism through educational programs.

World Press Photo is run as an independent, non-profit organization with its office in Amsterdam, the Netherlands, where World Press Photo was founded in 1955.

For more information about World Press Photo and the prizewinning images, for interviews with the photographers, and for an updated exhibition schedule, please visit: www.worldpressphoto.org

MIX
Paper from
responsible sources
FSC® C106007